DOONESBURY
AND THE ART OF
G. B. TRUDEAU

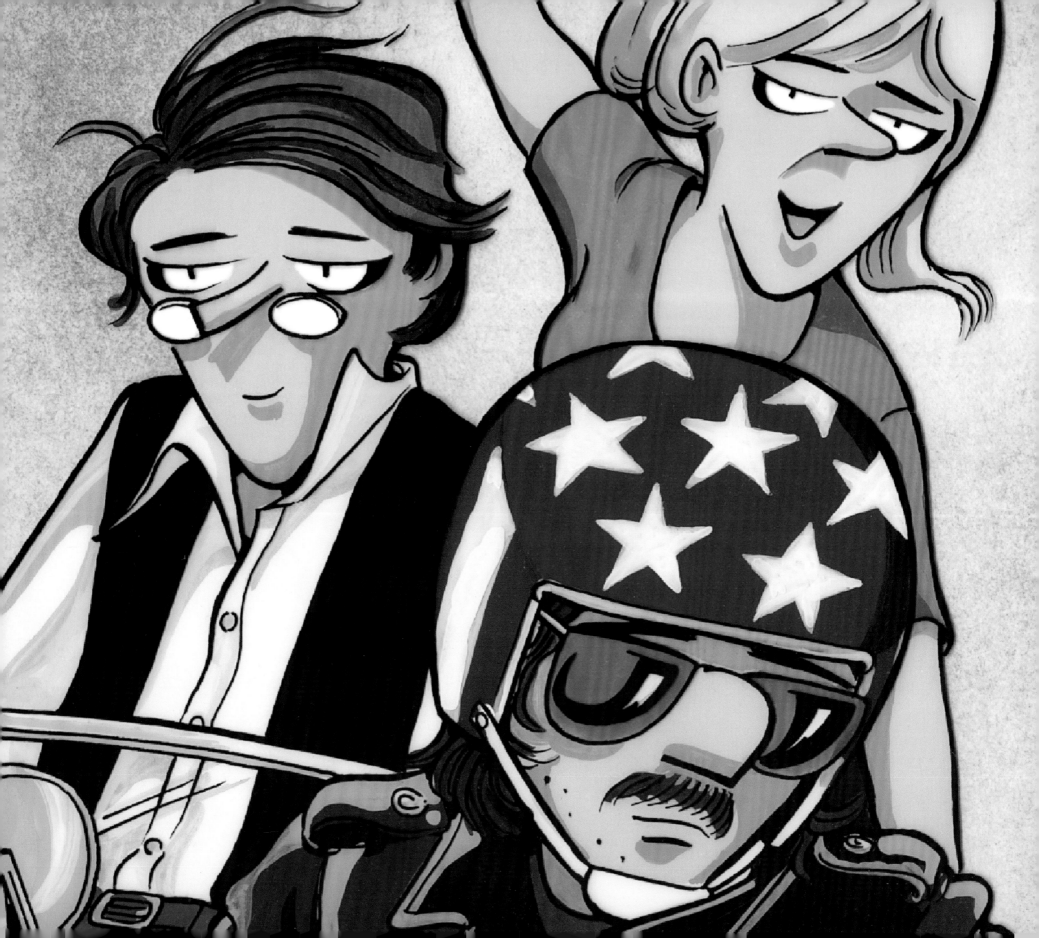

DOONESBURY
AND THE ART OF
G. B. TRUDEAU

Brian Walker

Yale University Press · New Haven and London

Yale University Press books may be purchased in quantity for educational, business, or promotional use.
For information, please e-mail sales.press@yale.edu (U.S. office) or sales@yaleup.co.uk (U.K. office).

Designed by George Corsillo/Design Monsters
Set in Duty Regular type by Amy Storm
Printed in China through Oceanic Graphic Printing, Inc.

Library of Congress Cataloging-in-Publication Data
Walker, Brian.
 Doonesbury and the art of G. B. Trudeau / Brian Walker.
 p. cm.
 Includes bibliographical references and index.
 ISBN 978-0-300-15427-6 (cloth : alk. paper)
1. Trudeau, G. B., 1948–. Doonesbury. 2. Trudeau, G. B., 1948–Criticism
and interpretation. 3. Satire, American–History and criticism. I. Title.
 PN6728.D653W35 2010
 741.5´6973–dc22 2010009783
A catalogue record for this book is available from the British Library.

This paper meets the requirements of ANSI/NISO Z39.48-1992 (Permanence of Paper).

10 9 8 7 6 5 4 3 2 1

"No matter what sort of figure I draw, once I slap that hooded eye on him, he instantly becomes a *Doonesbury* character."
- G. B. Trudeau

CONTENTS

PREFACE

The first conversation I had with Garry Trudeau was in 1973 when I interviewed him for a research paper I wrote during my senior year in college entitled "The Comic Strip as a Communicative Art Form." After I graduated, I began doing articles for an alternative weekly newspaper that my brother Greg had started in southern Connecticut called the *Silver Lining*. I decided to do a piece on the contemporary comics scene and drove to New Haven with Greg to meet Garry at his apartment near the Yale campus. I immediately identified with him as a member of my generation who was doing what many of us aspired to do—challenging the establishment with fresh perspectives and innovative ideas.

In a story on "The New Comix," which was published in the *Silver Lining* on May 8, 1974, I introduced my subject: "Garry Trudeau, aged twenty-five, who has been labeled as everything from 'an apologist for the New Left' to a 'witty social satirist,' has undertaken most of the ground breaking in the newspaper comics business that other cartoonists seem so reluctant to do."

Although Garry insisted that he was not a spokesman for the counter-culture, he did admit that Zonker Harris reflected the idealism of the flower-power era. Garry described Zonker's function in the strip: "His values are those worth preserving from the counterculture. It is a more sensitive and humane society we're living in now. People are more aware and more com-mitted to understanding what makes society work; there isn't that passivity that characterized the fifties." Garry concluded the interview by saying, "If [*Doonesbury*] has any impact, it is because I don't assume the reader is an idiot; nothing's off the table."

At the time this article appeared, I was cleaning and painting an old mansion in Greenwich, Connecticut, which was the first home of the Museum of Cartoon Art. We opened on August 11, 1974, and I worked at the museum for the next eighteen years. In 1982, when Garry announced that he was going on a sabbatical, I suggested to him that he use the break as an oppor-tunity to mount an exhibition of artwork from his twelve-year career. He agreed and introduced me to his book editor at Holt, Rinehart and Winston,

The Silver Lining, 1, no. 3, May 8, 1974. The author interviewed Garry Trudeau for an article on "The New Comix."

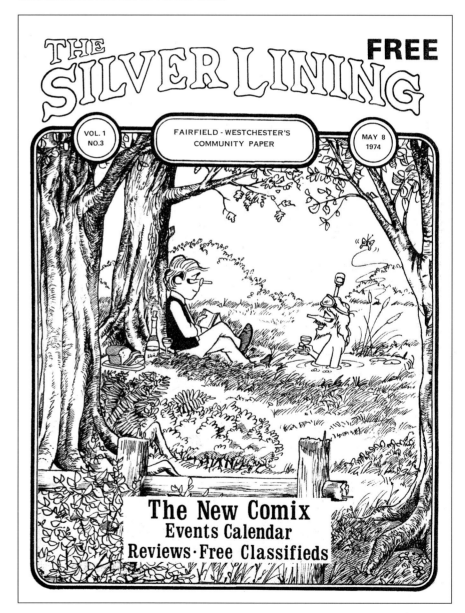

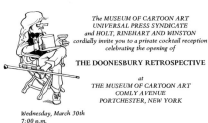

THE MUSEUM OF CARTOON ART
UNIVERSAL PRESS SYNDICATE
and HOLT, RINEHART AND WINSTON
cordially invite you to a private cocktail reception
celebrating the opening of

THE DOONESBURY RETROSPECTIVE

at

THE MUSEUM OF CARTOON ART
COMLY AVENUE
PORTCHESTER, NEW YORK

Wednesday, March 30th
7:00 p.m.

R.S.V.P.
914-939-0234
914-939-7214

(Directions Enclosed)

Top, ticket stub for *Doonesbury: A Musical*, preview engagement at the Wilbur Theatre in Boston on October 29, 1983. Middle, invitation to the opening reception of The Doonesbury Retrospective at the Museum of Cartoon Art in Port Chester/Rye Brook, New York, on March 30, 1983. Bottom, *Comic Relief: Drawings from the Cartoonists Thanksgiving Day Hunger Project*, Henry Holt and Company, 1986.

David Stanford, who helped me organize The Doonesbury Retrospective, which opened at the museum on March 30, 1983. David and I became close friends and continued to work on projects together.

In 1984 I attended the closing night of *Doonesbury: A Musical* at the Biltmore Theatre in New York with David. Two years later, I served on the committee for the second Cartoonists Thanksgiving Day Hunger Project with Garry and David, and we planned promotional events for Hands Across America, including a traveling exhibit of strips from the first year of the fund-raising effort. During the 1980s, with David's editorial supervision, I published four cartoon-related books with Holt. Over the years, I continued to stay in touch with both Garry and David and saw them regularly at National Cartoonist Society events.

In 2002 David obtained permission from Garry to reproduce one of his *Doonesbury* pencil sketches in my book *The Comics: Since 1945*. None of these drawings had ever been published before. In the book, I concluded a profile of Garry with a short summary of his career: "*Doonesbury* earned a reputation for being poorly drawn during its formative years. By the mid-1980s Trudeau's creation was among the most graphically adventurous strips on the comics (and editorial) pages. It has continued to provide a consistently high level of satire and entertainment for more than thirty years."

Between 2005 and 2007 I served as co-curator for the Masters of American Comics exhibition and co-editor of the catalogue, which was published by Yale University Press. In 2008 I made a proposal to Yale for a book based on a series of exhibitions I was organizing at the Charles M. Schulz Museum, entitled The Language of Lines. When editor Michelle Komie indicated an interest in related book proposals, I thought of Garry.

I had always felt that he had not received adequate recognition for his talents as an artist and graphic designer. When I worked on The Doonesbury Retrospective at the Museum of Cartoon Art, I had seen, in addition to his original strips, illustrations and designs he had done for many special projects. I knew there was a wealth of material waiting to be uncovered.

After getting Garry's approval for a book on the art of *Doonesbury*, I sent a proposal to Yale, and the Press responded immediately. It was a perfect project for the publishing company affiliated with Garry's alma mater,

and the release date was scheduled to coincide with the fortieth anniversary of the strip in 2010.

After the contract details were finalized, the first step was to go to the Beinecke Rare Book Library at Yale, where all of the *Doonesbury* original strips from 1970 to 2001 are deposited. I spent days in the reading room there, looking through more than ten thousand strips and making the selections that are reproduced on the following pages. I also made numerous trips to Garry's studio in New York, where I searched through boxes and portfolios of artwork, sketchbooks, files of letters and photographs, binders of news clippings, and drawers of memorabilia.

I made many unexpected discoveries. Garry had hundreds of pencil drawings for books, posters, magazine covers, and newspaper columns, as well as products that he designed for various fund-raising campaigns. There were animation cels for *A Doonesbury Special* and buttons he had produced for the Saranac Lake Winter Carnival every year since 1981. I learned that he had a great-great-grandfather who had been an amateur sculptor and had assisted John James Audubon with his ornithological research. During one visit, Garry found a file of letters he had exchanged with the founders of Universal Press Syndicate, John McMeel and Jim Andrews, when he was an undergraduate at Yale.

I also discovered that George Corsillo, who had worked with Garry on special projects since the late 1980s, was a neighbor of mine in Connecticut. George showed me many wonderful items he had designed with Garry and agreed to work on this book. Everything was falling into place with uncanny serendipity.

As I continued my research, I became increasingly overwhelmed by the scope of the story to be told. In addition to documenting the many milestones in the forty-year history of the strip, I tried to learn as much as I could about all of the related projects in the endlessly expanding *Doonesbury* universe. After I shared with Garry the wealth of material I had accumulated, he admitted that he was surprised by all that had transpired since the strip started. But there was only so much that could be covered in one volume.

Another writer will inevitably face the daunting challenge of compiling the definitive biography of Garry Trudeau. In the meantime, this monograph

Tabletop at George Corsillo's studio cluttered with *Doonesbury* items that he designed with Garry.

should provide a long overdue showcase for his artwork and give some insights into his creative processes. *Doonesbury and the Art of G. B. Trudeau* could serve as the catalogue for a comprehensive museum exhibition. I was fortunate to see all of this original artwork firsthand, and I hope that the general public will have the chance to do so at some point in the future. It was my goal to faithfully reproduce Garry's fine pencil drawings, pen-and-ink strips, and brilliantly conceived books, posters, and products. I am confident that readers will come to the same conclusion as I have. These are the creations of one of the most talented artists ever to work in comics and graphic design.

I would like to thank the many individuals who helped make this project a reality. Michelle Komie at Yale University Press has been a supportive and enthusiastic editor since I first suggested the idea to her. Louise Bernard and Anne Marie Menta at Yale University's Beinecke Rare Book Library gave me access to the *Doonesbury* strips in their collection, and their professional photo-duplication department produced high-quality scans of my selections. Mary Suggett at Andrews McMeel Universal went beyond the call of duty to search for a group of classic Sunday pages in their archives, and Hugh Andrews generously provided permission to reprint them. Garry's office manager, Mike Seeley, showed me around the studio and gave me some valuable insights. Don Carlton talked candidly about his long collaboration with Garry. Neal Walker scanned hundreds of original drawings, strips, and paintings, as well as photographs, books, and other items, and helped with a variety of technical issues. George Corsillo and Susan McCaslin welcomed me into their studio on numerous occasions, sharing stories, artwork, and friendship, and George did a spectacular job designing this book. David Stanford recounted tales of his long association with Garry, lent rare pieces of artwork from his personal collection, reviewed my manuscript, and provided positive encouragement for the project from the beginning.

My wife Abby, once again, has been patient and understanding while my mind has been off in Walden Puddle. And, finally, although I know it was uncomfortable for him to be the focus of so much attention, Garry was generous with his time, provided unlimited access to his archives, and was cooperative and supportive at every step of the journey. I hope he is pleased with the result.

The author in his studio. Photo by Fran Collin.

Bull Tales. The first book collection of strips was published by the *Yale Daily News* in February 1969.

BULL TALES

Garretson Beekman Trudeau was born in New York City on July 21, 1948. He is the first cartoonist in a family of doctors, civil servants, and businessmen.

In the 1650s a carpenter named Etienne Trudeau moved from France to Montreal. The branch of the family that stayed in Canada includes among its members former Prime Minister Pierre Elliott Trudeau. Another group headed south and settled in Louisiana, where Garry Trudeau's great-great-grandfather, James de Berty Trudeau, was born on September 14, 1817.

James began his medical training in Paris, graduating from the University of Pennsylvania in 1837. He moved to New York City, married a doctor's daughter, Cephise Berger, set up his medical practice, and was one of the founders of the New York Academy of Medicine. He also dabbled in sculpture and created a group of plaster statuettes and bronze bas-reliefs that caricatured his fellow physicians. These are said to have created much ill will among the small fraternity of New York doctors.

Garry Trudeau's great-grandfather, Edward Trudeau, who was born to James and Cephise in 1848, claimed in his autobiography that "the love of nature and hunting was a real passion with my father—a passion which ruined his professional career in New Orleans, for he was constantly absent on hunting expeditions." In 1841 James accompanied the famous naturalist John James Audubon on the Fremont expedition to the Rocky Mountains. He assisted with ornithological research and painted illustrations of birds and eggs, and Audubon named a species of tern after him.

During one of his expeditions through Indian territory, an Osage hunting party was sent to welcome James because the tribe remembered another Trudeau who had previously saved one of their chiefs from a knife wound. James was invited to hunt with them and stayed with the Osage for more than two years. When he left, they presented him with a full buckskin suit embroidered with beads. A portrait of James in this outfit, painted by Audubon's son James Woodward Audubon in 1841, hangs today in the Trudeau home. The resemblance between Garry Trudeau and his forebear was par-

James Woodward Audubon, portrait of James de Berty Trudeau, 1841.

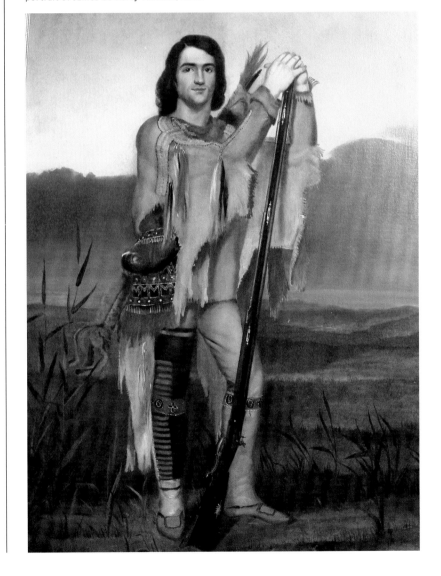

Photograph of Trudeau from the
St. Paul's School yearbook, 1966.

Garry Trudeau, *Horae Magazine.* The early Jules Feiffer influence was evident
in this drawing, which accompanied an article Trudeau wrote for the student
literary magazine of St. Paul's School, 1965.

ticularly striking when the great-great-grandson wore his hair long during his
teenage years.

Cephise moved to Europe with Edward and her parents in 1851 and,
after divorcing James, married a French military officer. James remarried,
served as a brigadier general in the Confederate Army during the Civil War,
and was wounded at the battle of Shiloh. He died in New Orleans on May
25, 1887.

Edward lost a brother to tuberculosis in 1865 and was diagnosed with
the same disease in 1873. During a trip to the Adirondack Mountains in
upstate New York, Edward discovered that fresh air, healthy food, and relax-
ation alleviated his symptoms. He relocated his family to Saranac Lake and
set up the first "cure cottage" to pioneer his innovative rest therapy. The
Trudeau Sanitarium eventually became the Trudeau Institute, which was
founded by Garry Trudeau's father, the physician Francis Berger Trudeau, in
1954 and continues to provide a center for biomedical research.

The cartoonist's mother, Jean Douglas Moore, can claim a former trea-
surer of the United States under Abraham Lincoln and a founder of I.B.M. on
her side of the family. Garry Trudeau has two sisters; Jeanne is four years
older and Michelle is three years younger. His father had a long, distinguished
career as a physician in Saranac Lake and was known for his earnest demeanor.
"Life is not to be enjoyed, it's to be gotten on with," he once advised his son.

Trudeau characterized his childhood in the Adirondacks as "an idyllic
Huckleberry existence—fishing, tree houses, and little adult supervision." At
the age of seven he developed a passion for theatrical productions. "The
Acting Corporation," as he called his ten-year enterprise, recruited local tal-
ent and staged plays in his basement, complete with scripts, tickets, and
programs. "At first I created the shows from scratch—book, music, lyrics,"
Trudeau recollected. "But then I discovered a catalog from Samuel French,
the premier publisher of theatrical works. I dropped my playwriting overnight,
determined to mount only professional fare. At that age, the goal is sophis-
tication, not precocity. I was in a rush to join the adult world." His sister
Michelle described his productions as "complete in every detail—there was a
fullness to them. He could actualize whatever was in his imagination."

In 1960, Trudeau learned that his parents were getting a divorce. He

took the news hard and developed an ulcer, which went undiagnosed for ten years. After attending Harvey, a private preparatory school outside of New York, he was shipped off to St. Paul's School in Concord, New Hampshire. "I was not the class clown—too risky," he admitted. "The hazing was relentless and exhausting. I spent six years in a defensive crouch." An art teacher encouraged him to take a creative path. He became president of the Art Association, co-editor of the yearbook, won the senior-class art prize, and even painted murals on the walls of the children's dormitories at a local mental institution.

A pop-culture enthusiast, Trudeau loved television, movies, music, theater, and cartoons. Although he can remember discovering the subversiveness of *MAD* magazine in his bunk at summer camp in his adolescent years, he didn't start drawing cartoons until he was a teenager. "Newspaper comics were generally unavailable to me in boarding school, so I had few early influences. I was a dabbler. I thought my path would be in theater or fine art," he explained. He was first exposed to the cartoons of Jules Feiffer when students at St. Paul's used Feiffer's dialogue in dramatic performances. He was soon reading all of Feiffer's stories, including *Munro* and *Sick, Sick, Sick.*

Trudeau's first cartoon character, "Weenie Man," appeared on a weekly poster that was displayed on the school's bulletin board to promote the sale of hot dogs at football games. The hot dogs—known as "Mish Weenies"—were sold to raise money for the Missionary Society. As he recalled, "Weenie Man was a fantasy figure—a zero-to-hero character, like those I'd seen in Feiffer's work. He would solve vexing problems by literally tossing hot dogs at them. This may seem like a limited premise, and it was, but the six episodic posters that featured Weenie Man gave me that first little buzz of peer recognition, something I could build on." When one of the posters disappeared from the bulletin board, the rector addressed the entire student body to demand its return.

Trudeau started at Yale University in 1966 and soon began to experiment with a comic strip about an awkward freshman who failed to meet girls at college mixers, but he put the crude drawings away and moved on to other pursuits. He became editor of the campus humor magazine, the *Yale Record,* and wrote columns for the *Yale Daily News.*

Garry Trudeau, "The Mish Weenie Story," 1964. The explanation of how Mish Weenies were made was on the back of this drawing for a poster.

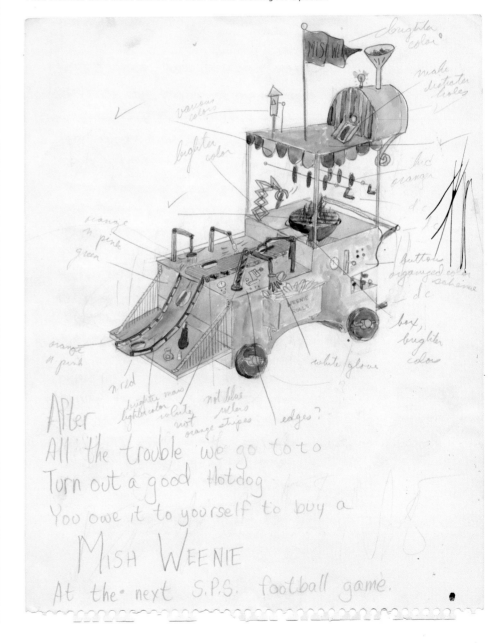

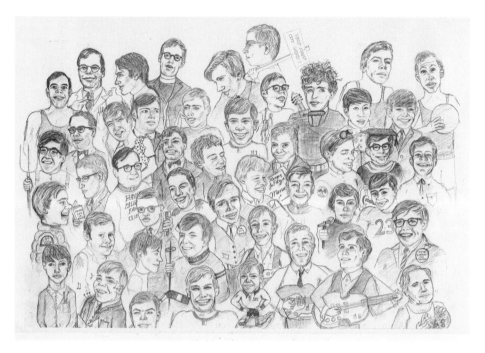

Garry Trudeau, caricatures of St. Paul's School classmates, 1966. These, and
another group of similar drawings, were the end pages of the school yearbook.

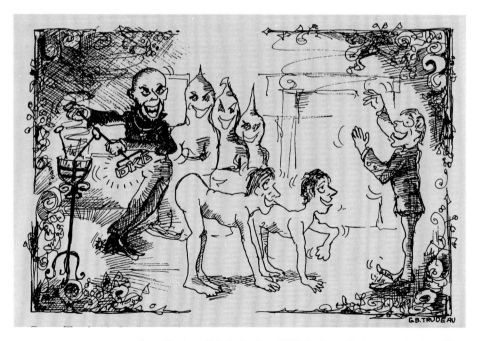

Garry Trudeau, *Yale Daily News*, 1967. Trudeau's first cartoon for his college
newspaper depicted the branding of Delta Kappa Epsilon fraternity pledges.

During his freshman year, Trudeau served on the Armour Council, the
social committee for his residential college, chaired by the upperclassman
George W. Bush. Once a month they would meet to decide such matters as
which bands to book and how many kegs of beer to order for the upcoming
mixers. "It was during these meetings that I came to appreciate George's
mastery of organized socializing. He knew the vendors, he knew the agents,
he knew the brands, he knew cups per keg. He had all the tools. We rubber-
stamped everything he asked for."

The following year, the *Yale Daily News* did an article about the hazing
practices of Yale fraternities, focusing on Bush's Delta Kappa Epsilon. By
tradition, a DKE pledge was initiated by having the tip of a red-hot wire coat
hanger pressed against the small of his back, leaving a delta-shaped scar.
Accompanying the exposé were a couple of Trudeau cartoons which satiri-
cally depicted the ritual. The *New York Times* picked up the story and
obtained a quote from DKE fraternity president Bush, who characterized the
wound from the branding as "only a cigarette burn."

Trudeau pursued a variety of extracurricular activities during his stu-
dent years. He operated an electron microscope, worked at an archaeologi-
cal dig, designed light murals for the Ping Pong room at Gracie Mansion, was
a photo researcher for *Time* magazine, an assistant to the producer of an
Off-Broadway show, and a subject for a series of psychological experiments.
The summer after his sophomore year at Yale, Trudeau and three friends
started a twenty-four-page, biweekly, trilingual magazine for foreign visitors
to Washington, D.C. By the end of the summer they were putting in twenty-
hour days, scrambling to coordinate eighty-five volunteers and losing weight
from tension and anxiety. "It nearly killed us, but we managed to bang out
eight issues on deadline," he claimed. "I fell in love with graphic design and
returned to school brimming with ideas for the publications I worked on."

In early September 1968, Trudeau, now a tall, lanky junior, showed up at
the York Street offices of the *Yale Daily News* with a handful of cartoons
about the football team. His comic strip creation, named *Bull Tales* after Yale's
bulldog mascot, chronicled the on-and-off-field exploits of the current star
quarterback, Brian Dowling. Editor Reed Hundt looked at the crude sketches,
shrugged, and said, "Sure. We print pretty much anything."

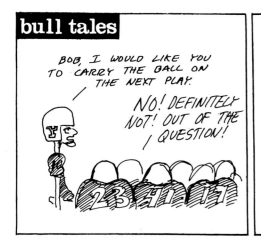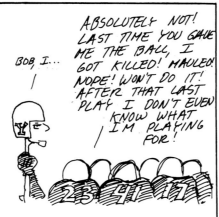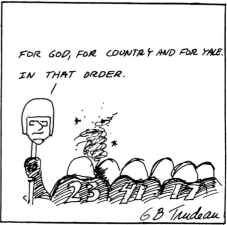

Garry Trudeau, *Bull Tales, Yale Daily News,* 1968. In this early strip, quarterback Brian Dowling told his teammates what they were playing for.

"He was a really, really bad drawer—horrible," Hundt later told an interviewer. The debut episode of *Bull Tales* appeared on September 30, 1968, just after the first victory of the football season. It featured Trudeau's soon-to-be-famous huddle motif. The quarterback was initially identified with a "Y" on his helmet, but by the October 14 episode, Dowling's number "10" was added to the jersey. Two days later, one of the players referred to him as "B.D." By November 2, *Bull Tales* was familiar enough to readers of the *Yale Daily News* to be parodied. The spoof, entitled *bull,* showed the football team attacking the cartoonist.

Trudeau's cartoons were effective because they humanized the popular quarterback by caricaturing him as a dumb jock who never took off his helmet. "World-wise Yalies," wrote Frank Deford in *Sport Illustrated,* "attending this prestigious institution of learning, preparing to spend the rest of their lives as stock brokers or CIA operatives, had suddenly found themselves going bananas over a silly football team, just as if they were in the Big Ten—and Trudeau gave them back their sophistication. Once they had laughed at the idiotic football players in *Bull Tales*—and certified their Ivy cynicism—they could go out and be hero worshipers, just like everybody else."

On November 28, 1968, Trudeau received a letter from editor John B. Kennedy of Universal Press Syndicate at 475 Fifth Avenue in New York. "I have noticed your cartoon panel, *Bull Tales* in the *Yale Daily News* and think it is very clever," observed Kennedy. "I was wondering if I could see other samples of your work with a possible view to future syndication."

Universal Press Syndicate founders Jim Andrews, left, and John McMeel, 1975.

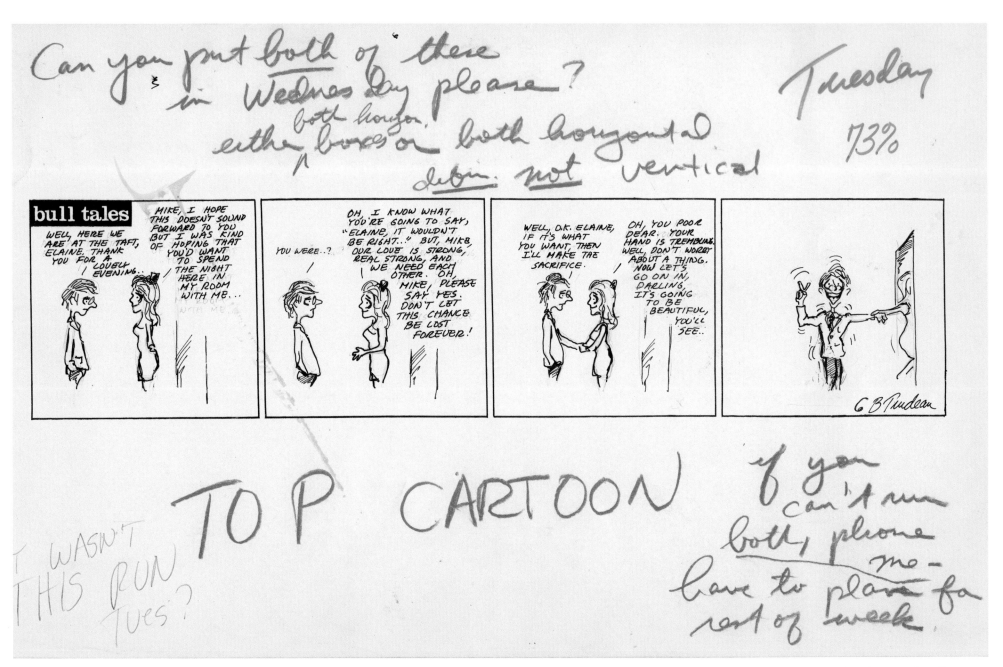

Garry Trudeau, *Bull Tales*, *Yale Daily News*, 1968. This strip was part of a series about Mike's date with a student from a nearby college. Although it appeared as if Mike had finally scored when Elaine invited him into her room at the Taft Hotel, they ended up watching television all night. It was drawn on a preprinted sheet that a friend of Trudeau's made up for him to avoid having to create the logo and boxes from scratch each day.

Although its name sounded impressive, Universal Press Syndicate was actually a moonlighting operation set up by two friends who had both attended the University of Notre Dame. By day, John McMeel was the national sales director for Publishers-Hall Syndicate, the company that distributed *Dennis the Menace* and *Andy Capp.* During his off hours, he ran the sales and marketing side of the fledgling syndicate out of a one-room office five floors above a bar in Manhattan with the help of his wife, Susan. Jim Andrews, who was employed by the *National Catholic Reporter,* constituted the editorial department. Andrews's office was in his rented home in Leawood, Kansas, where he worked with his wife, Kathleen, who was the syndicate's chief financial officer. Andrews had been looking at a column by the theologian Malcolm Boyd in the *Yale Daily News* for possible syndication when *Bull Tales* caught his eye. He used the "John B. Kennedy" pseudonym so that his employer would not find about the Universal Press Syndicate undertaking.

Trudeau didn't answer the letter until December 28, 1968, because his editor at the *Yale Daily News* hadn't given it to him. "I am not certain as to exactly how a strip of this nature could be of interest to you," he replied, "for as you might have noticed the cartoons as they stand now are rather specific to Yale and college life." He sent some samples of his most recent work and offered to adapt future strips for a broader audience.

Soon after *Bull Tales* started appearing in the *Yale Daily News,* Trudeau had a friend make up some blank sheets with the logo and the panel borders preprinted. Although this created the illusion of an ongoing, professional operation, the slick paper was difficult to draw on. Trudeau learned about flexible nib pens in one of his art classes and purchased a Speedball C-6 pen to ink over the pencil lines.

When the football season was over, *Bull Tales* expanded its focus, taking on other aspects of Yale campus life, including mixers, swim meets, hockey games, student organizations, school politics and president Kingman Brewster. Trudeau worked at a large wooden table in his room at Davenport College, spending about two hours a night producing two to four strips a week. He acknowledged his debt to Jules Feiffer and Charles Schulz to a reporter from the Yale alumni magazine, who noted in June 1969: "His artwork reflects the technique of these two masters, keeping details to a minimum by reducing

Doonesbury print advertisements, 1970. Universal Press Syndicate provided promotional material for subscribing newspapers to announce the debut of the strip.

A new look at the world of college as seen by Gary Trudeau, humorist, cartoonist and Yale, Class of 1970.

Let Mike "The Man" Doonesbury take your sense of humor on a tour of life on and about campus daily in Doonesbury.

Beginning Monday in Your Paper.

Meet the man who kept Yale laughing for years... but watch out for your own funnybone when you meet

Doonesbury
by GB Trudeau.

in Your Paper
Starting Monday

College football may never be the same after one look into the huddle with Doonesbury!

Doonesbury
by GB Trudeau.

coming your way every day with the wildest, freshest humor to come from the campus in many a year.

Starts Monday in this newspaper.

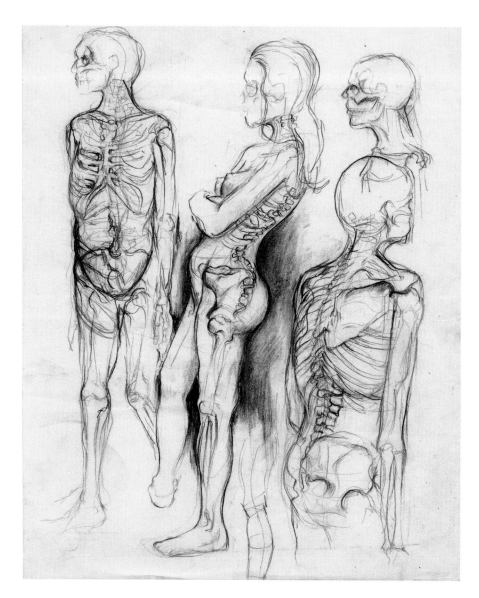

Above and opposite:
Garry Trudeau, anatomy exercise and Goya "mash up," 1968.
Art class drawings from Trudeau's senior year at Yale.

the background to a basic bed, bar, or table, and by mirroring the mood of the situations in the characters' facial expressions."

A book collection of *Bull Tales* strips was published by the *Yale Daily News* in the spring of 1969. Brian Dowling was asked to write the introduction, and Trudeau went to pick it up from him. It was the only time the two ever met. "He came up to my room, said thank you, and that was it," Dowling remembered. When he graduated, Dowling was drafted by the Minnesota Vikings; he spent a year with the Bridgeport Jets, signed with the New England Patriots, and ended his playing career with the Los Angeles Rams in 1977. After that he worked for a hardware company in Boston and was a broadcaster for the PBS Ivy League Game of the Week.

The first *Bull Tales* book collection, which was available in the Yale Co-Op and peddled in the dining halls, sold two thousand copies on a campus of four thousand undergraduates. A second book, entitled *Michael J,* was published later that year. "It was the success of those books that gave me an inkling that maybe I was on to something," Trudeau explained.

The correspondence with John B. Kennedy continued, but the uncertainty of Trudeau's future made him reluctant to commit to a career in cartooning. "All of us were standing in the shadow of the draft. The lottery had not yet taken place, so nobody could make plans. Career opportunities didn't have that much meaning in our lives," he acknowledged.

In the summer of 1969 Trudeau took the initiative and went to visit the syndicate offices in New York. To his surprise, "475 Fifth Avenue" was a mail drop. Soon after, Andrews and McMeel revealed their secret and asked him for six weeks of strips for a sales brochure they planned to publish in the fall.

A major setback occurred in late July, when a suitcase containing the thirty-six sample strips was stolen from the trunk of Trudeau's car while he was visiting a friend in Washington, D.C. He worked nonstop and had them all redrawn by August 28. In early September, Trudeau finally met Andrews and McMeel face to face when he dropped off the strips in New York.

A month later the young cartoonist was beginning to have some reservations about the proposed national launch of his strip. In a letter dated October 17, 1969, he admitted to Andrews: "Since I have been doing *Bull Tales* at Yale this year and have been having a rugged time of it doing five a week, I'm

beginning to fathom just how much work it would be to do six a week, especially considering doing them for syndication is harder for me (more restrictions)." He expressed his concern that no formal agreement had been signed and no deadlines set. In a follow-up letter he wrote, "After careful deliberation, I have decided that all things being equal, it will be impossible for me to be a student and a cartoonist simultaneously and expect to be good at either. The way things look now, I can just not conceive bearing up under all the pressure involved in syndication. Therefore, I would like to postpone syndication until next September."

During the intervening months, Universal Press Syndicate officially incorporated and had success with a number of new features. A Pulitzer Prize–winning series of articles by Seymour Hersh about the My Lai massacre in Vietnam put the syndicate over the top, proving that it could compete with the major newspaper content providers. "We knew from the beginning that we had to do things differently if we were to take on the Big Six," claimed McMeel, referring to the established King, United, Field, Chicago Tribune–New York Daily News, L.A. Times, and Register and Tribune syndicates. "Our size and position in the market meant we could move quickly and take risks—we had nothing to lose."

On May 15, 1970, Trudeau communicated to Jim Andrews that he was ready to renew his efforts to prepare for national syndication. He noted that the increasing attention focused on campus unrest provided "a great opportunity for a comic strip which is a little more poignantly satirical than the first series of *Bull Tales*." He wanted to explore such topics as drugs, sex, and the war in Vietnam. "You may not be able to sell as many of these at first, but I think it has a greater potential for catching on." Trudeau graduated from Yale in June and received a medical deferment from the military in August. He was finally free to plan his future.

Andrews instructed Trudeau to redraw many of the early episodes of *Bull Tales* in preparation for the national launch. He put clothes on the naked coeds, cleaned up some of the language, and had eight weeks of samples ready at the end of July. He also renamed the strip. Combining *doone,* a preppy slang term for a well-meaning fool, with the name of his former roommate, Charles Pillsbury, an heir to the Minnesota flour fortune, he came up with *Doonesbury.*

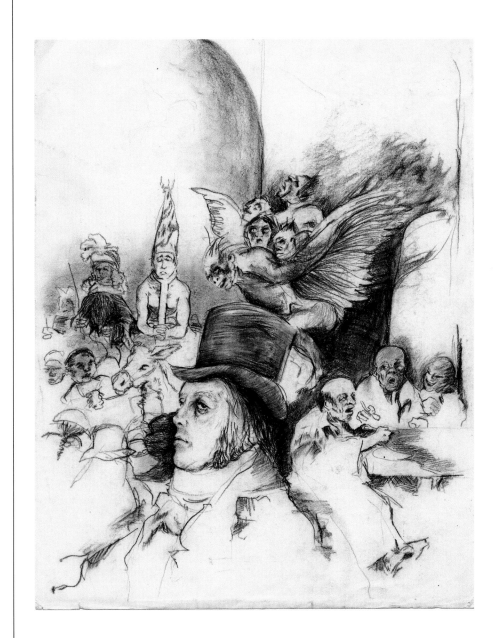

TO THE CHAIRMAN OF THE NEWS:

TODAY I READ THE YALE DAILY NEWS REVIEW OF THE YALE DRAMAT'S RHINOCEROS.

"ACTING IS NOT THE STRONG POINT.
"GOOD ACTING IS WHAT THIS PRODUCTION LACKS."

I COULD JUST IMAGINE THE GOOD FUN THOMAS HINE MUST HAVE HAD IN FLIPPANTLY THROWING TOGETHER THE ARTICLE WHICH WOULD SERVE AS THE ONLY CRITERIA BY WHICH 4000 UNDERGRADUATES DECIDED WHETHER THE PLAY WAS WORTH SEEING.

HOW IRRESPONSIBLE, HOW DESTRUCTIVE, HOW DELIGHTFUL!

A POWERFUL FELLOW, THAT THOMAS HINE

AND NOT TOO UNLIKE RAY WARMAN, '70, THAT GAY RACY BLADE WHO WROTE OF THE YALE RECORD,

"UNCERTAIN AS TO WHETHER ANOTHER ISSUE WILL BE FORTHCOMING."

RECORD SALES DROPPED ACCORDINGLY IN THE NEXT FEW DAYS. O.K.!

AND THEN THERE WAS THAT FAMOUS DEVASTATING REVIEW OF THE YALE LIT. BEAUTIFUL!

"OH THOSE NEWS PEOPLE" I THOUGHT, "THEY REALLY ARE SOMETHING ELSE.

"PRINTING TOTALLY UNCONSTRUCTIVE REVIEWS SUCH AS THESE..."

THAT'S REALLY SOMETHING!

IT MUST BE QUITE SOME SENSATION!

SORT OF LIKE PULLING WINGS OFF OF FLIES.

SINCERELY, G.B. TRUDEAU, '70

Garry Trudeau, *Yale Daily News*, 1967. A response to a negative review of *Rhinoceros*, a play for which Trudeau did the graphics.

By August, Trudeau had hired the attorney Nelson Buhler to negotiate a contract. Buhler sent samples of the strip to King Features Syndicate and contacted Lew Little of the Register and Tribune Syndicate, offering them the opportunity to bid on the property. Milton Kaplan, the president and general manager of King Features, wrote back on September 4 that he and comics editor Sylvan Byck had "spent a good deal of time going over Trudeau's work." "While he is a man of some talent," Kaplan concluded, "it is our considered judgment that he does not have here a strip that could be successfully syndicated."

Three months after the successful launch of the strip, Buhler reported to Trudeau that he had finally negotiated a contract with Universal Press Syndicate. In addition to signing him up for twelve years at the standard royalty rate of fifty percent, Buhler also secured copyright ownership of the strip, a concession that was highly unusual, and an arrangement one would not get from other syndicates at the time.

Thirty years later, Trudeau looked back on these heady times: "Only a new syndicate would take a chance on a feature that was never designed to appeal to a broad audience. The early *Doonesbury* didn't fit anyone's idea of what a mainstream comic strip should look like. It was written on the fly, crudely executed, and ignored pretty much every convention of the craft, not surprising since I'd never really studied it. In fact, I'm not sure I even knew what syndication was at the time it was offered to me. I'd only been cartooning for about two months when that first letter arrived, so the sheer randomness of it can't be overemphasized. I was anything but ready."

He was about to begin a period of on-the-job-training.

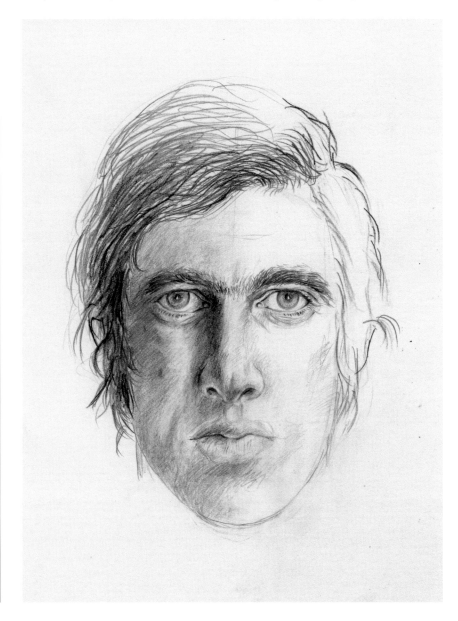

Garry Trudeau, self-portrait, 1971. Trudeau drew this during his first year of graduate school.

The Doonesbury Chronicles, cover photograph for the first anthology published by Holt, Rinehart and Winston, 1975. Trudeau was at a friend's house in Branford, Connecticut.

A FOUR-PANEL SMILE

Doonesbury debuted in twenty-eight papers on October 26, 1970. Among the initial clients were some major newspapers, including the *Washington Post*, the *Boston Globe*, the *Chicago Tribune*, and the *Los Angeles Times*. Soon after the launch, Garry Trudeau attended a gathering of cartoonists and proudly showed off his list of subscribers. Although the veterans were polite and supportive, they seemed mystified by the brash newcomer. Looking back on this first encounter with his professional peers, Trudeau speculated that the cool reception he received was due to a number of factors: "I don't think they could get a read on me. I obviously hadn't paid any dues, and I didn't have the skill set most of them associated with professional cartooning. To make matters worse, I was regularly introducing subject matter that they were quite certain did not belong in the comics. It was clearly unsettling."

Newspaper clients were sold on the idea that *Doonesbury* appealed to a different audience. "When John McMeel and Jim Andrews first took the strip out into the marketplace," Trudeau maintained, "they tried to position it as singular, as unlike anything that had ever appeared in the comics before." The *Miami Herald* reflected this perception in a convincing testimonial that Universal Press Syndicate used in an early sales brochure: "It seems that, more than any other artist, Garry Trudeau has stretched the bounds of comic strip commentary. He is bridging the gap between the editorial page cartoon and the comic strip. In doing so, he is establishing a place for himself in newspaper journalism that is unique."

In January 1971 a reporter from *Editor and Publisher* interviewed Trudeau and John McMeel at a restaurant in New York City. When McMeel referred to the "gags" in *Doonesbury*, Trudeau corrected him: "They're not gags; they're perceptions of the human condition!" The writer observed, "He's got it all worked out, this one. And a lot of people are going to enjoy watching Garry do it his way."

At the time of that interview, Trudeau was living at a ski resort in Vail, Colorado, intending to return to Yale in the fall to get his master's degree in graphic design. Throughout that first year, the circulation of the strip con-

Doonesbury Universal Press Syndicate sales brochure, designed by Trudeau, 1971. Ninety-seven client newspapers were listed in this early brochure, which was published about nine months after the debut of the strip.

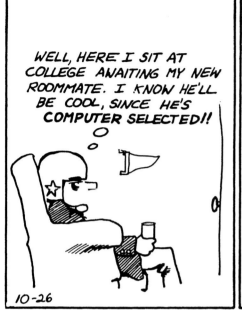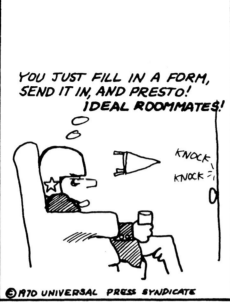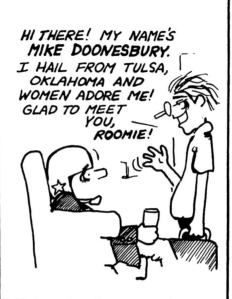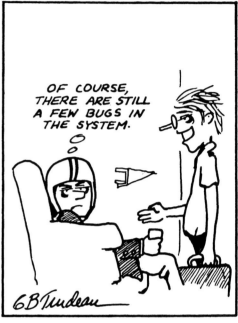

Garry Trudeau, the first *Doonesbury* strip, October 26, 1970. All *Doonesbury* strips and illustrations in this book are by Garry Trudeau, the medium is pen-and-ink on paper, and they are from the artist's collection, unless otherwise noted.

tinued to climb and reached 150 newspapers by the end of the summer. The first *Doonesbury* Sunday page appeared on March 21, 1971, and a book deal with Holt, Rinehart and Winston was signed in the fall.

Trudeau still wasn't completely convinced that he would be successful as a syndicated cartoonist. Just after the roll-out of the strip, he talked enthusiastically to a reporter from *Glamour* magazine about an idea for a media arts commune that would be called Calligraph. It was to be composed of young artists and writers who would work commercially eight months a year and take the remaining four months off to pursue pet projects and get involved in the community. "We will have photographers, designers, and a couple of editors, plus some guys who will put on coats and ties and go to New York and get accounts during those eight months of working time. We're going to allow people to maximize their creative energy."

Trudeau started graduate school at Yale in the fall of 1971. There were ten graphic designers and three fine arts photographers in the program. Classes and workshops were intense and often lasted from eight in the morning until midnight, leaving him little time to work on the strip. Although he tried to catch up during academic breaks, it was a struggle to meet his

deadlines. He sought help from the syndicate, which recommended Don Carlton, a freelance artist who had worked on a variety of assignments for U.P.S. Trudeau and Carlton agreed on a collaborative arrangement, one that has remained essentially unchanged over almost four decades. Trudeau penciled the strips, initially in six-week batches, and mailed them to Carlton, who inked them and delivered them to the syndicate. "At first it was a little jarring because his line wasn't really that close to mine, particularly in the lettering, but over a relatively short period of time our styles seemed to converge, and we found a good rhythm," Trudeau recalled. "I discovered very quickly that it was the original drawing that I loved; inking, for me, was redrawing. I'd already been over those lines, and there was no need to revisit them. I was happy— and grateful—to hand them off to Don."

During the Watergate scandal, it became increasingly difficult for Trudeau to keep pace with current events when he had to produce the strip six weeks in advance. After he finished graduate school in 1973, he found that he could write about the news more effectively by cutting back on the lead time. "Watergate was a problem for a topical feature," he contended. "We kept being overtaken by events. The day John Ehrlichman resigned, we had to recall an entire week of strips. After that, my lead shrank, initially to five weeks, but within a couple years, I was sending out one week at a time." From that point forward, until just recently, he typically worked ten days in advance of publication.

In the early years, Trudeau was very self-conscious about his limitations as an artist. "I rendered the strip in a kind of urgent scrawl; I used to joke that it was cartoon vérité. But remember, by 1970 my generation had effectively hijacked the culture, and that worked in my favor. If *Doonesbury* looked like it had been created in a stoned frenzy, then that was evidence of its authenticity. The strips were dispatches from the front." In 1976 *Time* magazine described him as "an indifferent draftsman," noting, "the artist is usually just good enough to strike an attitude or sink a platitude. But at his best, Trudeau manages to be a Hogarth in a hurry, a satirist who brings political comment back to the comic pages."

The consensus may have been that he was challenged artistically, but the quality of Trudeau's writing was frequently praised. Nicholas von Hoffman,

Trudeau standing in front of the townhouse he owned in New Haven, 1974.

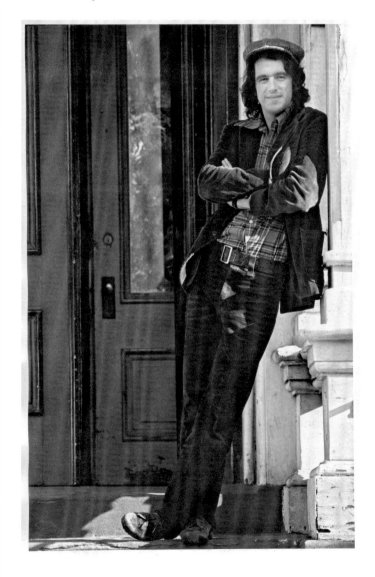

Doonesbury: The Original Yale Cartoons by Garry Trudeau. This book collection of *Bull Tales* strips was first published by American Heritage Press in 1971 and subsequently reissued by Sheed and Ward in 1973.

who collaborated with him in 1973 on *The Fireside Watergate,* claimed: "He has a golden ear. He pays attention to words and the way they're said and captures the essence of what's there that most people don't hear." Trudeau once confessed, "I feel more comfortable referring to myself as a writer because it all starts with the idea."

Although the media focused most of their attention on the political content of *Doonesbury,* the strength of the strip came from its characters. The original *Bull Tales* cast—B.D., Michael J. Doonesbury, and Megaphone Mark Slackmeyer—provided a mix of temperaments and perspectives. Trudeau played off the different roles—the jock, the nerd, and the radical—to create a dynamic clash of personalities in the strip. Although they were fairly stereotypical at first, he eventually made them less predictable. "You don't really want readers to think of your characters as simply the quarterback, the freak, the radical, and so forth. If they're immobilized in those boxes, they lose their vitality and wither. Better to move them through life with all its vicissitudes and see what changes, what shakes loose."

Human vulnerability provided the source for most of Trudeau's humor. He made fun of both radicals and conservatives and depicted their short-comings in a sympathetic way. He insisted that he was not writing jokes or gags. Instead, his goal was to produce "a four-panel smile, a short, jazzy riff with a sustained finish and throwaway coda. The best character humor avoids the rim shot."

One device that Trudeau used effectively to reveal the thought processes of his characters was to have them "narrate" their activities. In one early episode, Mike walked into a college mixer thinking to himself, "'Mike the Mix,' inexperienced but eager freshman, still looks around for his first score of the evening." In the introduction to the first large-format anthology, *The Doonesbury Chronicles,* the author, journalist, and historian Garry Wills pointed out the importance of this mental dialogue: "Trudeau's way of making characters deliver a running commentary on their own acts, a commentary cast in the third person, opens up that inner space in which personality can grow." This process enabled the characters to evolve as they tried on new roles and identities.

In addition to Brian Dowling, who was the model for B.D., other real-life

individuals provided the source for fictional characters in the *Doonesbury* cast. Mark Slackmeyer was loosely based on Columbia political activist Mark Rudd. Yale chaplain William Sloane Coffin, Jr., inspired Reverend Sloan. Lacey Davenport bore a striking similarity to Congressional Representative Millicent Fenwick, a likeness Trudeau was unaware of until after he created her. Duke was the alter-ego of gonzo journalist Hunter S. Thompson, who never appreciated the homage. "I was seriously mortified to see myself," Thompson once lamented. "You can't expect others to understand how horrible it was. How would you like to be mocked in *Li'l Abner* or *Dick Tracy* every day?"

By the mid-1970s readers needed a cast directory to keep track of the characters in the strip. It had also become increasingly difficult for Trudeau to work them all into story lines. "I always felt oddly guilty when the regulars didn't get face time," he says. "But there was always some new world to be explored, and the need for new characters to populate it. The ever-expanding cast is a tremendous burden to readers—how can anyone be expected to keep track of some sixty-odd characters? And for newer readers, taking up *Doonesbury* is like opening a Russian novel in the middle. It can take a long time to get your bearings."

Perhaps the most significant innovation that Trudeau introduced to the comics pages was the way in which his fictional characters played off the pronouncements and misdeeds of well-known personalities and politicians. Before *Doonesbury*, comic strips that dealt with social and political comment used anthropomorphic creatures or characters with pseudonyms to lampoon people in power. Senator Joseph McCarthy was caricatured as Simple J. Malarky, a bobcat, in Walt Kelly's *Pogo*, and folksinger Joan Baez was ridiculed as Joanie Phoanie in Al Capp's *Li'l Abner*. Trudeau did not disguise the identities of the politicians he portrayed or referenced in the strip, including Richard Nixon, John Mitchell, and Henry Kissinger. "There are certain names and personalities that are a very important part of our lives," he told an interviewer in 1972. "To change those names would be to destroy the authenticity I'm shooting for."

This approach often got him into trouble. The most memorable of the many controversies generated by the strip in the early years was the episode in which Mark proclaimed on his radio program that the Watergate

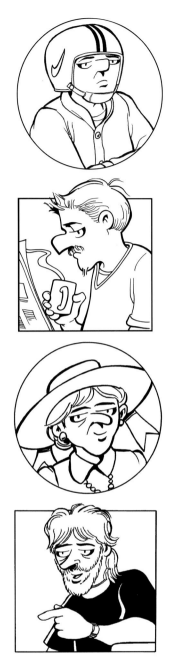

Doonesbury characters inspired by real people include, top to bottom: B.D. (Brian Dowling), Mark Slackmeyer (Mark Rudd), Lacey Davenport (Millicent Fenwick), Reverend Sloan (William Sloane Coffin, Jr., and Scott McLennan), and Duke (Hunter S. Thompson).

conspirator John Mitchell was "Guilty, guilty, guilty!!" The *Washington Post* refused to run the strip, declaring, "If anyone is going to find any defendant guilty, it's going to be the due process of justice, not a comic-strip artist." In 1973 the *Lincoln Journal* became the first newspaper to start printing *Doonesbury* on the editorial page instead of the comics page. Eventually, about a quarter of the strip's clients made the same move, on either a temporary or a permanent basis.

Jim Andrews once advised his young cartoonist to alternate biting political satire with poignant plotlines. Trudeau learned this lesson well and masterfully blended the lives of his characters with current events. On November 9, 1976, Joanie Caucus, after fixing dinner for her boyfriend, Rick Redfern, decided to "go for broke" by blurting out, "I'm also pretty good at breakfast." The following day, Joanie's roommate, Ginny, discovered her empty bed. For the next three days, the strip wordlessly "panned" from Joanie's bedroom window, across town, past the fluttering curtains of Rick's bedroom to reveal the unmarried couple in bed together. The story stirred up a great deal of controversy without having any connection to a news event. Fifteen papers, including the *Boston Globe,* the *New York Daily News,* and the *Chicago Tribune,* refused to print strips in the sequence because editors were concerned that their readers might be offended. "There's nothing overt or obscene about it," Trudeau argued. The press's reaction "just shows that adults are uptight about sex."

The college campus, which served as the original setting for the strip, provided a microcosm of human society, a world within a world. Although Walden College and the Walden Puddle commune would remain home base for the *Doonesbury* gang for many years to come, the characters began to pursue more varied adventures that took them off the campus. Mike tutored kids in the ghetto, B.D. went to Vietnam, and Mark organized a trucker's strike. During the 1970s, Trudeau traveled to American Samoa and also joined the press corps covering President Gerald Ford's trip to China. These, and other exotic locales, were featured in *Doonesbury* plotlines.

Trudeau expanded the range of topics beyond football and dating, the main preoccupations of his early strips. Among the many issues he explored during the first decade of *Doonesbury* were women's liberation, the war in

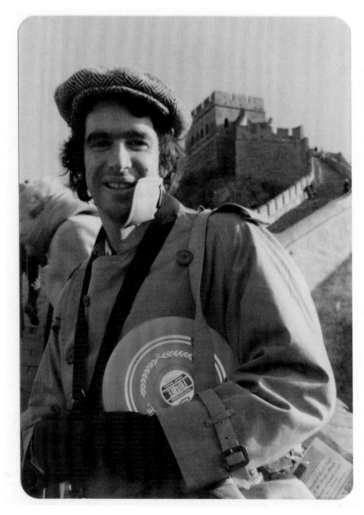

Trudeau with a Frisbee on the Great Wall of China during his visit as a member of President Ford's press corps in January 1976.

Vietnam, divorce, communal living, media exploitation, presidential elections, class warfare, drug use, the energy crisis, homosexuality, rock and roll, political corruption, suntanning, higher education, organized crime, religion, physical fitness, the environment, and natural childbirth. Many of these subjects had never been addressed on the nation's comic pages.

After he graduated from the Yale School of Art, Trudeau bought a red brick town house in New Haven, Connecticut. It was a typical bachelor pad, with stacks of books and records cluttering the floors, original cartoons and posters covering the walls, and a drawing board tucked in a corner. He was notoriously private, earning a reputation as "the J. D. Salinger of comics" for his reluctance to do interviews. He once hid in a bathroom for four hours, avoiding a reporter from the *Baltimore Sun.* In 1971, when he appeared on *To Tell the Truth,* three of the four panelists failed to identify him. On a talk show in Boston, the host asked him how it felt to be "rich, famous, and eligible." He didn't do another television interview for thirty years. "I don't like celebrification," he declared at the time. "Everything I have to share I share in the strip."

During the Watergate years, as *Doonesbury* continued to be bounced from newspapers for sensitive material, editors were forced to provide their readers with some words of explanation to justify their decision to drop the strip on certain days. "All the calls I was fielding got to me. I found myself brooding about how to defend work I hadn't even completed. Being so self-conscious was short-circuiting the process. So I decided to drop off the radar. Unlike any other form of popular culture, comic strips don't actually need promotion to prosper, so there was no downside." Over the years, he has turned down some high-profile publicity, including interviews with *Time* and *60 Minutes,* but has been able to work without the distractions of maintaining a public persona. When he married the *Today* show host Jane Pauley in 1980, helicopters buzzed over their island wedding. "That's no way to live," Trudeau remarked in a recent interview. Since 1980, when Jim Andrews died of a heart attack at the age of forty-four, Lee Salem, who started at the "syndicate that *Doonesbury* built" in 1974, has served as a "human firewall" between the controversial cartoonist and the media.

In 1975 Trudeau became the first comic strip artist to win the Pulitzer Prize. The administrator of the Pulitzer Committee sent him a letter inviting

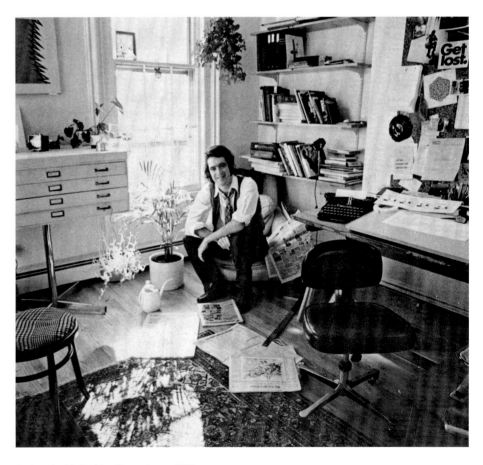

Trudeau inside his New Haven home, 1974.

Trudeau with Faith Hubley, co-director of the animated film *A Doonesbury Special*, 1977.

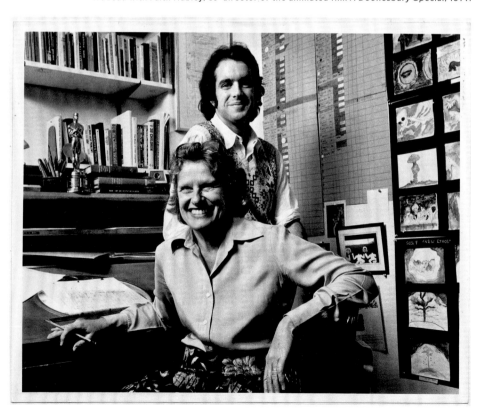

him to send in some samples of his work, and he won the award the first time he submitted. The American Association of Editorial Cartoonists responded by passing a resolution criticizing the Pulitzer Committee for giving the coveted prize to a cartoonist from outside their discipline. When Trudeau was informed that the award was irrevocable, he added his endorsement to the resolution.

The prestigious award also earned him some long overdue respect from his family. "The day I won the Pulitzer Prize for editorial cartooning, my eighty-five-year-old grandmother informed my hometown paper that while she was 'perfectly thrilled and delighted' about the honor, she had always kept her fingers crossed for fear I would 'end up in jail.'" Trudeau said his grandmother had been horrified by his career choice. "After nineteen years of schooling, a cartoonist stood where a doctor was supposed to be."

As the strip became a certified success, Trudeau turned down numerous offers to license his characters for advertising or merchandise, other than books. Beginning in 1972, Holt, Rinehart and Winston published two small paperback collections a year, and the first anthology, *The Doonesbury Chronicles,* went on to sell over 800,000 copies. Trudeau gave selected nonprofits, most notably the National Women's Political Caucus, permission to use his art to raise money for their causes.

One of Trudeau's Yale art school professors was the legendary animator John Hubley, a veteran of the Disney Studio and a pioneer in independent filmmaking. John and his wife Faith approached their former student with the idea of doing an animated adaptation of his comic strip. "Hubley did not regard the static quality of the drawings as a drawback," Trudeau recollected. "He felt that in the presence of strong characterizations, certain dynamics would inevitably suggest themselves. He also believed that no idea was too abstract or too serious to be conveyed through animation." He agreed to collaborate with the Hubleys, but John passed away midway through the production. Faith and Garry finished the film, and *A Doonesbury Special* aired on NBC on November 27, 1977. It received the Special Jury Prize at the Cannes Film Festival and an Academy Award nomination in 1978.

On September 9, 1982, newspaper readers were shocked by an unexpected press release from the reclusive cartoonist. "Investigative cartooning

is a young man's game," the thirty-four-year-old artist announced. "Since the industry frowns on vacations I'll be claiming a medical leave." He planned to take a "sabbatical" beginning on January 2, 1983. This was an unprecedented event in the comic strip business. Syndicated cartoonists were under contract to deliver their strips seven days a week, 365 days a year. Although there had been many instances when artists fell ill or couldn't continue to work for other reasons, no comic strip creator had ever taken an official leave of absence from the daily grind.

In the release, Trudeau offered a few words of explanation about why he had decided to give the *Doonesbury* gang a well-deserved respite. "For almost fifteen years the main characters have been trapped in a time warp and so find themselves carrying the colors and scars of two separate generations. It was unfair to stretch their formative years to embrace both Vietnam and preppy. My characters are understandably confused and out of sorts. It's time to give them some $20 haircuts, graduate them and move them out into the larger world of grownup concerns. The trip from draft beer and mixers to cocaine and herpes is a long one and it's time they got a start on it."

Loyal readers of the strip would have to wait twenty months to see what kind of transformations Trudeau had in mind for his pen-and-ink creations.

Doonesbury daily strip. March 3. 1982. Mike confronted the generation gap when he tried to talk his younger brother, Benjy, into going to college.

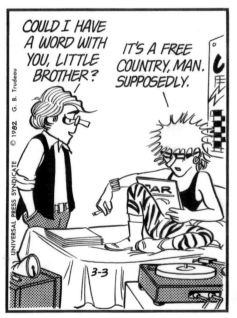
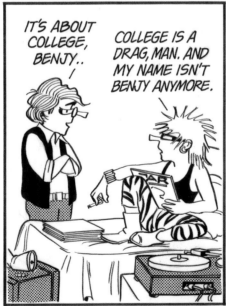
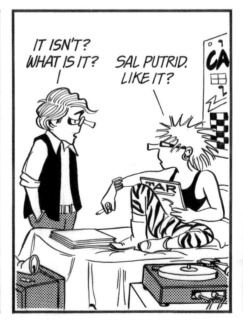
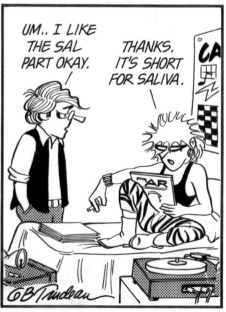

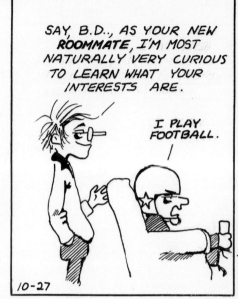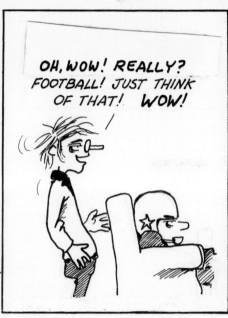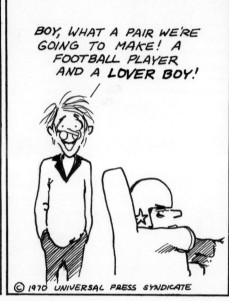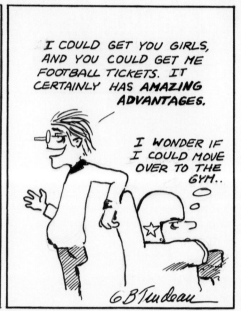

Doonesbury daily strip, October 27, 1970. Mike and B.D. learned something about each other the day after they met.

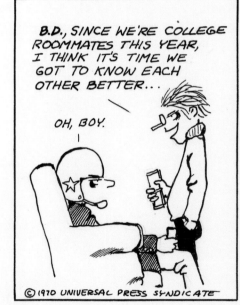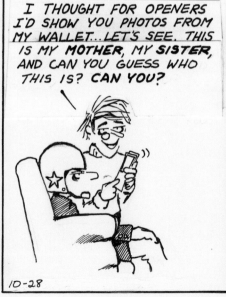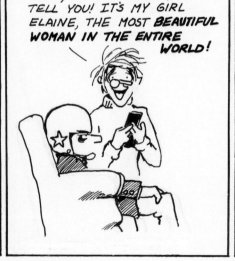

October 28, 1970. In the early years, Trudeau occasionally drew his characters without their mouths.

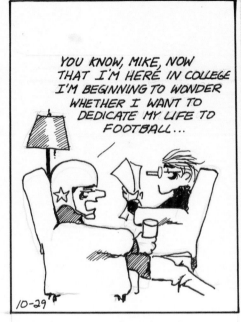
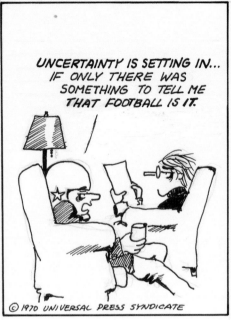
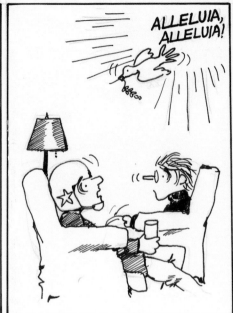

October 29, 1970. B.D. looked for a sign to confirm his true calling.

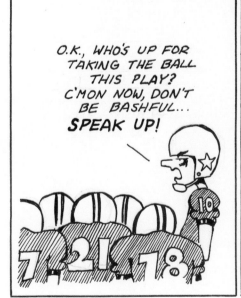
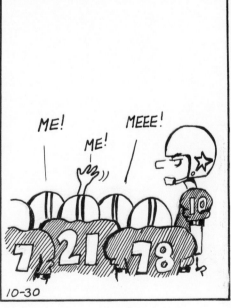
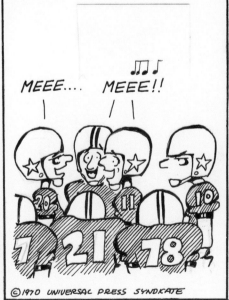
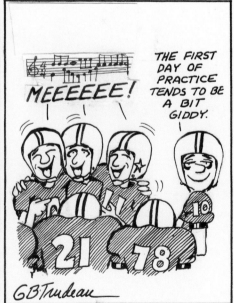

October 30, 1970. The football huddle scene is shown for the first time in the syndicated feature.

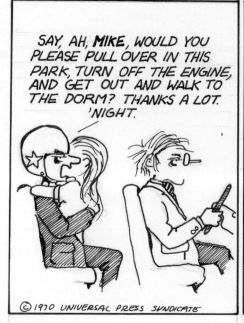
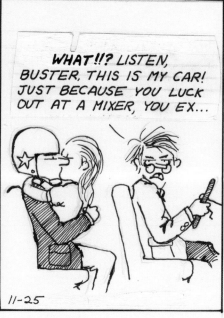
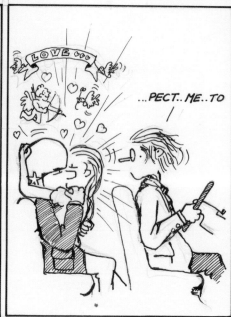
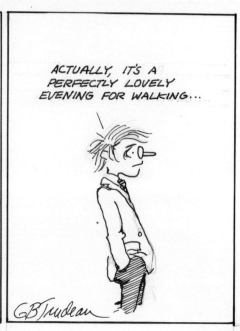

November 25, 1970. Trudeau cleaned up the lovemaking scenes from *Bull Tales* for a mainstream audience.

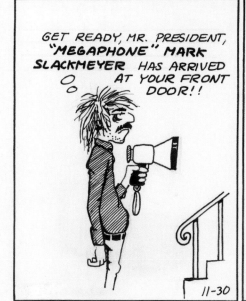
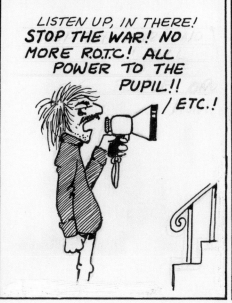
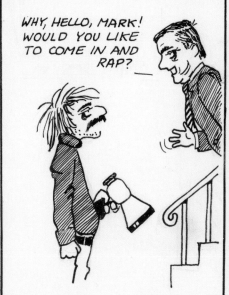

November 30, 1970. In his first appearance in the syndicated strip, Megaphone Mark Slackmeyer confronted Yale president Kingman Brewster, Jr.

DOONESBURY

by Garry Trudeau

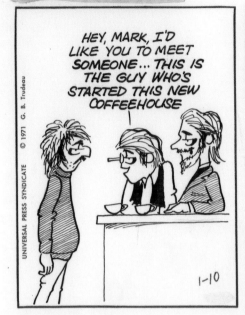
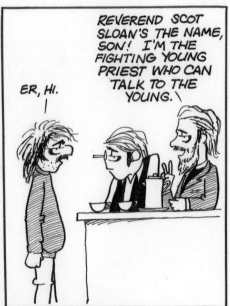
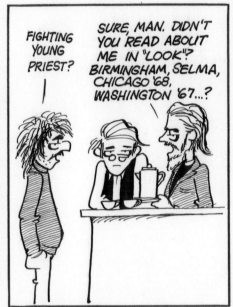
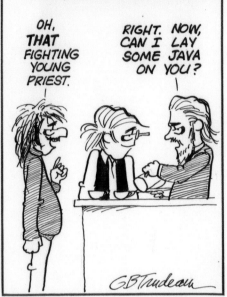

January 10, 1971. Mike introduced Reverend Scot Sloan to Mark.

DOONESBURY

by Garry Trudeau

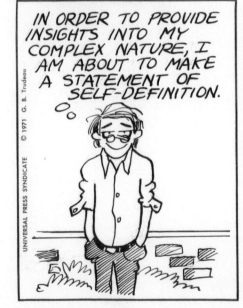
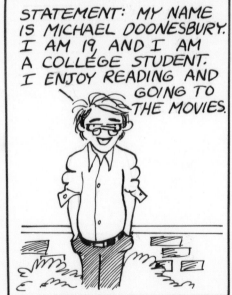
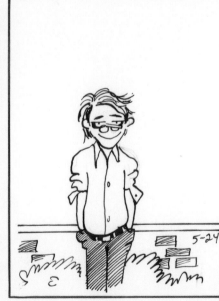

May 24, 1971. A self-defining moment for Mike.

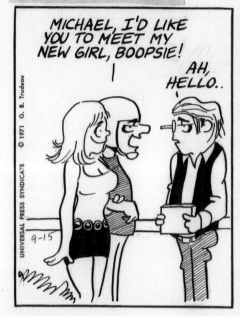
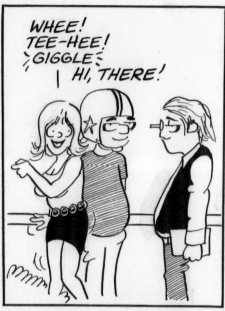
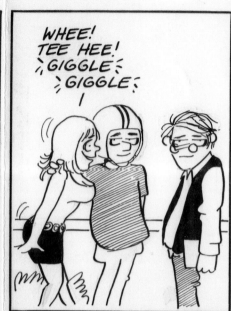
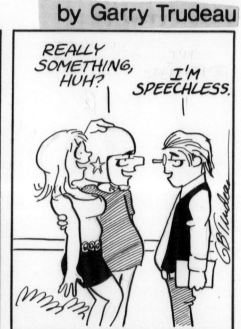

September 15, 1971. Boopsie made her debut.

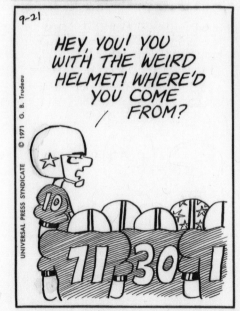
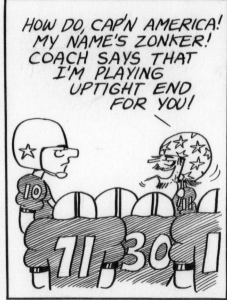
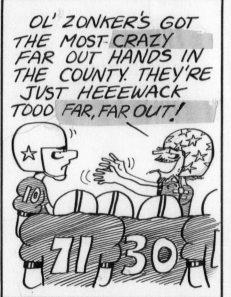

September 21, 1971. Zonker joined the huddle for the first time.

DOONESBURY

by **Garry Trudeau**

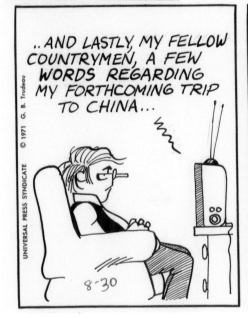

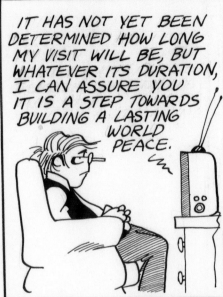

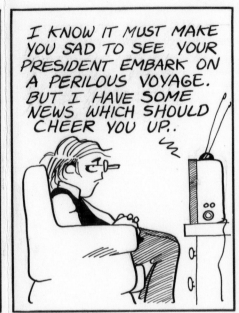

August 30, 1971. Mike kept up with current events by watching TV.

DOONESBURY

by **Garry Trudeau**

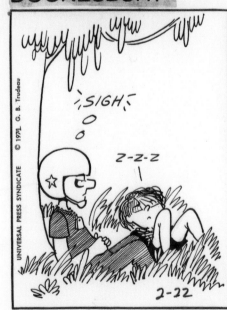

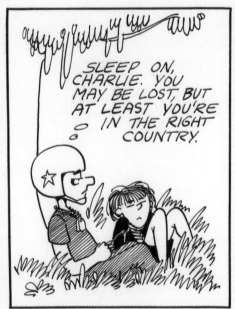

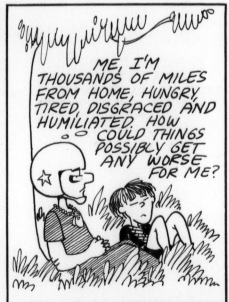

February 22, 1972. B.D. got lost in Vietnam, met Phred the terrorist, and was dumped by Boopsie.

Collaborator:
Don Carlton

Don Carlton first met Garry Trudeau on Labor Day weekend of 1971. He remembered the young cartoonist driving through Kansas City in an old jeep, on his way from Vail, Colorado, to New Haven, Connecticut, where he was about to begin graduate school. Although Carlton had served in the army and was relatively conservative politically, he was immediately impressed with Trudeau's intelligence and ambition. After the meeting Carlton told his wife that he had made an agreement to help out on *Doonesbury* but told her not to worry because he "didn't think it was going to work out." This was the beginning of a collaboration that has lasted for almost four decades.

Born in Iowa Park, Texas, on December 28, 1936, Carlton graduated from Texas Christian University in 1960 with a degree in commercial art. He started his professional career in 1956 as a technical illustrator for a nuclear engineering firm and worked as an advertising artist at the *Fort Worth Press* from 1959 to 1966. He then moved to Kansas City, where he found employment as a circulation manager and freelance artist. One of his clients was the *National Catholic Reporter,* where he crossed paths with Jim Andrews, who operated a small syndicate that distributed features to Catholic publications. In 1968 Carlton started working as a writer, designer, and layout artist for the fledgling syndicate, doing in-paper advertisements, brochures, and other promotional pieces. When Andrews teamed up with John McMeel to launch Universal Press Syndicate, Carlton continued to provide the same services for the expanded operation.

One day, Andrews showed Carlton some tear sheets from the *Yale Daily News* and two book collections of a comic strip, *Bull Tales,* and asked for his opinion. Carlton thought it was a fresh and topical creation but expressed some doubt about whether newspaper editors were ready for such controversial subject matter. Andrews forged ahead, and when the syndicate prepared to launch *Doonesbury* in the fall of 1970, Carlton worked on the first sales brochure. Much to his surprise, *Doonesbury* started with an impressive list of papers, and by the spring of 1971, the list had grown to more than a hundred subscribers. Andrews asked Carlton whether he might be interested in helping on the strip when Trudeau started graduate school in the fall. After first declining the offer, he agreed to a meeting when he came through town on that fateful Labor Day weekend.

Shortly after he returned to New Haven, Trudeau sent Carlton six penciled dailies for inking. Although Carlton had done a few cartoons and spot drawings of his own, he had never assisted on a syndicated comic strip. He used the Speedball C-6 pen that Trudeau recommended and returned the samples. A few weeks later, they came back with red markings that indicated things that needed to be redone. Before Carlton had a chance to perfect his technique, Trudeau informed him that he was already overwhelmed with graduate school and needed help on the inking right away. The first batch of finished dailies that Carlton inked were done in late October 1971 and were published in the newspapers in early December. Although Carlton did the lettering for the first few weeks, Trudeau decided to do his own lettering to maintain consistency and to allow him more time to work out the dialogue. Carlton gave up using the Speedball C-6 and settled on a no. 2 Rapidograph for both the linework and the lettering, which he resumed about a year later.

For the first few years, Trudeau sent the penciled strips by special delivery mail in six-week batches, but eventually he started cutting back on the lead time to keep the strip more current with the news. The schedule changed dramatically when Trudeau purchased a fax machine in the early 1980s. "That was a scary moment in my life," Carlton remembered. Trudeau

could now send his pencil drawings any time of the day or night. Carlton, who lived a few miles from Universal Press Syndicate headquarters in Kansas City, delivered the finished artwork by hand. He said that Trudeau began working so close to the deadline that "the ink would still be wet by the time I got it to the syndicate office."

Although Carlton claimed that "in the thirty-eight years I've been working with Garry, I don't think he has done the work the same way twice," a relatively consistent schedule developed. Trudeau would fax the pencil drawings for the Sunday page on Wednesday and do the six daily strips on Thursday and Friday. Carlton described how this process typically worked: "Frequently he would send just the drawings or a portion of the art for a given strip, or a portion of the art for several strips, not the dialogue. I would be waiting until the end of the day to get the dialogue and it would have to be fitted in and some of the art would have to be retouched to get the dialogue in. It was just a long day of sitting and responding to the fax machine. I would take the drawings out of the fax machine and tape them to the backs of the boards—Strathmore one-ply for the dailies and two-ply for the Sundays—and go to the light table and do the tracing, the inking, and the Zip-A-Tone screens. Many a long Friday was spent during those years when Friday was the hard deadline day." There were times that the strips weren't delivered to the syndicate until Saturday or Monday, but that was not typical. On a few occasions, bad weather altered the schedule, but Carlton never missed a deadline due to health reasons.

In the early years, the task of replicating props and backgrounds in the strips, panel after panel, could get tedious, so Carlton welcomed the changes that Trudeau made after his sabbatical ended in 1984. "I was very happy to see Garry adding different viewpoints, going with a lot of blacks," Carlton recalled. Although he had no input in the redesign, he found the innovative layouts more challenging to do.

In 1991 Carlton was interviewed by a reporter from *Entertainment Weekly* who told him that she was working on an article about how cartoonists work with their assistants. He was shocked when the article came out and "it became a headline that I was Garry's ghost. I immediately got on the phone to Garry to say 'I've been screwed.'" Carlton has always insisted that "my existence is not heavily publicized and for that I am very happy."

In the early years, Trudeau's pencil drawings vanished when Carlton inked over them, so very few people had the opportunity to see the original art. After Trudeau started using a fax machine, he would discard his pencil drawings after he sent them, and it wasn't until 1990 that he began saving them. Carlton acknowledged that "the pencilings tend to be freer, spontaneous, and have a certain quality that you can't replicate in ink." He admitted that it is extremely difficult to preserve this looser look in the finished strips.

After more than two decades of Friday deadlines, Trudeau began pushing the final flurry of faxes into the following week, working as little as five days ahead of the publication date. Carlton adapted to this new schedule by continuing to ink the strips as soon as he received the faxes. "Garry works very spontaneously," he explained. "He is capable of juggling an entire week's worth of dialogue constantly in his mind, all six dailies, and he's perfecting or changing words in such a vital, one-moment sort of way." He could understand how even a slight change in the schedule, dictated by the syndicate, might have thrown Trudeau off his creative rhythm.

In 2008 Trudeau became concerned that if Carlton were unable to continue inking the strip, the lettering would be difficult to duplicate. A type specialist from Brooklyn was hired to create a *Doonesbury* computer font. This changed the production process. Now, after Trudeau faxed his pencil drawings, Carlton inked the linework, scanned the strips into Photoshop and typed in the computer lettering. Two versions of the strip were sent digitally to the newspaper clients. One had computerized shading for reproduction in black-and-white. The other had no shading so that color could be added for posting electronically.

Carlton describes his collaboration with Trudeau as "a long-distance friendship." He has no plans to retire. "I find it such a unique twist in history to have led my life down this way, to be working with Garry on what I consider to be a very unique strip. I never dreamed I would be viewing things through the eyes of *Doonesbury,* and yet I have and I like it to this day." He makes a habit of reading the strip in the newspaper on a daily basis because

he can't digest the story lines properly when he's rushing batches through on tight deadlines.

Carlton has never had a problem with his behind-the-scenes role. "I'm perfectly happy to have Garry Trudeau's name to be the one on it because it is *his* creation."

Don Carlton almost missed a deadline when his cat Murray had his way with a *Doonesbury* strip coming out of the fax machine.

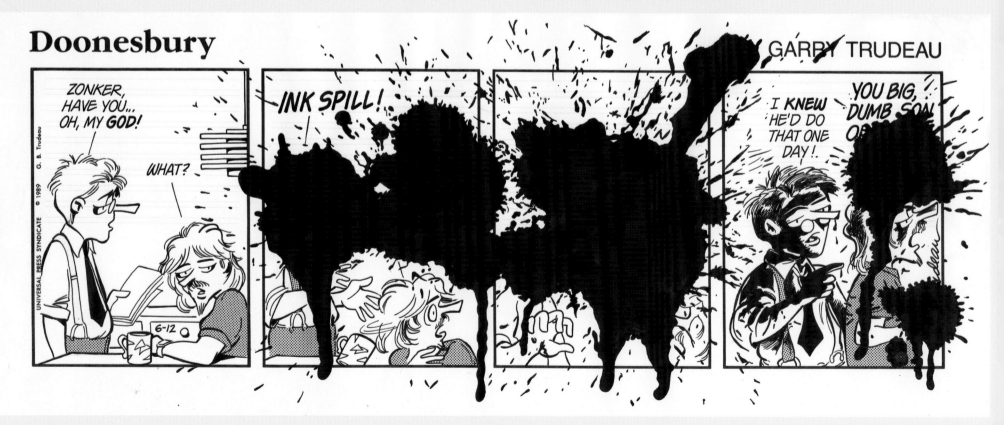

Doonesbury daily strip, June 12, 1989. When a news story forced Trudeau to rewrite an entire week of strips, Carlton helped "ink" this replacement strip.

DOONESBURY

by Garry Trudeau

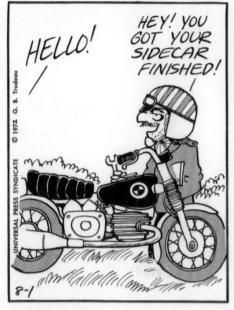
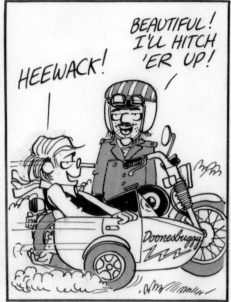
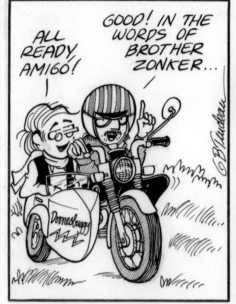

Doonesbury daily strip, August 1, 1972. Mike and Mark set off on a cross-country motorcycle trip.

DOONESBURY

by Garry Trudeau

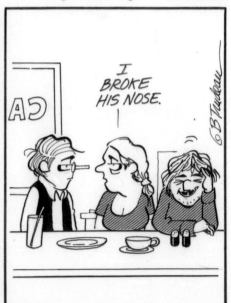

September 12, 1972. While on the road, Mike and Mark met Joanie Caucus,
a housewife who had just left her husband.

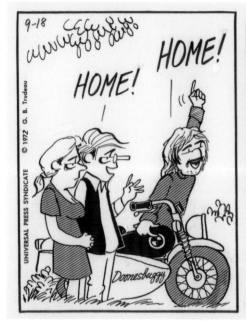
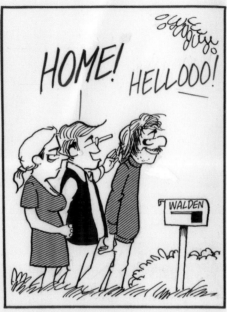
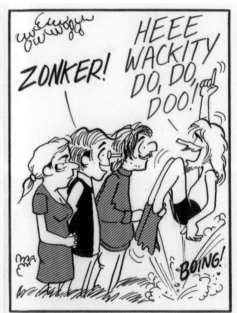
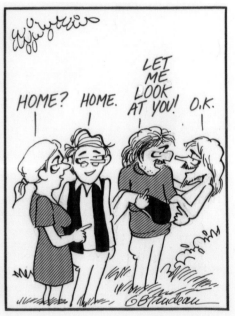

September 18, 1972. When Joanie arrived at Walden, she met Zonker for the first time.

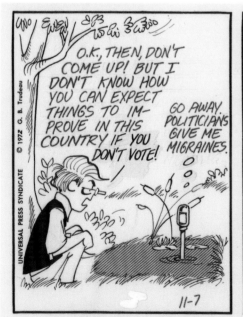

November 7, 1972. Mike tried to get Zonker to vote.

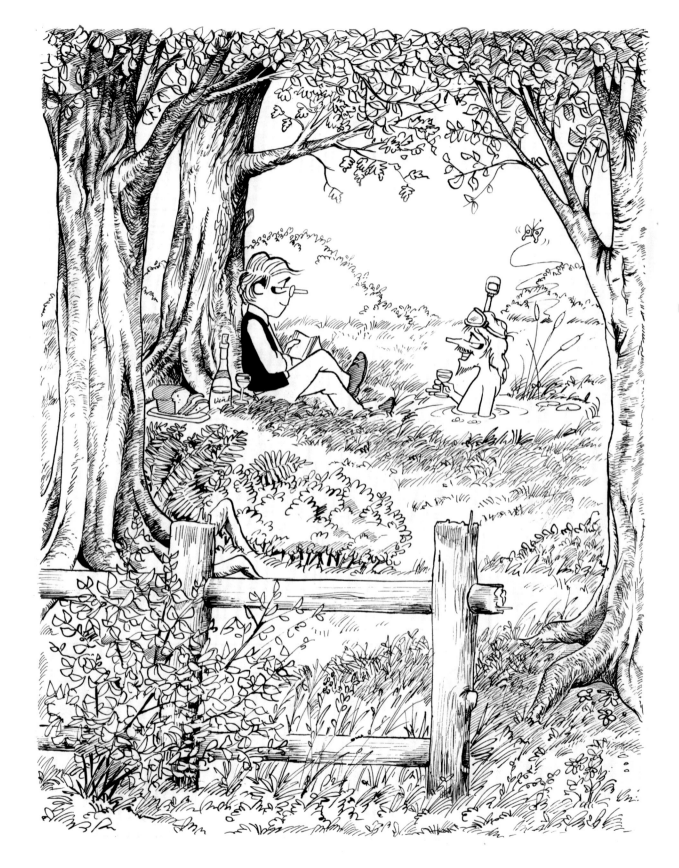

New York Daily News, 1972. Drawing of Mike for a T-shirt iron-on printed in the newspaper.

Universal Press Syndicate brochure illustration, 1972. Trudeau was inspired by the beautifully rendered foliage in Walt Kelly's *Pogo* when he did this pen-and-ink piece.

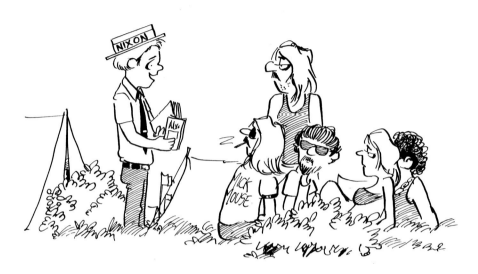

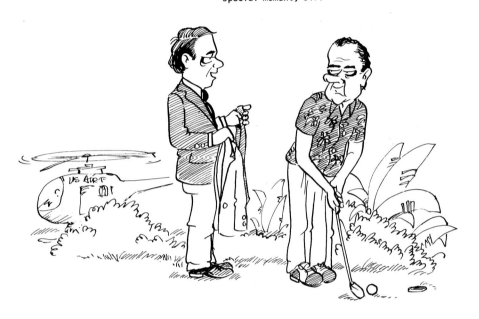

Miami Herald, "Notes from Collins Avenue," August 1972.
Drawings from an illustrated series by Trudeau that chronicled
the nomination of Richard Nixon at the Republican National
Convention in Miami.

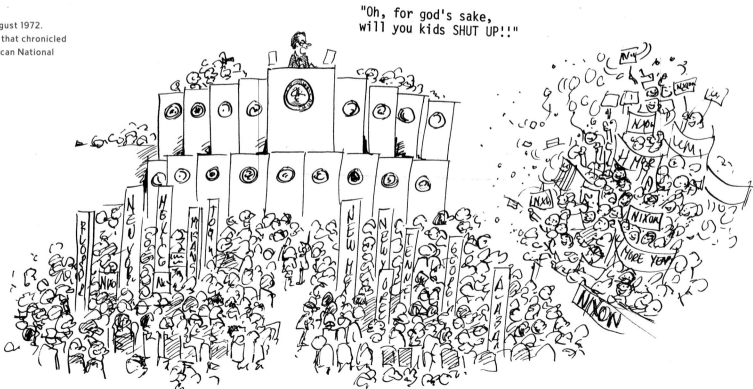

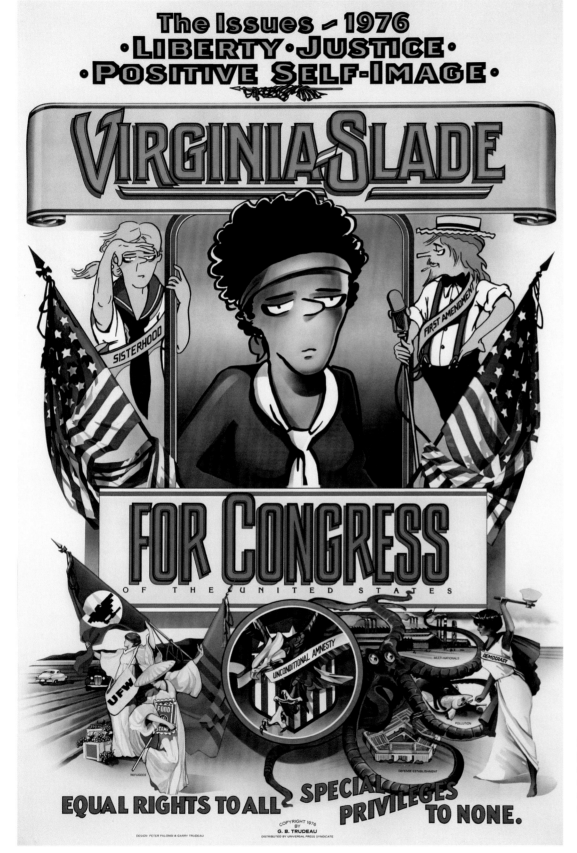

"Speaking of Inalienable Rights, Amy, . . ."
illustration for trade paperback book,
Holt, Rinehart and Winston, 1976.

Virginia Slade for Congress, poster designed by
Peter Palombi and Garry Trudeau, 1976. This was
part of a promotional package for newspapers to
offer to their readers that also included a T-shirt,
campaign pin, and bumper sticker packaged in
confetti. Palombi used a vintage William McKinley
poster that Trudeau once owned as inspiration.

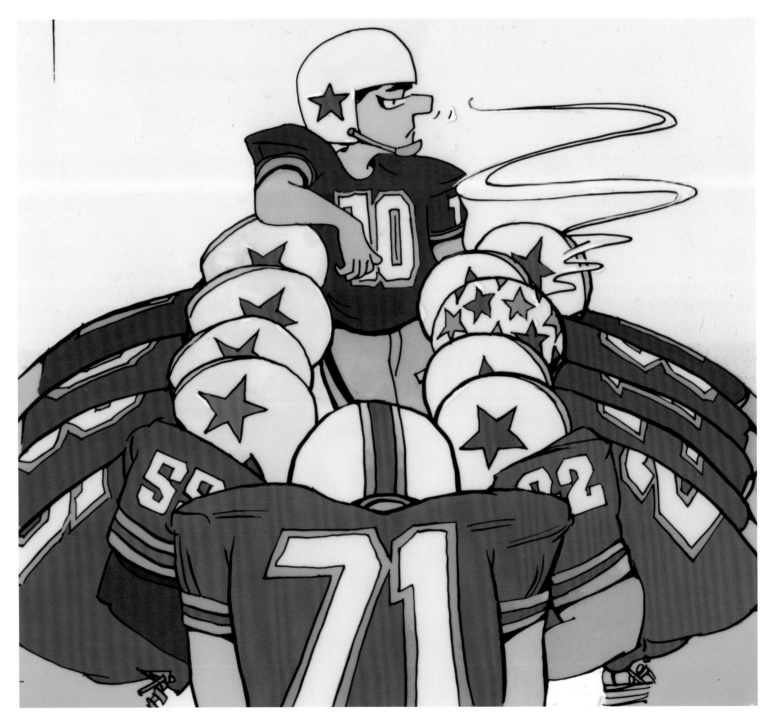

Still a Few Bugs in the System, painting for cover of trade paperback book,
Holt, Rinehart and Winston, 1973, redesigned in 1980.

Even Revolutionaries Like Chocolate Chip Cookies, painting for cover of mass-market paperback book, Popular Library, 1972.

Don't Ever Change Boopsie, painting for cover of mass-market paperback book, Popular Library, 1973.

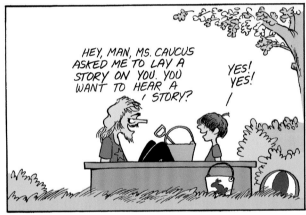
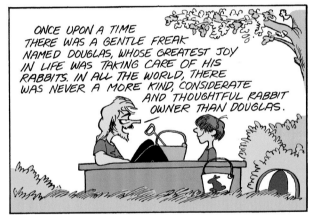
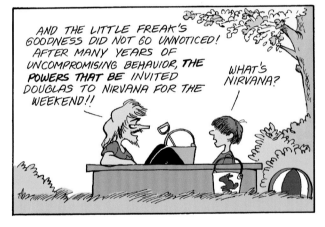
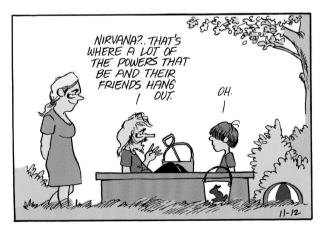
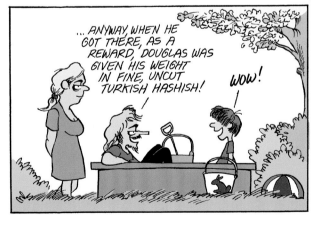
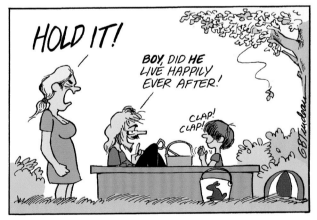

Doonesbury Sunday page, November 12, 1972. The drug reference in this episode provoked an avalanche of outrage from newspaper editors and readers.

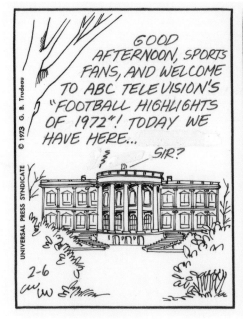

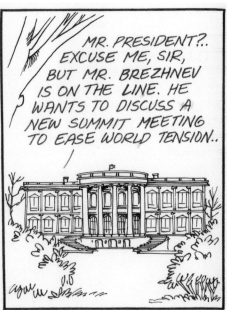

Doonesbury daily strip, February 6, 1973. Off-stage voices of fictional conversations in Richard Nixon's White House became a permanent fixture in the strip.

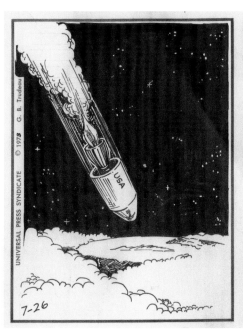

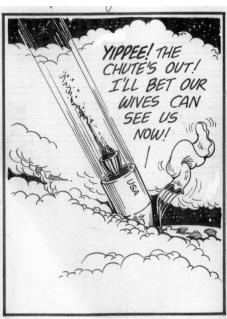

July 26, 1973. Trudeau explored outer space during a sequence about the return of Skylab.

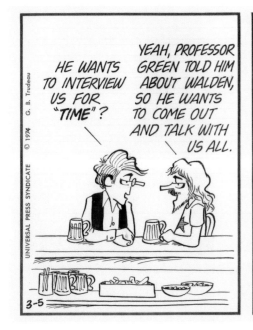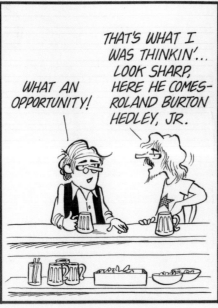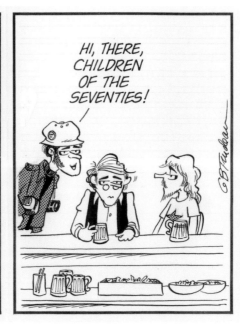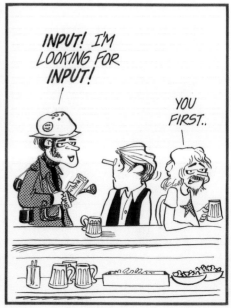

Doonesbury daily strip, March 5, 1974. The first assignment for Roland Burton Hedley, Jr., was an article for *Time* on "The New Hedonism."

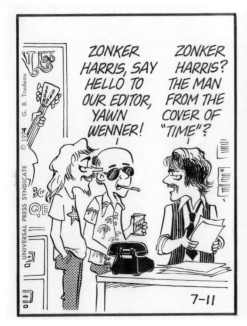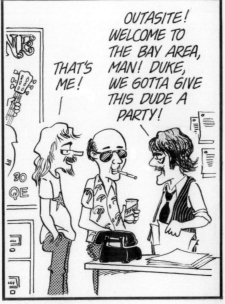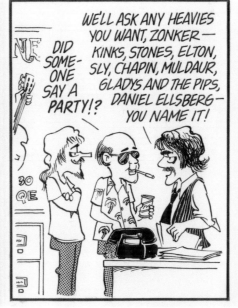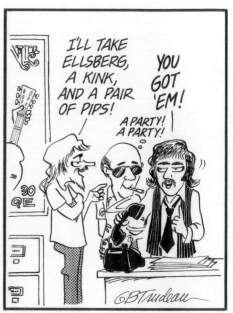

July 11, 1974. In his debut episode, Duke introduced Zonker to *Rolling Stone* editor "Yawn Wenner," a playful poke at the magazine's co-founder, Jann Wenner.

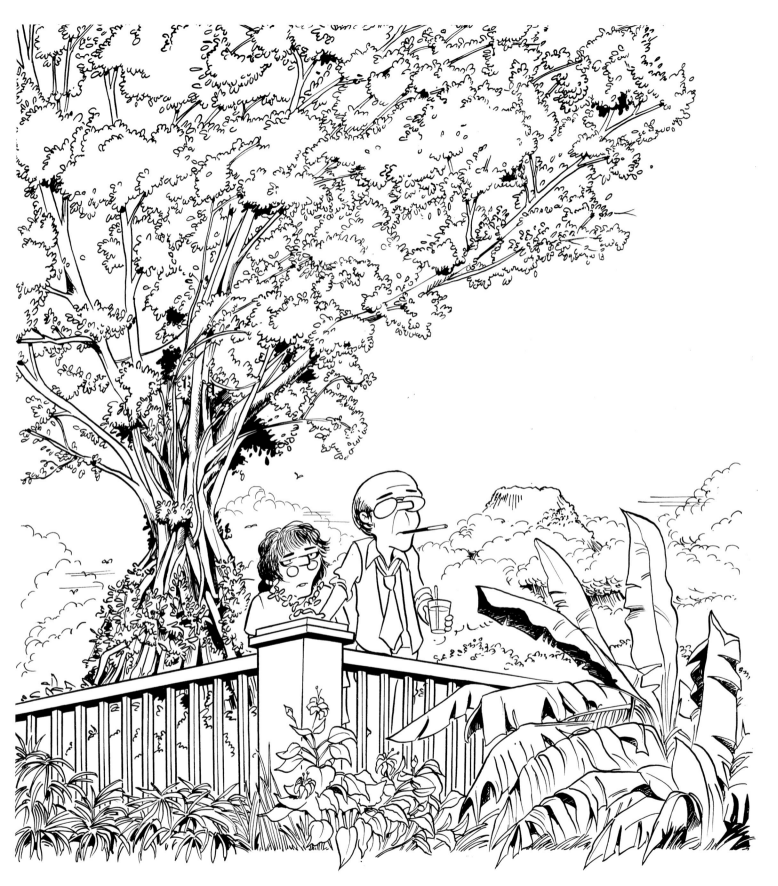

Rolling Stone, illustration for cover story, "Doonesbury's Last Tago in Pago Pago," August 28, 1975. Duke became governor of American Samoa. MacArthur was Duke's assistant.

Doonesbury Sunday page, December 21, 1975. The denizens of *Doonesbury* jammed on a Christmas carol that ended on a commercial note.

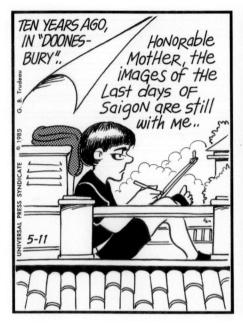
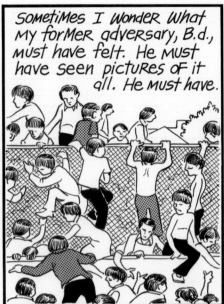

May 11, 1985. Ten years after drawing a strip marking the fall of Saigon, Trudeau redrew it as a flashback.

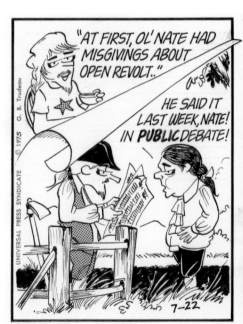

July 22, 1975. Zonker peeled back the panels of time to tell a tale about his Uncle Nate Harris, who was a Minuteman during the American Revolution.

Rolling Stone, painting for cover story, February 9, 1978.
In the introduction to his interview with Jimmy
Thudpucker, Trudeau wrote: "Few contemporary
rock and roll giants have done more with less than
the reclusive little New England troubadour."

Doonesbury daily strip, September 25, 1975. Resident rock star Jimmy Thudpucker made his debut in this recording session.

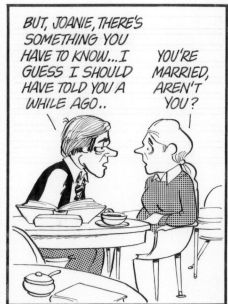
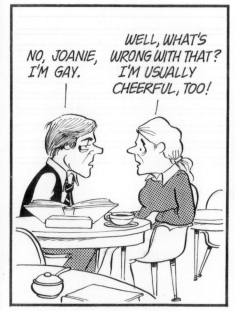
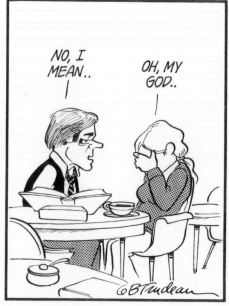

February 10, 1976. Joanie was romantically attracted to fellow law student Andy Lippincott until he revealed his sexual orientation.

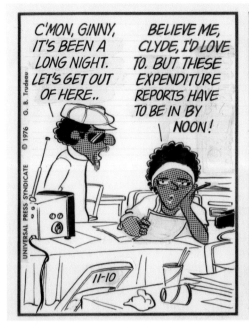
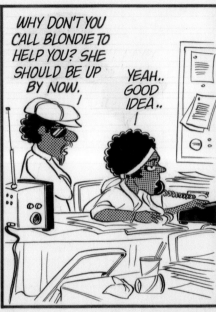
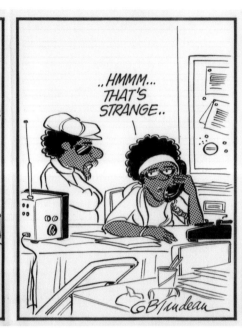
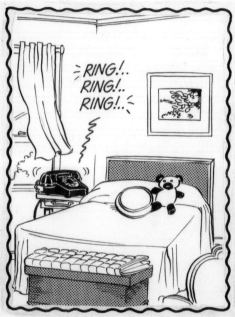

Doonesbury daily strip sequence, November 10–13, 1976.
This innovative and controversial sequence, which Trudeau described as a "long reveal," introduced premarital sex to the comics pages.

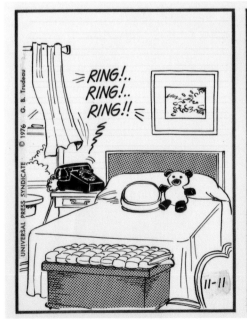

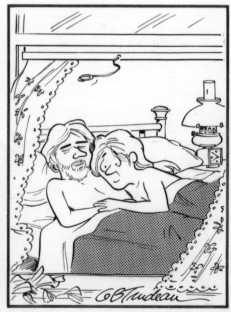

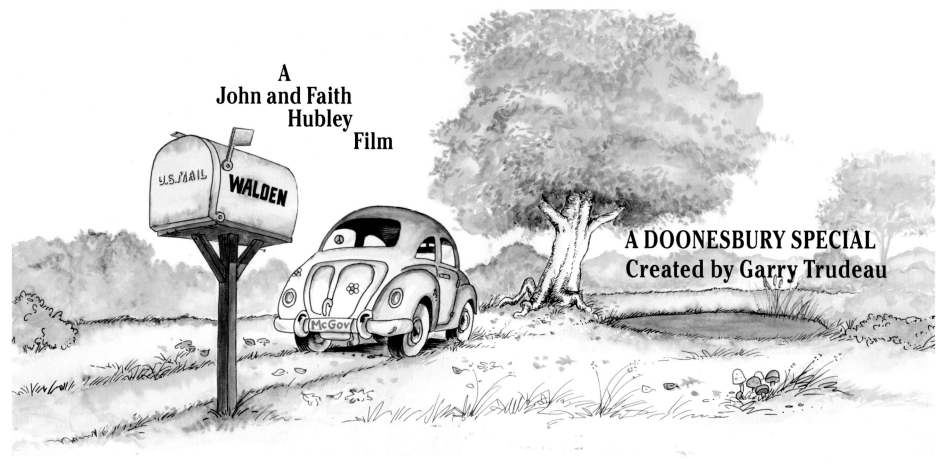

A Doonesbury Special, watercolor backgrounds for the opening credits of the Academy Award–nominated film Trudeau produced with John and Faith Hubley, 1977.

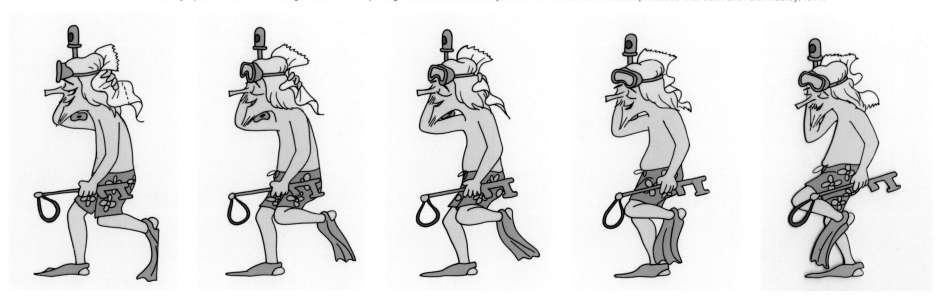

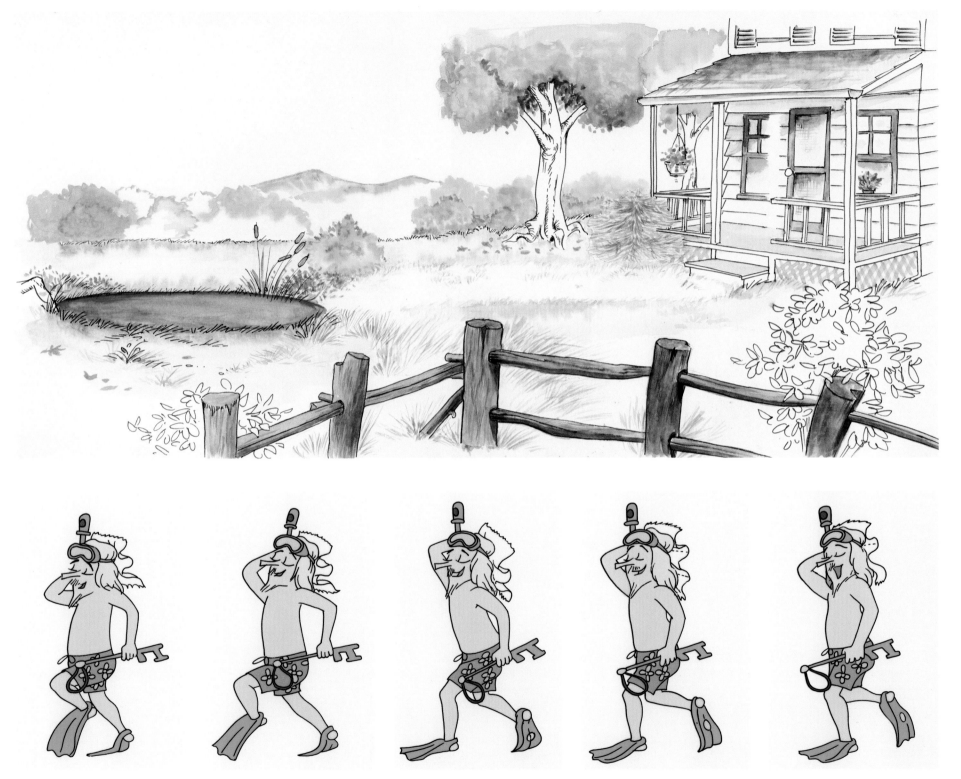

A Doonesbury Special, cels from the opening sequence of the film, in which Zonker emerged from Walden Puddle wearing a snorkel, mask, and fins and dried his hair with a towel while he walked to the house, 1977.

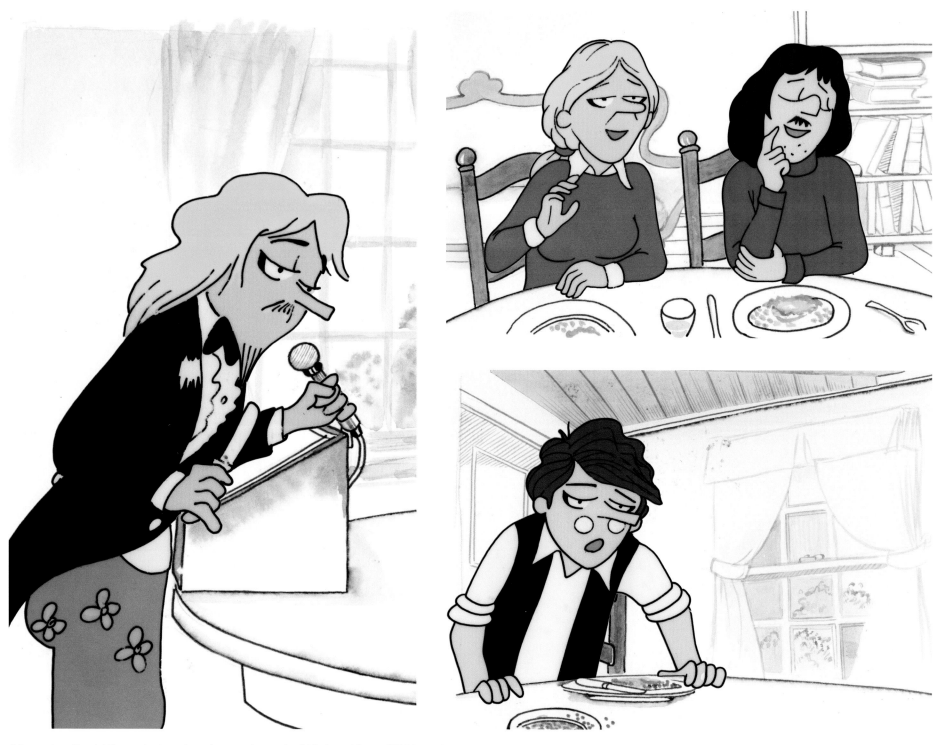

A Doonesbury Special, three cel set-ups from the second scene in which the residents of Walden gathered around the dinner table while Zonker delivered his "State of the Commune" address, 1977.

A Doonesbury Special, cel set-up of B.D. suiting up in the locker room before a confrontation with Zonker in the team huddle, 1977.

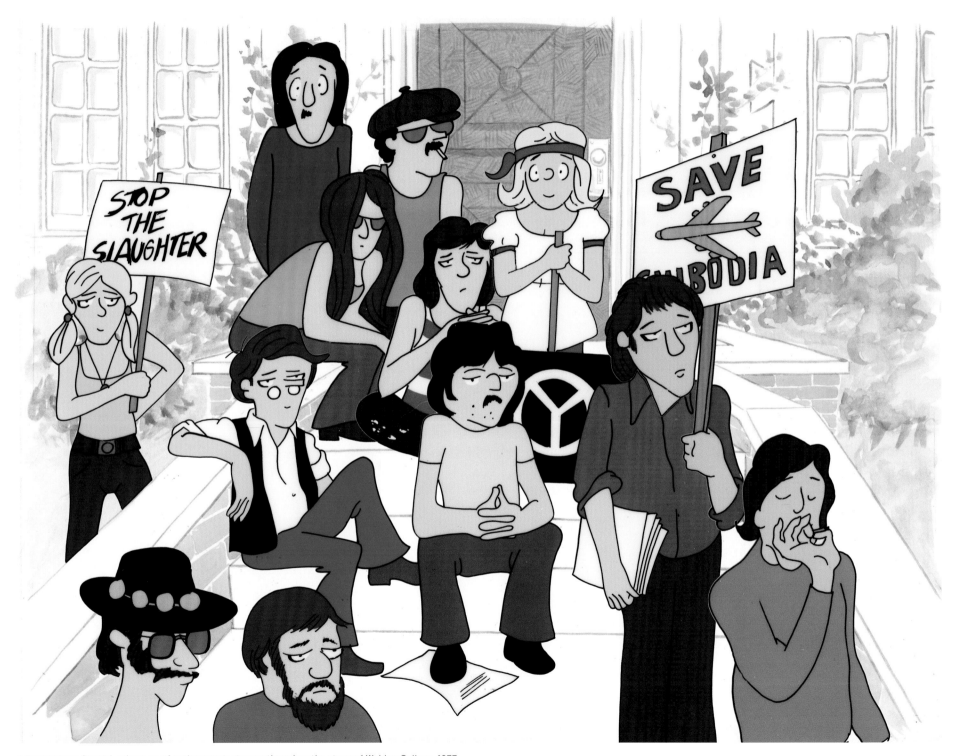

A Doonesbury Special, cel set-up of antiwar protestors gathered on the steps of Walden College, 1977.

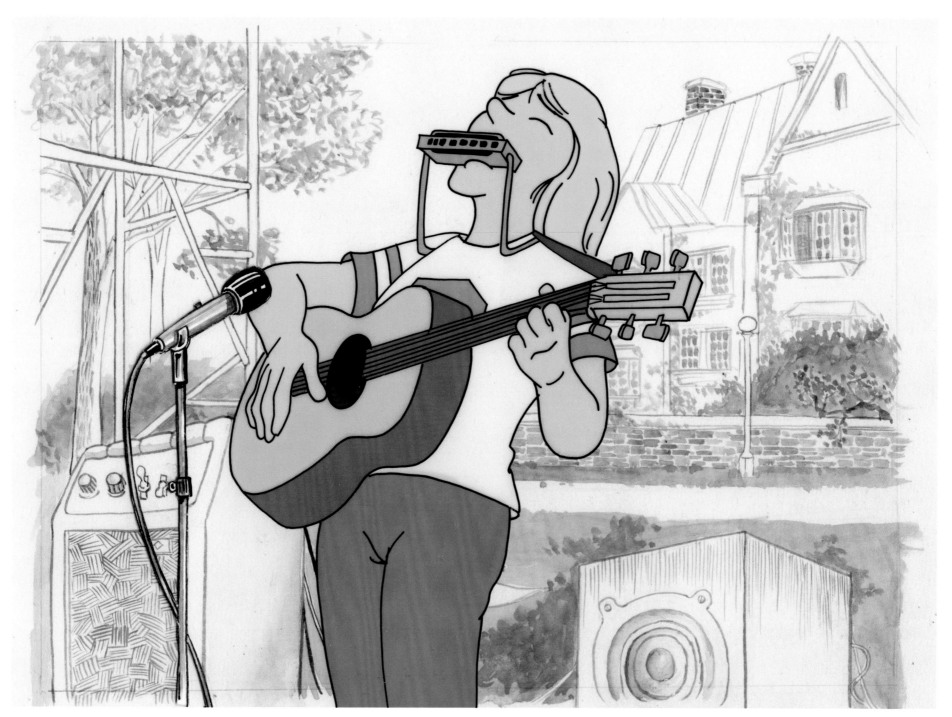

A Doonesbury Special, cel set-up of Jimmy Thudpucker performing live at the "Peace Concert," 1977.

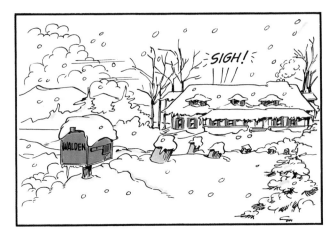

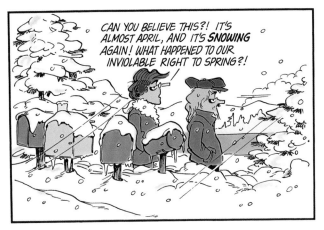

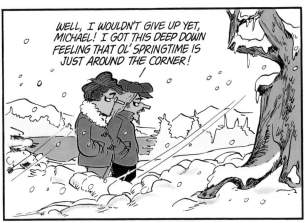

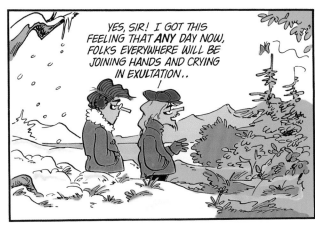

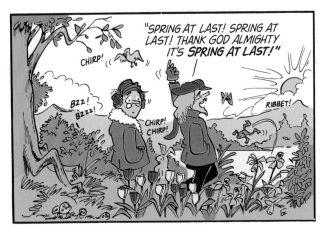

Doonesbury Sunday page, March 27, 1977. Zonker showed Mike that spring was just around the corner with the help of some special effects.

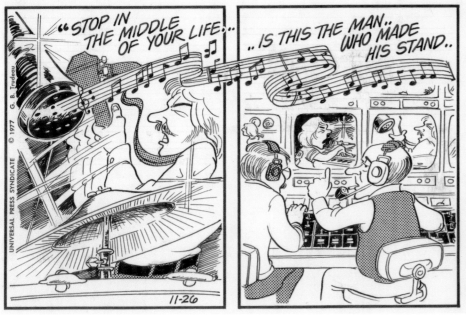
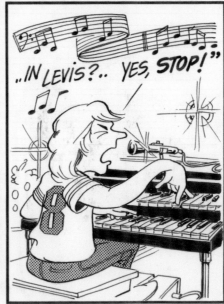

Doonesbury daily strip, November 26, 1977.
Jimmy Thudpucker turned one of the tunes from *A Doonesbury Special* into a jingle for jeans.

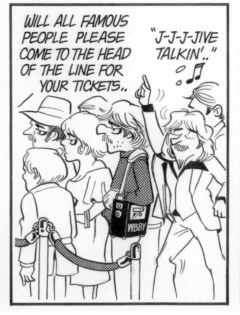

July 28, 1978. Zonker caught disco fever and made the scene at New York's notorious nightspot Studio 54.

"Guilty, Guilty, Guilty!" painting for *Doonesbury Wall Calendar*, 1989. Mark's infamous rant originally appeared in the strip on May 29, 1973.

"He's Never Heard of You, Either," painting for *Doonesbury Wall Calendar*, 1989. Republican Congressman John Anderson was dubbed "the *Doonesbury* Candidate" by Barbara Bush when he received Mike's endorsement during the 1980 presidential campaign.

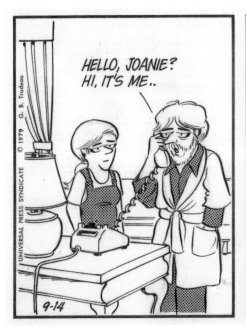
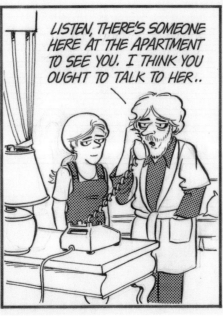
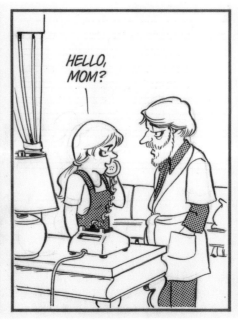

Doonesbury, daily strip, September 14, 1979. Seven years after abandoning her family, Joanie got a visit from her daughter, Joan Jr. (a.k.a. J.J.).

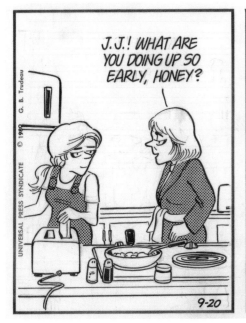
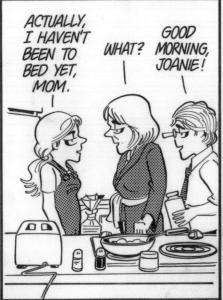
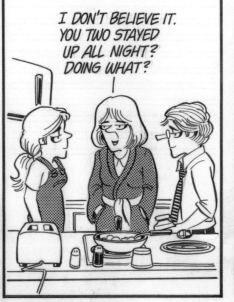
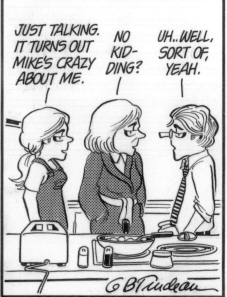

September 20, 1980. Mike and J.J. hit it off on the first night they met.

In Search of Reagan's Brain, illustration for trade paperback book, Holt, Rinehart and Winston, 1982.
Holt's Owl Books featured black-and-white artwork like this on the interior title pages.

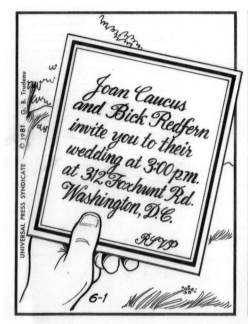
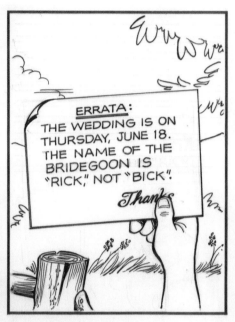
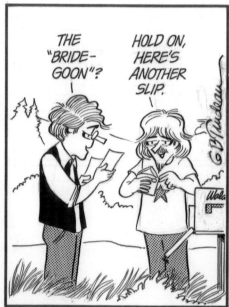

June 1, 1981. Mike and Mark received their invitation to Joanie and Rick's wedding.

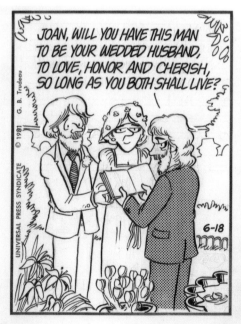
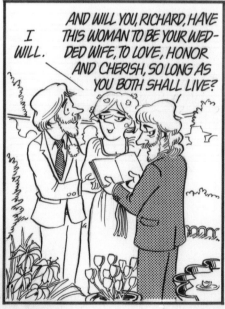
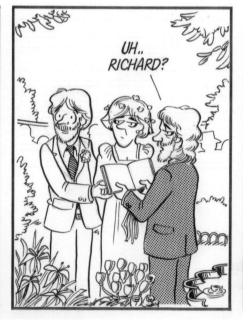
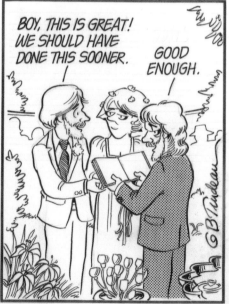

June 18, 1981. Joanie and Rick exchanged their wedding vows.

(opposite) *Ask for May, Settle for June,* painting for cover of trade paperback book, Holt, Rinehart and Winston, 1982.

In Search of Reagan's Brain, painting for cover of trade paperback book, Holt, Rinehart and Winston, 1982. This was one of the first pieces that was painted by graphic artist Peter de Sève. After the line art was printed on acetate, Peter applied vinyl paint on the reverse side to add color. "For me, it was exactly the opposite of the way I learned to paint," he explained.

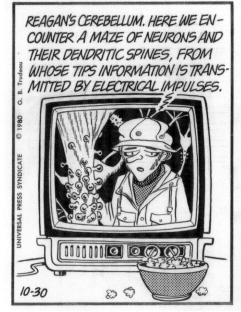 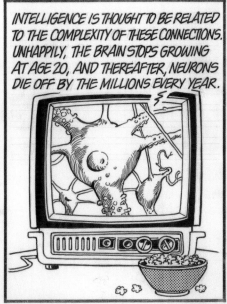 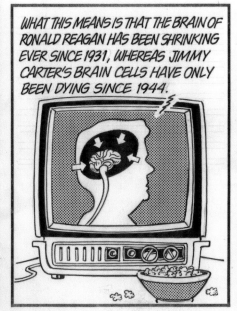 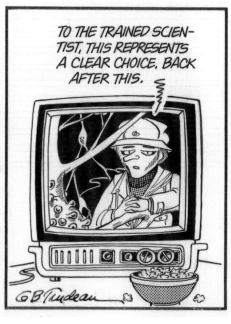

Doonesbury daily strip, October 30, 1980. During the presidential election of 1980, Roland Hedley took a journey inside candidate Ronald Reagan's brain.

January 20, 1981. When the former Hollywood actor took office, the White House was turned into a movie set.

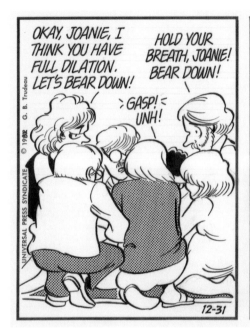
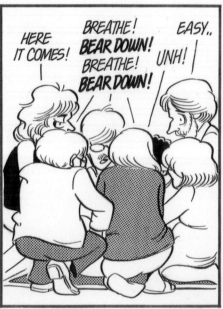
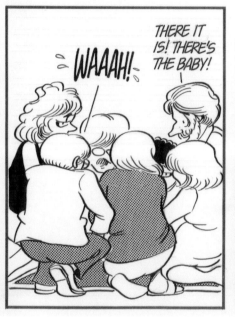
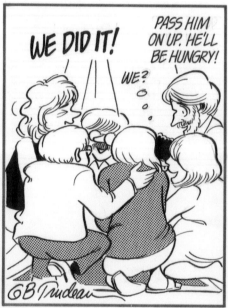

December 31, 1982. When Joanie went into labor at her birthing class, the delivery became a group experience.

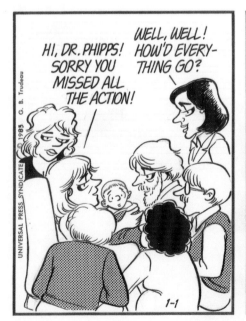
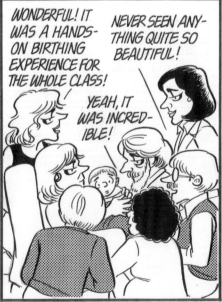
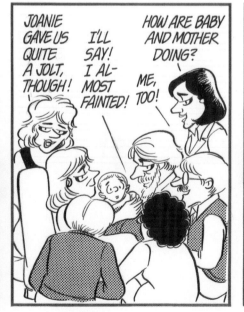
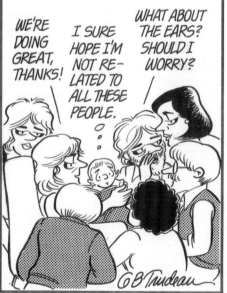

January 1, 1983. The first glimpse of Joanie and Rick's new son, who was later named Jeff.

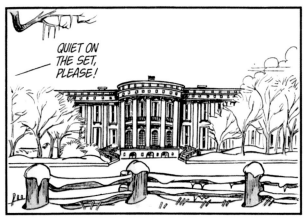
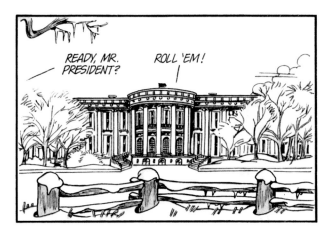
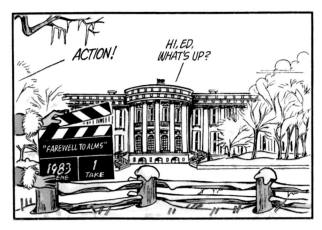
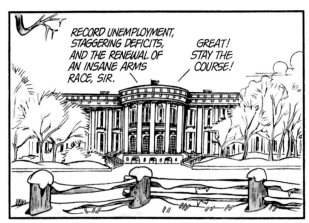
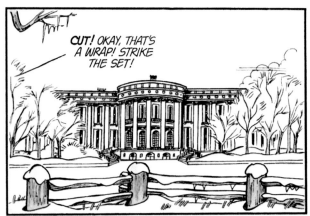
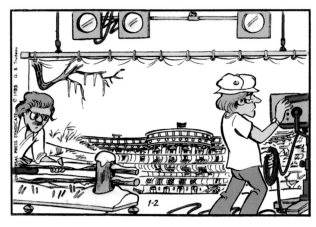
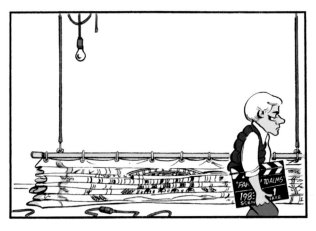
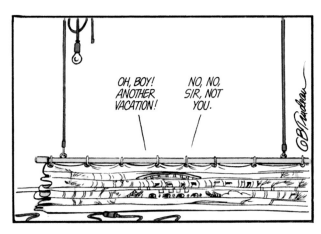

Doonesbury Sunday page, January 2, 1983. Reagan remained clueless as the White House set was dismantled in preparation for Trudeau's twenty-month sabbatical.

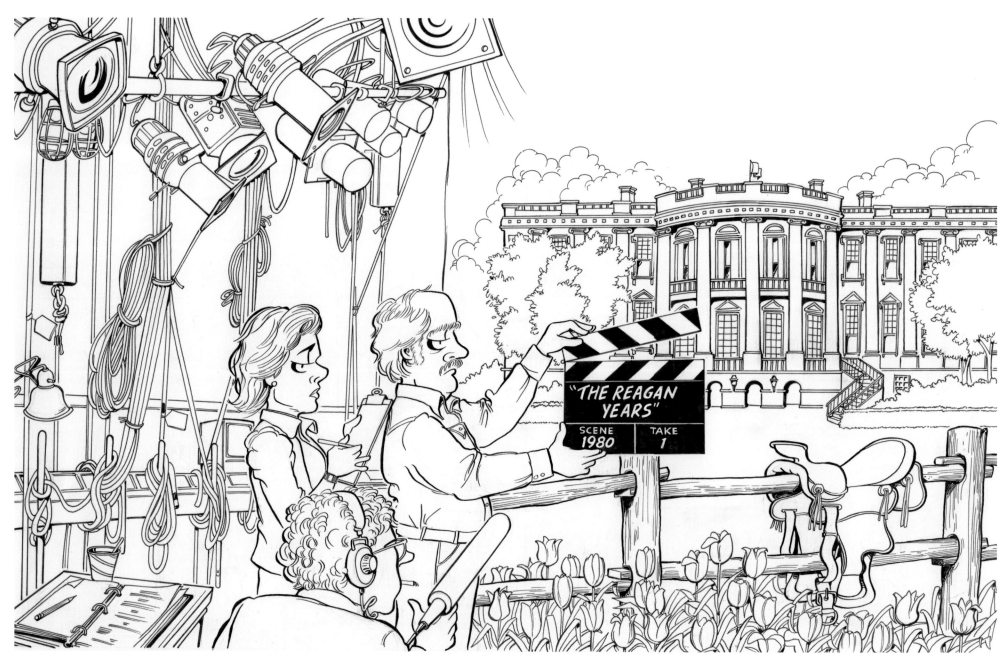

Doonesbury Dossier: The Reagan Years, cover illustration for anthology collection published by Holt, Rinehart and Winston, 1984.

DOONESBURY IS BACK!

Garry Trudeau made productive use of his time off. The day after the final presabbatical *Doonesbury* Sunday page appeared in newspapers on January 2, 1983, he began work on a stage musical adaptation of the strip. A talented team of theater professionals was assembled, including the producer James Walsh, the director Jacques Levy, the designer Peter Larkin, and the composer Elizabeth Swados. In June, Walsh described the recently completed eleven-week workshop in which they had developed the book for the play: "Liz [Swados] and Garry work well under pressure. We had a writer's room. Garry called it the Writer's Pit. Jacques and the actors would eat up the material as soon as it came out of the typewriter. Liz would write the songs overnight. It is to Garry's credit that he enjoyed the collaborative process. He is someone who has always worked alone and had control of his work."

While the workshop was going on, the search for actors was also under way. The casting director Juliet Taylor had to find not only good singers and dancers but performers who looked like the characters in the strip. Taylor claimed that Trudeau, "unlike a lot of writers, could see beyond how the characters appeared on the page to how they would need to come alive on stage."

Working with the actors posed a creative challenge for Trudeau. Reflecting back on the experience he said: "The first thing the actors wanted to know was where the characters they're playing have been and where they wanted to go. It was easy enough to pull up the back story, but as to the future, I had no idea. That was the question to which the play, as yet unwritten, was the answer. The one thing I was sure of was that the characters couldn't continue to stand in for the generation that in real life was replacing them—it was time for them to part company and move on. The *Doonesbury* diaspora had begun."

Doonesbury: A Musical started final rehearsals on September 6, 1983. A three-week preview engagement at the Wilbur Theatre in Boston, beginning on October 8, preceded the opening at the Biltmore Theatre in New York on November 21.

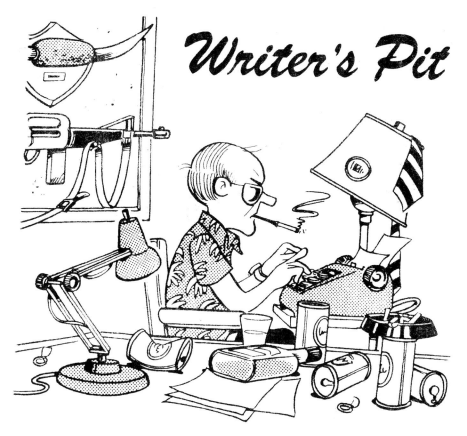

Writer's Pit, Trudeau put this drawing on the door of the room where he worked during the development of *Doonesbury: A Musical,* 1983. It originally appeared in *You're Never Too Old for Nuts and Berries,* trade paperback book published by Holt, Rinehart and Winston, 1976.

Doonesbury: A Musical, 1983. Illustration for the program. This Broadway production, which Trudeau worked on during his sabbatical, provided his characters with an opportunity to make the transition from college to adulthood.

Doonesbury: A New Musical, poster for Wilshire Theatre, Los Angeles, October 1984.

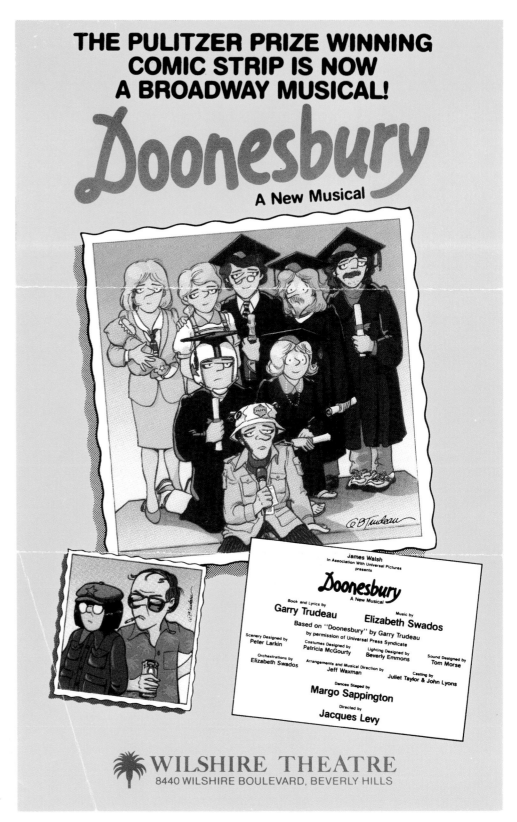

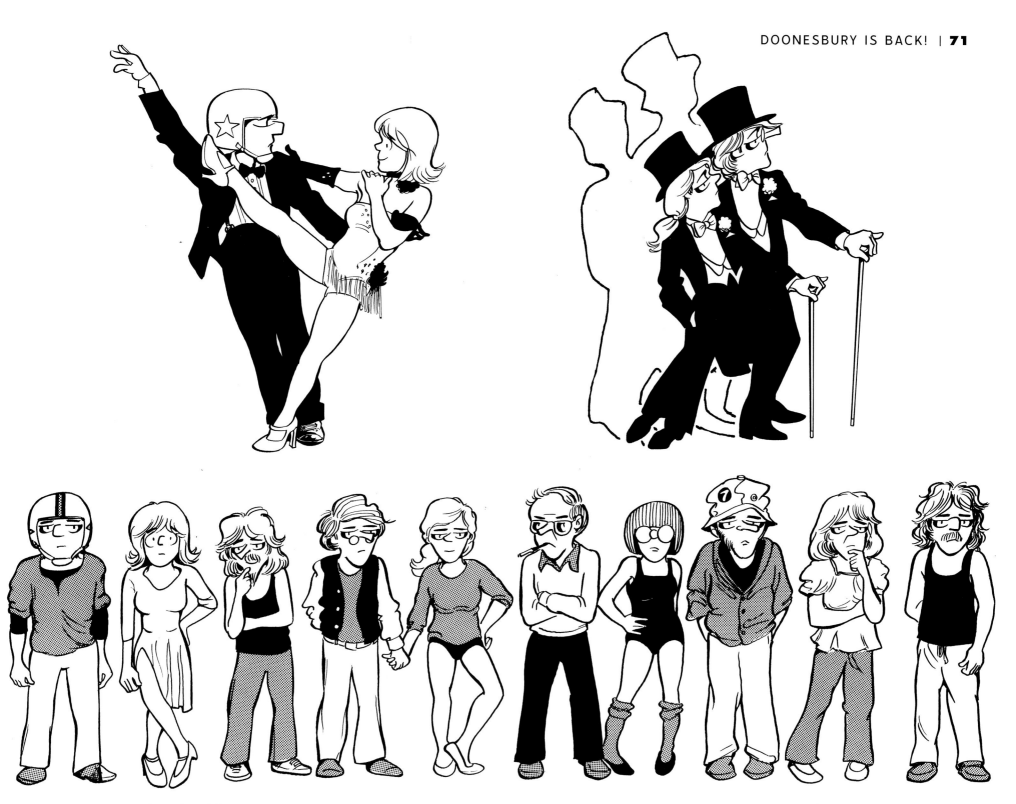

Doonesbury: A Musical, promotional illustrations parodying the graphics of contemporary Broadway shows, including *A Chorus Line* and *My One and Only*.

Doonesbury: A Musical, cast portraits used for publicity, 1983.

CLASS OF '83

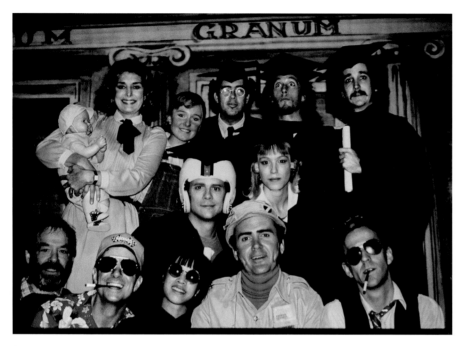

Original cast photograph of *Doonesbury: A Musical*, 1983.

Reviews for *Doonesbury: A Musical* were mixed. A writer for the *Boston Phoenix* complained that although it was good to get a dose of *Doonesbury* during the strip's absence, "there are also times when the familiar characters, now roundly and blondly humanized, robbed of their bleary low-slung eyes and made to cavort like the kids from *Fame*, are enough to drive any dyed-in-the-ink *Doonesbury* fanatic to the loathed borders of *Bloom County*."

The performance didn't get rave reviews from the New York critics either, although Trudeau did receive two Drama Desk nominations for book and lyrics, and the soundtrack album was nominated for a Grammy award. John Simon commented in *New York* magazine: "*Doonesbury*, which but for a few big scenic effects might be better Off Broadway, is richer in chuckles than in laughs, and now and then mawkish or silly." *Doonesbury: A Musical* closed after 104 performances.

Although the stage adaptation was less than an unqualified success, it did provide Trudeau with an opportunity to make the transition he had talked about when he announced his sabbatical. At the end of the play, the *Doonesbury* characters received their diplomas from Walden College. They were left standing on the precipice of adulthood, poised to make the leap into the real world.

The musical wasn't the only project that Trudeau pursued during his time off from the strip. From March 30 to July 3, 1983, The Doonesbury Retrospective, an exhibition of original comic strips and related material, was on display at the Museum of Cartoon Art in Rye Brook, New York. Trudeau also wrote a screenplay for Robert Redford about the radical right and another script about the White House press corps. An Off-Broadway political review, *Rap Master Ronnie*, which was a spinoff from the musical, began a four-year run of performances in September 1984.

He also became a parent. Trudeau's wife, Jane Pauley, gave birth to twins, Ross and Rachel, on December 30, 1983. Their son Tommy was born two years later.

On April 26, 1984, Trudeau resigned from the National Cartoonists Society in protest of nude female drawings that appeared in the program for the annual Reuben Awards dinner, which was intended as a tribute to women cartoonists. "I no longer feel I can remain a member of an organization which

consistently condones this kind of puerile, patronizing attitude towards the 'gals,'" he wrote in a letter. "While publishing drawings of naked female cartoon characters may be the Society's idea of a 'salute' to women, it certainly isn't mine." It was years before he again took part in any N.C.S. functions.

As the *Doonesbury* strip prepared to return to newspapers on September 30, 1984, the syndicate signed up 776 clients, fifty more than before the sabbatical. But newspaper editors howled in protest over a new size requirement that Universal Press had established for the feature. While Trudeau was away, the industry had adopted a new Standard Advertising Unit format. Among its repercussions was the reduction of the width of comic strips in print, from 44 picas ($7\,^5/_{16}$ inches) to 38.6 picas ($6\,^7/_{16}$ inches). U.P.S. president John McMeel informed subscribing editors that they would have to run *Doonesbury* at 44 picas or not run it at all. He explained in a letter to all of the clients that the larger size was necessary to legibly reproduce the dialogue in *Doonesbury*, which averaged more than seventy words per episode, compared with the fifteen to thirty words of other comic strips.

Only a handful of newspapers elected not to run *Doonesbury* at the larger size. Many had to redesign their comics pages and drop strips to make room for it. Some moved *Doonesbury* to other parts of their newspapers. One editor, who decided not to resume the strip, protested, "I do not feel it is [Trudeau's] right to dictate column widths to America's newspaper publishers." In response to editors who threatened to ignore the edict, Universal Press Syndicate warned, "If someone stonewalls us on this, we will cancel their contract."

Trudeau eventually wrote a personal letter of explanation to newspaper editors. "Forty-four picas used to be an industry standard," he pointed out. "The strip was designed for it and most papers originally ran it that size. In recent years, however, editors have taken to drastically reducing the size of comics, and they have done so unilaterally, not feeling any need to consult with the syndicates."

The letter continued: "Understandably alarmed about rising newsprint costs, editors have found that shrinking comics is a painless way to save space, but in the process, many have lost sight of the comic strip's appeal. It is self-defeating—and not a little ironic—that at a time when newspapers face

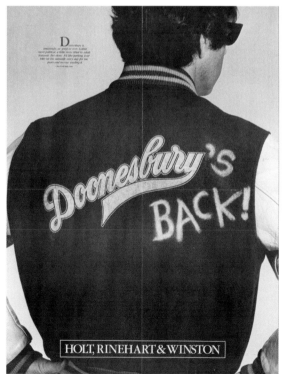

Publicity photograph and poster for "*Doonesbury* Is Back!" campaign, 1984.

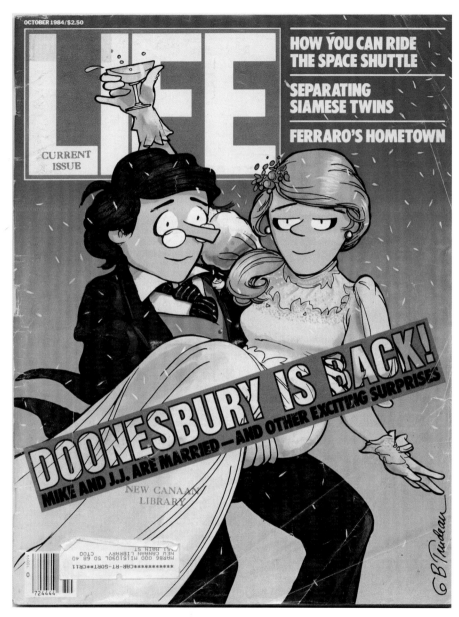

Life magazine cover, October 1984. Author's collection.

their gravest threat from television and other visual media, they have moved to reduce the comics page, the one area of genuine pictorial interest in their papers—and one of proven popularity."

Only a few syndicated cartoonists publicly supported Trudeau's efforts. Bil Keane, creator of *The Family Circus,* stood up at a meeting of the American Association of Sunday and Feature Editors on September 19, 1985, and thanked Trudeau for taking a stand. "I think it has focused, for all of us, the attention of editors on the importance of the size of comics."

A *Doonesbury* cover story in the October 1984 issue of *Life* magazine helped readers catch up with the many changes that the strip's cast had gone through during the sabbatical. After graduating from Walden College, Mike attended business school but dropped out halfway through his first year and got a job at an advertising agency. Mike cohabitated with Joanie's daughter J.J. for six months, after which they were married. J.J. planned to pursue a career in the plastic arts. Mark lived at home for a while with his parents and eventually was hired by National Public Radio to host his own program, *All Things Reconsidered.* Boopsie moved to Los Angeles and landed a few bit parts in some Hollywood movies. B.D. was signed by the Dallas Cowboys, traded to the Tampa Bay Buccaneers, and then lost to the Los Angeles Rams in a poker game. Duke became president of the Baby Doc School of Physicians in Haiti. Honey joined Duke at the school as the dean of women. Zonker, the least changed of the group, withdrew to Walden Puddle to avoid any serious commitments.

The sabbatical also provided Trudeau with the opportunity to redesign the look of the strip. When *Doonesbury* started, he consciously established a consistent iconography of three static images followed by a subtle take in the final panel. "The minimalist aesthetic was all Feiffer. His great insight was that if the art was stripped down and unchanging, the reader would naturally focus on the dialogue. It was his way of bringing serious ideas to the fore." The images in *Doonesbury* were so repetitive that some readers assumed he was photocopying his drawings. Cartoonist Al Capp famously quipped, "Anybody who can draw bad pictures of the White House four times in a row and succeed knows something I don't. His style defies all measurement."

After twelve years of this approach he felt it was time for a change. "I'd

created a signature look and feel to the strip—the basic iconic elements were well established. But I was nodding off at the drawing board." He decided to experiment with a new look. "While *Doonesbury* was off line, I sat down and tried to reimagine the strip. What I came up with was surprisingly retro; the new art had all the shifting changes in scale and perspective that cartoonists had been using for decades. I liked it, but I'd taken a hard turn toward a very conventional aesthetic. And I had serious misgivings."

Trudeau once admitted that his "early, postmodern, deconstructionist scrawlings made the cartoon industry safe for bad art." Now, in the years following the sabbatical, *Doonesbury* was beginning to look more like a story strip from the 1940s than the contemporary strips it had spawned. Trudeau studied how adventure strip cartoonists like Milton Caniff used the lighting techniques of cinematography and experimented with establishing shots, close-ups, and silhouettes. It was a gradual process. "The early changes were all over the map. But over time, a few simple techniques emerged. For instance, I discovered that silhouetting was inherently soulful, perfect for conveying second thoughts, regret, or loneliness. And close-ups are useful for inflection —to guide the reader to focus on a particular character at a specific point in the conversation, whether he's talking or reacting. With the earlier art, everyone was of equal importance all the time. That had its dramatic limitations."

By the mid-1980s Trudeau was stretching the limits of the art form. In sequences featuring J.J.'s performance art, Duke's flashbacks, the Return to Reagan's Brain, and Boopsie's participation in the Harmonic Convergence, he introduced innovative visual elements that challenged the perceptions of his readers. Shattering and melting panel borders, disassembling images into puzzle pieces, shifting between real and imaginary perspectives, changing styles for visual effect and mimicking graphic elements from other mediums, Trudeau was enjoying the creative freedom he had gained by redesigning the strip.

Although Reagan wasn't as easy a target as Nixon, Trudeau managed to stir up even more controversy in the 1980s than he had in the strip's first decade. During the 1984 election, he suggested that Vice President George H. W. Bush lacked political courage and had "placed his manhood in a blind trust." In 1985 Universal Press Syndicate advised Trudeau to pull a week of

Trudeau began experimenting with close-ups and silhouettes to enhance the storytelling in the strip during the mid-1980s.

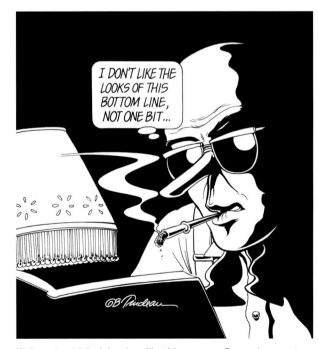

High-contrast inked drawings like this one gave *Doonesbury* a retro look, similar to the story strips of the 1940s.

Doonesbury daily strip, pencil drawing, October 24, 1986. Trudeau redrew this strip from the Duke flashback sequence for a T-shirt during *The Great Doonesbury Sellout* in 1991.

strips that satirized the antiabortion film *The Silent Scream.* Later that year he ran photos of Frank Sinatra with Gambino crime family members after the singer had been given the Medal of Freedom by President Reagan. In 1986 Mark Slackmeyer read a list of Reagan "back-scratchers, till-dippers and conscience-cutters" in his *Sleaze on Parade* radio show segment. The next year Trudeau invited readers to clip and save pieces of the Iranscam puzzle which, at the end of the week, was still missing a vital piece. In 1988 he did a profile of Democratic presidential candidate Al Gore, giving him the title, "Albert, the Prince of Tennessee Valley." Trudeau closed out the decade by going after Donald Trump, the tobacco industry, and Vice President Dan Quayle.

In March 1989 Andy Lippincott, who had created controversy in 1976 as the first openly gay character in a major comic strip, revealed to his employer, Congresswoman Lacey Davenport, that he had contracted the AIDS virus. Although some newspapers refused to run the series, many AIDS activists came to Trudeau's support. One AIDS sufferer admitted, "The epidemic does have its funny side." After Andy succumbed to the disease on May 24, 1990, a square was added to the AIDS Memorial Quilt in Andy's honor.

Between September 1984 and April 1987, Trudeau temporarily modified

his policy of turning down interviews to support a cabaret revue of satirical songs he had created with Elizabeth Swados to spoof the Reagan administration. *Rap Master Ronnie* debuted at the Village Gate Theater in New York in September 1984 and was subsequently staged in nine cities during a four-year period. Trudeau realized that they wouldn't sell any tickets if the public didn't know where and when the show was appearing next, so he did interviews with the *New York Times*, the *Los Angeles Times*, the *Chicago Tribune*, the *Boston Globe*, the *San Francisco Chronicle*, the *Washington Post*, and the *Seattle Times* in conjunction with performances in those cities. "I felt passionately about the show," he affirmed later. "I was trying to persuade audiences to revisit the basic assumptions of Reaganism, to get them thinking about what careless, smile-button governance had already cost us. Working Off-Broadway made that sell a little easier. Expectations are different; you don't come downtown if you're not prepared to be challenged."

Trudeau relaxed his media policy again in 1988 to promote two cable television specials—*Rap Master Ronnie* on Cinemax and *Tanner '88: The Dark Horse* on HBO. The *Tanner* series provided Trudeau with an opportunity to work with Robert Altman, a filmmaker he had admired since his college days. "The first time I saw *M*A*S*H*, I was just astonished," he told an interviewer for *New York Newsday*. In that 1970 film, Trudeau said, Altman "was orchestrating voices like jazz. And it had a lot of influence on how I came to write dialogue." *Tanner*, a mockudrama written by Trudeau and directed by Altman, chronicled the campaign of a fictitious presidential candidate, Jack Tanner, played by the actor Michael Murphy. In his progress through the primaries, Tanner had encounters with real-life politicians, including Pat Robertson, Gary Hart, Bob Dole, and Jack Kemp. After viewing the debut episode, which aired on February 15, 1988, a reviewer for the *New York Times* observed: "*Tanner '88: The Dark Horse*, not surprisingly, works best when it feels and almost looks like *Doonesbury*. A character who seems otherwise vacant will say something hip. Mr. Trudeau can create that kind of humor better than anyone. One wishes he had done more of it for television." The two-part miniseries was expanded by HBO into a bimonthly series, and a total of eleven episodes were aired between February and August 1988. Altman won a Primetime Emmy Award for the episode "The Boiler Room."

Tanner '88: The Dark Horse, fake press pass, 1988.

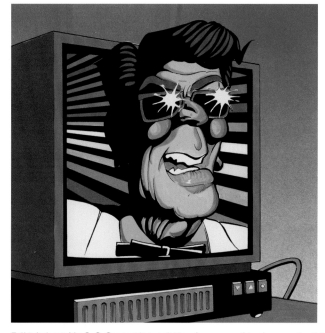

Talkin' about My G-G-Generation, painting for cover of trade paperback book, Henry Holt, 1988.

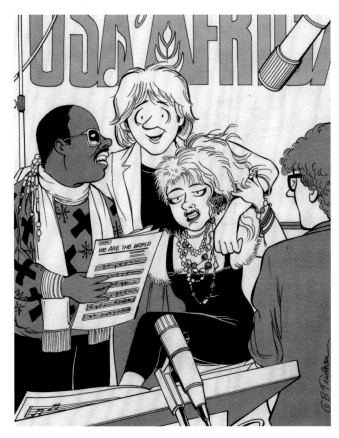

We Are the World–USA for Africa, illustration for
fund-raising campaign, 1985. Trudeau was the only
cartoonist invited to the historic recording session.

In the early 1980s Trudeau received a call from an account executive at an advertising agency working on a campaign for Diet Pepsi. The ad man's idea was to recruit famous individuals who normally didn't do television spots to endorse the product. The caller's offer was a quarter of a million dollars for an afternoon of work, but Trudeau declined. When he suggested that Trudeau could give the money to a charity that he cared about, the cartoonist hesitated. "I still turned it down, but that offer changed how I thought about leveraging the strip."

The first major effort he supported was World Hunger Year, founded by his friend the singer and songwriter Harry Chapin. A T-shirt Trudeau designed, which was sold at Hard Rock Cafés around the world, raised more than $200,000 for the charity. After that he realized, "I now have an official regret: I should have been doing this back in the seventies, when the strip had breakout heat. I could have raised some significant money."

In the summer of 1985 Trudeau sent a letter, which was co-signed by Milton Caniff and Charles Schulz, to 250 cartoonists inviting them to dedicate their features to the topic of world hunger on November 28, 1985. Initially worried about the response, Trudeau was delighted when he opened the newspaper on Thanksgiving Day. "Over 175 artists, inspired by the impact of a concerted effort among their ranks, did something they had never attempted before—they worked together." On February 22, 1986, fifty cartoonists attended the opening of an exhibit of original strips from that historic event at the Museum of Cartoon Art in Rye Brook, New York. In a four-hour session, they drew their characters holding hands on a fifty-foot mural to promote Hands Across America, a nationwide fund-raising event scheduled for May 25, 1986. More than one hundred cartoonists from around the country also sent in drawings to add to the chain, which was reproduced in the June 1986 issue of *Life* magazine. The sale of original art from the Cartoonists Thanksgiving Day Hunger Project, and a book collection of the strips, helped raise money for USA for Africa. The nation's cartoonists coordinated their efforts again on Thanksgiving Day 1986 to focus attention on the plight of the homeless.

Another fund-raising project, *The 1990 Doonesbury Stamp Album,* was published by Penguin Books on July 10, 1990. All the proceeds from the sales

of this unique collectible item were donated to the Writer's Voices program of the Literacy Volunteers of New York City. Working in close collaboration with the designer George Corsillo, Trudeau created 153 full-color stamps, which were printed on sixteen perforated, gummed sheets. Two months before this release, in a *Doonesbury* Sunday page, Zonker had attacked the U.S. Postal Service's decision to raise rates by offering a set of "protest stamps" with a value of "minus-five cents." Thousands of letter writers illegally affixed these to envelopes instead of real stamps. The Postal Service responded by alerting its employees to confiscate any letters with the bogus stamps. The stamps in the *Doonesbury* album, which included images of George Bush, Dan Quayle, Donald Trump, Mr. Butts, and all of the main cast members, plus a two-page map of "Doonesbury's U.S.A.," were intended to be purely decorative.

One of the stamps had a distinctive design. Surrounding a graphically striking representation of the trademark half-lidded eye was the legend "*Doonesbury* 1970 – 1990. What a long strange strip it's been." Garry Trudeau's college creation had survived in the competitive comics business for almost two decades. Time flies when you're having fun.

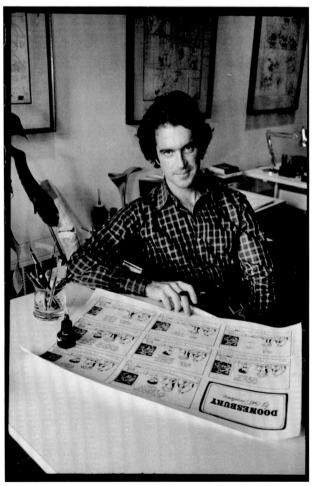

Trudeau at the drawing board in his New York studio, December 3, 1980. Photograph by Jill Krementz.

Life magazine, illustration for cover, October 1984.
Trudeau's original pencil drawing was inked by Don Carlton.

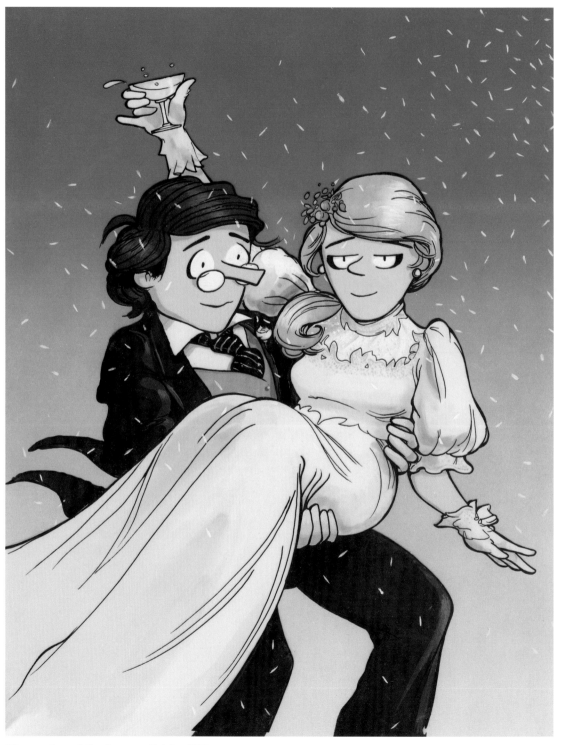

Life magazine, painting for cover, October 1984.
The finished color artwork was done by Peter de Sève.

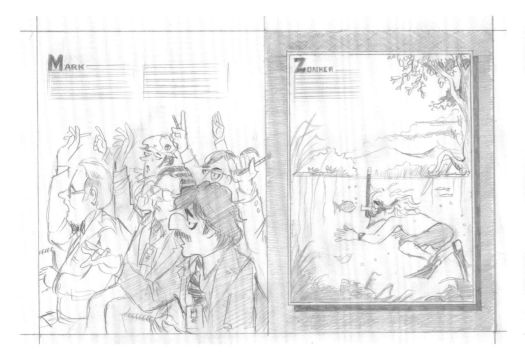

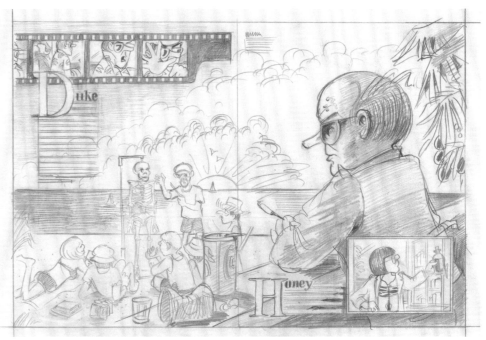

Life magazine, pencil layouts for interior pages, October 1984.
Trudeau used these thumbnail drawings to pitch his idea for an article to the editors at *Life*.

Life magazine, pen-and-ink illustration of Mike looking up at his new office at the World Trade Center, October 1984.

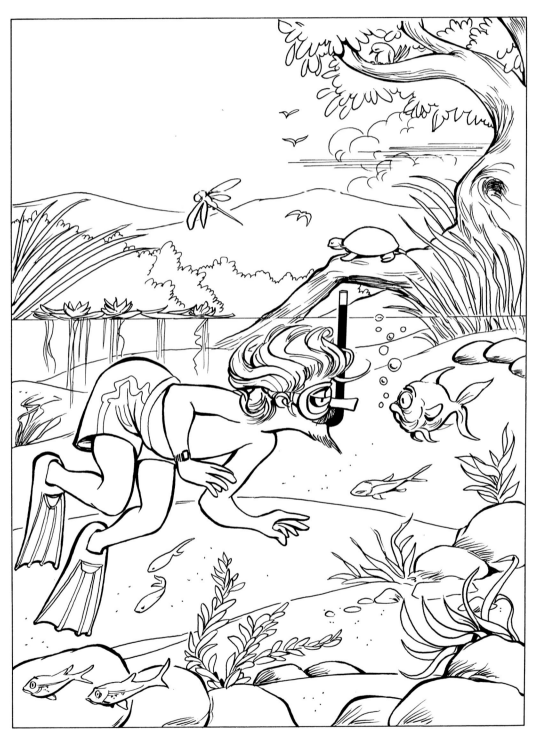

Life magazine, pen-and-ink illustration of Zonker snorkeling in Walden Puddle, October 1984.

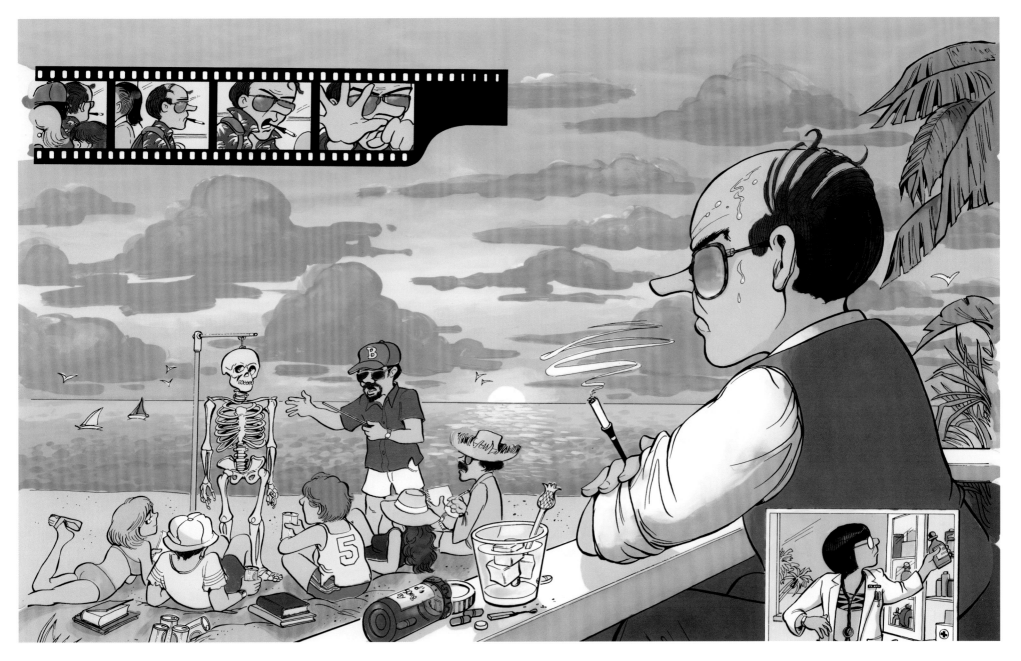

Life magazine, painting of Duke and Honey at the Baby Doc School of Physicians
in Port-au-Prince, Haiti, October 1984.

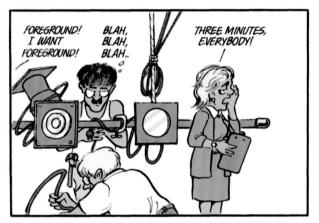

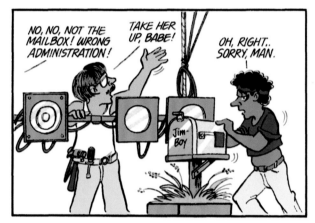

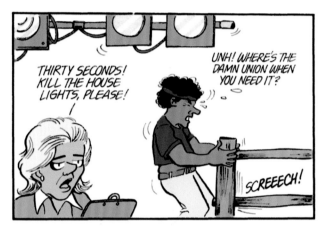

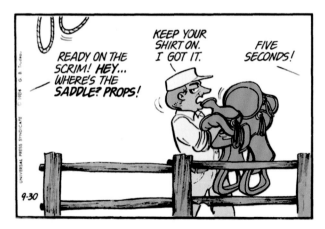

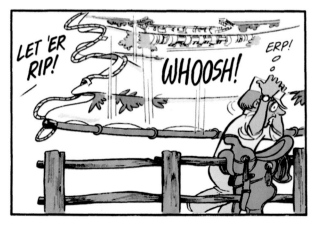

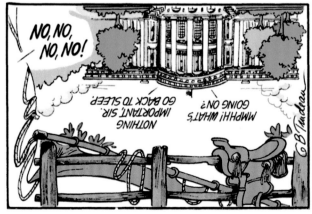

Doonesbury Sunday page, September 30, 1984. The Reagan White House set was reassembled when Trudeau returned from his sabbatical.

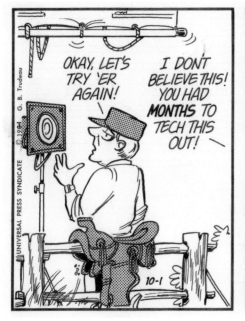
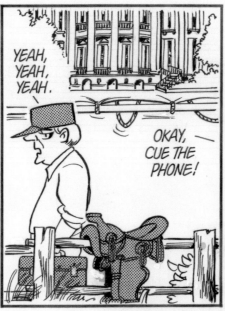

Doonesbury daily strip, October 1, 1984. Studio technicians restored order to the set as the daily strip resumed.

January 1, 1986. The boys marked another anniversary for the Walden Commune.

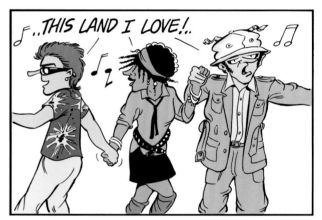

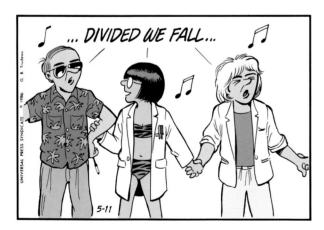

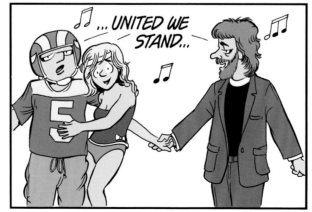

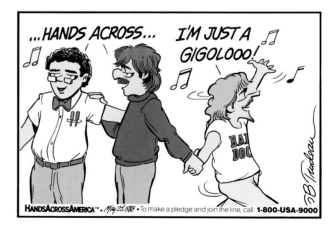

Doonesbury Sunday page, May 11, 1986. The cast participated in the Hands Across America fund-raising effort and, as usual, Zonker was out of sync.

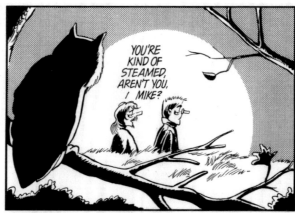

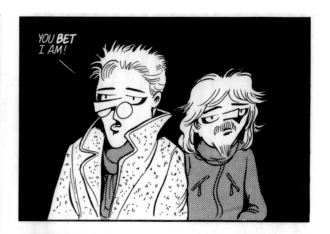

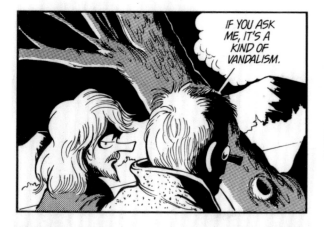

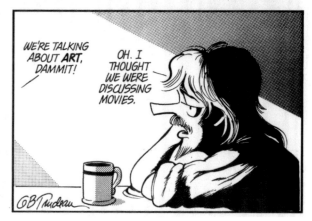

December 28, 1986. Trudeau experimented with chiaroscuro technique in this film noir–influenced episode.

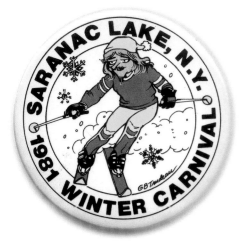

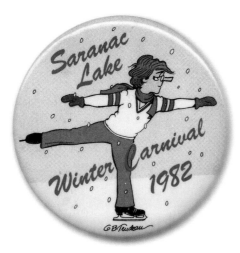

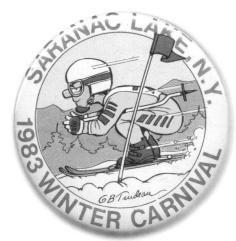

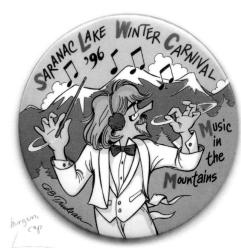

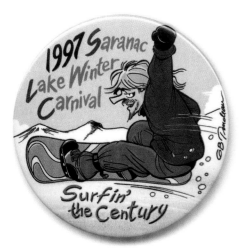

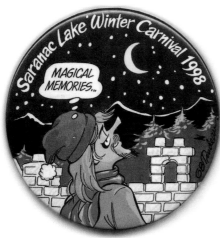

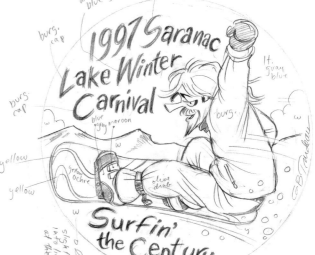

Saranac Lake Winter Carnival buttons. Trudeau began designing buttons for his hometown winter carnival in 1981 and has continued the annual tradition ever since. In 1995, the local newspaper reported that an average of four thousand of these buttons had been sold each year, at $2 each, to cover a significant portion of the budget.

Pencil drawing for button, 1997.

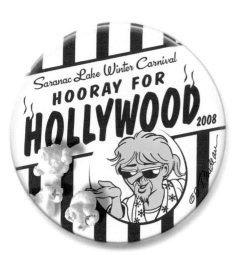

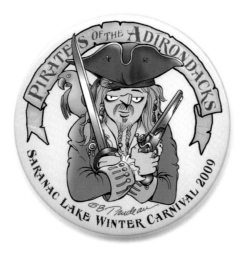

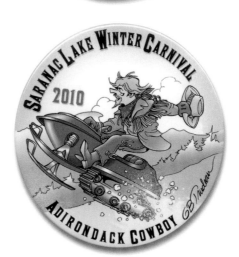

Saranac Lake Winter Carnival, pencil drawing for button, 2009.

Doonesbury daily strip, December 9, 1985. When Mike and J.J. moved into an East Village apartment, Trudeau had the opportunity to draw some New York City street scenes.

September 11, 1986. J.J. presented "Art-ville," a nine-hour performance piece, to Mike in a friend's loft.

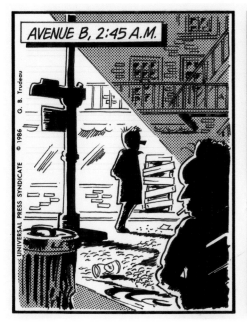
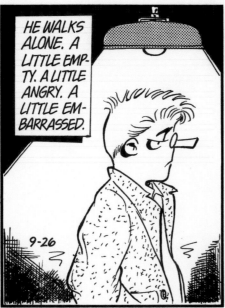
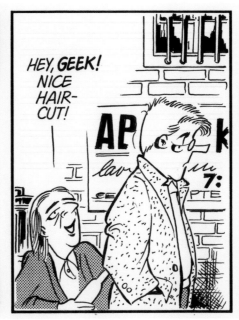
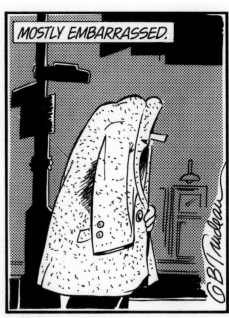

September 26, 1986. J.J. gave Mike a trendy eighties-style haircut.

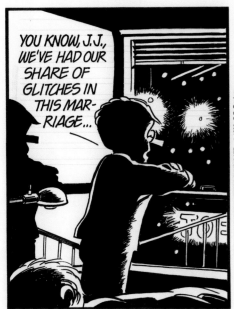
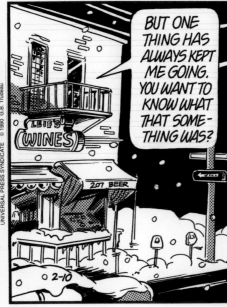
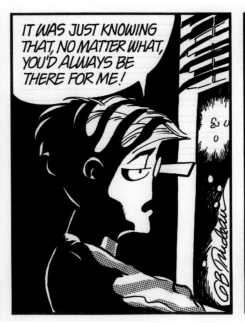
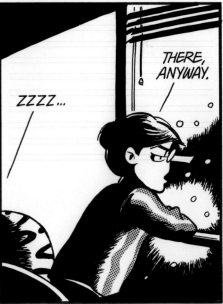

February 10, 1990. By the end of the decade, Mike and J.J.'s marriage was coming apart.
J.J. finally left Mike in 1995.

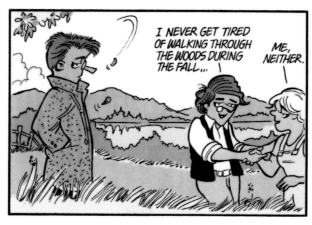

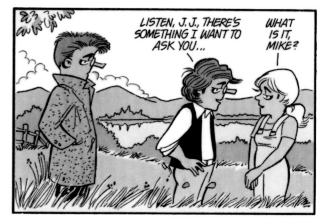

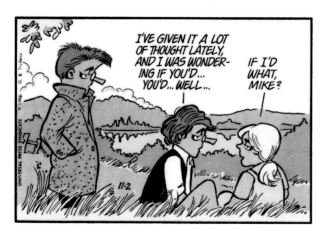

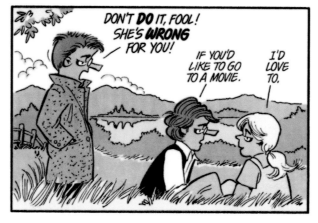

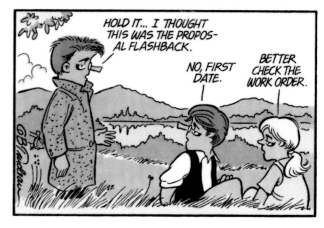

Doonesbury Sunday page, November 2, 1986. Mike revisited the time when he asked J.J. out on their first date.

Collaborator:
David Stanford

David Stanford first discovered *Doonesbury* when he was an undergraduate at the University of California, Santa Cruz, in the early 1970s. Immersed in underground commix at the time, he was not particularly interested in what was going on in newspaper comics. Stanford recalls his first reaction on seeing Trudeau's strip: "'How did this guy get inside the machine?' To see a kindred spirit suddenly show up on the inside of the media world was a revelation."

Stanford was born in Oakland, California, on October 1, 1951. After spending most of his childhood in Sacramento, he graduated from Berkeley High School in 1968 and from Santa Cruz in 1973. For the next two years he worked on his cousins' farm in Galesburg, Illinois, then attended the University of Minnesota, where he earned his M.A. in American history in 1977.

In 1973 Stanford produced the first issue of Animal Mitchell Publications, a series of forty independent comic books he wrote, illustrated, and distributed. "I just went down to a printer's shop and asked, 'How do you make comics?' and he showed me how to lay stuff out," he remembered. "I ended up stripping negatives, painting opaque, doing all the folding, collating, and stapling. Sometimes I'd hand-color the covers. I had subscribers—a couple of hundred people who would pay me by the year—and I would mail them out. And I would give them away in public wherever I was, all over the country. I'd published seven hundred pages by the time I went on hiatus. Comics were huge to me."

After graduate school, Stanford moved to New York City, where he endeavored to sell cartoons to the *New Yorker* and to break into the publishing business. "I started trying to become an editor by temping because I was a 105-word-a-minute typist," he explained. "I went to a temp agency and got a job in less than an hour." Eventually he was hired by Holt, Rinehart and Winston and was offered a permanent position to assist Don Hutter—Charles Schulz's and Garry Trudeau's editor. Stanford's interests in cartooning and editing had fortuitously merged. "That was a big moment for me," he recalled. "I only expected to work on the East Coast for a few years, but I'm still here."

When Hutter left Holt in 1981 Stanford took over as editor for both Schulz and Trudeau. The first time he met Trudeau was at a lavish sales conference held in the rooftop garden of a hotel on Central Park South. "It was easy to talk with him, and I enjoyed it," Stanford recounted. Their conversation continued in the elevator and out on the sidewalk.

At some point after their initial meeting, Trudeau was lamenting that he didn't have a studio assistant and could use some help, and Stanford responded by offering to work with him on side projects. His first assignment, which he did at his apartment in Brooklyn, was to write biographies of the characters for a promotional campaign. He asked to be paid with an original *Doonesbury* strip, and Trudeau obliged. After that Stanford spent Saturdays "wading into the backlog of the great undone" at Trudeau's home studio. His first major task was going through all of the *Doonesbury* originals, putting them in order for deposit at Yale's Beinecke Library. He also sorted an endless stream of newspaper articles sent in by a clipping service and pasted them into binders. "Anything that wasn't the strip itself, I would help him out with."

By the mid-1980s, Stanford was moonlighting regularly on Wednesday nights. "I would go over after work, visit a bit and have dinner, play with the kids, and then we'd go into the studio and get to work." He answered letters, responded to requests for original art, and managed special projects. "Garry would be over there working on the strip, and I would love watching him do it. He would show me the pencils, and I'd see how they were coming. We'd have music on and, later in the evening, *Cheers* and *Letterman*. Basically my job was to distract him by chatting. And of course we'd take breaks to make popcorn or Rice Krispies treats." Since one of Stanford's main duties was

reading the mail and discussing it with Trudeau, among his favorite *Doonesbury* sequences were the ones in which Mike and Zonker looked through letters in the mailbag. "I remember at one book convention, I was holding books open for Garry as he signed them, and a woman came up and whispered in my ear, 'I know who you are. You're Zonker!' As a long-haired California expat, I was of course happy to not deny it. Garry once referred to me as 'Zonker with survival skills.' I see him as Mike with confidence and an amazing work ethic. Most people have no idea how brutal and unrelenting the daily deadline is."

In 1988 Stanford left Holt for Viking Penguin, just as Trudeau's book contract ran out. Since Universal Press Syndicate's book arm had become *the* publisher of comics by that time, Andrews McMeel took over publishing the *Doonesbury* books, but Stanford continued to work on the collections and draft the flap copy. "Everything I ever write for *Doonesbury* goes through Garry and he always tweaks it, always puts the flourishes on it, ramps it up," Stanford explained. "Once in a while something will go through as written, but he almost always makes the copy better. It's a great collaboration. He has such a disciplined eye, and is such a good writer, that I've really benefited from working with him."

On his twenty years as a New York trade book editor and ten as an independent, Stanford says, "My goal has always been to work with creative people on projects that seem important, and help however I can. I've worked with really interesting nonfiction writers, novelists, cartoonists, and poets and have been blessed in that I've been able to gather my personal interests around me and serve as editor to some of my heroes—Garry and Sparky [Charles M. Schulz], historian Page Smith, poet and Grateful Dead lyricist Robert Hunter; I worked with Jack Kerouac's estate to republish many of his books and bring out his previously unpublished volumes, and I worked closely for twelve years with Ken Kesey. As a neo-Prankster I got to know the late Steve 'Zonker' Lambrecht, and spent many happy hours atop The Bus. A drawing of *Doonesbury*'s Zonker is collaged into the artwork inside." In addition to his work with Trudeau, Stanford acquires online comics for Andrews McMeel Universal's GoComics site and serves as the "aide de sherpa" at ComicsSherpa.com, a site for up-and-coming cartoonists.

Stanford first met George Corsillo when Corsillo was hired to design the *Doonesbury Desk Diaries* in the late 1980s, and they collaborated with Trudeau on *The 1990 Doonesbury Stamp Album*. He described this unique fund-raising project, which was published by Penguin, as "George and Garry going wonderfully berserk. It was so beautifully done, and they put an insane amount of time into it."

The *Stamp Album* led directly to *The Great Doonesbury Sellout* in 1991. "I remember sitting in the kitchen at Garry's place with George at one in the morning brain-jamming on products," Stanford recalls. They tossed out ideas for condom cases, cigarette lighters, ashtrays, and other items. "One of my favorite all-time contributions to *Doonesbury* was when we were talking about T-shirts and slogans for Duke and I said, 'Death before Unconsciousness!' That ended up on one of the shirts and was one of the best-sellers. It even made it onto the Duke action figure. I was pleased and proud."

Throughout the 1990s, Stanford continued to be intimately involved in every area of the expanding *Doonesbury* universe. When Mindscape produced the twenty-fifth-anniversary *Doonesbury Flashbacks* CD-ROM, he devised clever, descriptive titles for all nine thousand strips. This information could then be used to search strips in the archives by date, character, or subject. Mindscape built the first *Doonesbury* Web site, which was launched in December 1995. Stanford wrote for various features on the site, including Mike's Kwik Kwiz, and would come up with new trivia questions on a daily basis. As the site's "duty officer," he continues to write content, respond to queries, and post feedback from readers. The site moved to Universal Press Syndicate's digital division uclick in 1998, and since 2003 it has been hosted by the online magazine *Slate*. Stanford also contributed to *The Doonesbury Game* and worked on the *Duke 2000* campaign, in addition to keeping up with his ongoing editorial and copywriting duties for the *Doonesbury* book collections.

In October 2006 Trudeau came up with the idea of adding a military blog called The Sandbox to the Web site. In preparation for the launch Stanford roamed the Net searching for interesting posts from soldiers in Iraq and Afghanistan. When he found one that he liked, he contacted the soldier who

wrote it, introduced himself, and explained the mission of the blog. After The Sandbox was announced via a Sunday strip, Stanford began receiving e-mailed submissions directly from deployed troops and continued to find work on existing milblogs. "It is a huge project. It really consumed me. It was very intense what was going on, and the stories are impressive and moving," he recalled. In the first four years, he edited and put up more than five hundred posts by more than 120 soldiers, and Andrews McMeel published an anthology, which raised money for Fisher House.

After working closely with Trudeau for so many years, Stanford has a unique appreciation of his creative processes. "He has an amazing sense of timing," Stanford observed. "Sometimes it seems remarkable that a particular strip appears on just the right day, so that it rests against a background of reality absolutely attuned to its commentary." Trudeau has been "plugged into the zeitgeist for so long and he's such an omnivore in terms of his sources of news and information, that there's some part of him, on a very sophisticated level, that is tuned in and makes that happen," Stanford explained. "He's keeping track of various threads, he's following the various big movements that are happening, and when he goes to write a Sunday page and send it out there six or seven weeks ahead of time, his intuitive foresight makes it land just right. The week before wouldn't have been as good, and the week after wouldn't have been as good. That day was the best day for that strip to run."

Looking back at his long association with Trudeau and his creation, Stanford says, "I love the way that *Doonesbury* grew and evolved over time." He follows the work of a variety of artists, writers, and musicians. "If I'm interested in an artist, I want to see everything that they do because it's the consciousness behind the work that I'm interested in, and the unfolding. Garry has created an epic body of work that is absolutely fascinating. Here is a guy who in different ways, using different tools, is constantly responding to the world that he's living in and commenting on it and having interaction with it." Garry Trudeau's creative evolution has held David Stanford's attention on a day-to-day basis for more than thirty years.

The Great Doonesbury Sellout, T-shirt, 1991. The slogan that David Stanford created, "Death before Unconsciousness!" was also used on the Duke action figure.

The Sandbox, published by Andrews McMeel and edited by David Stanford, 2007. In the introduction, Garry Trudeau wrote: "Thanks to David Stanford's tireless scouting sorties to the hundreds of mill-blogs that have sprung up in the last four years, The Sandbox has managed to bring together and showcase some of the very best of these young writers."

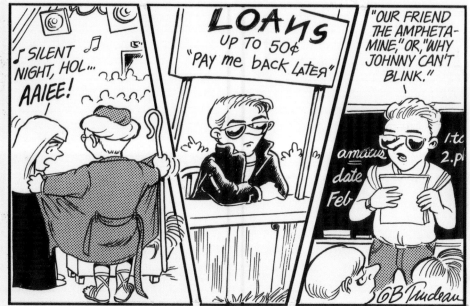

Doonesbury daily strip sequence, October 21–24, 1986. Duke's life flashed before his eyes during a jailhouse altercation while Trudeau shuffled and shattered the borders of the strip.

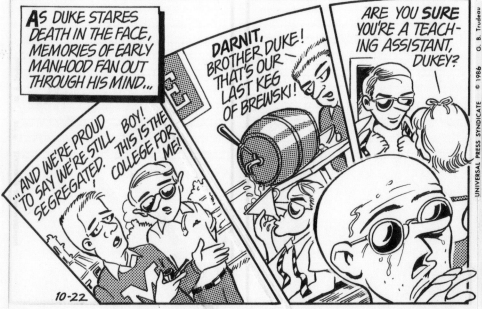

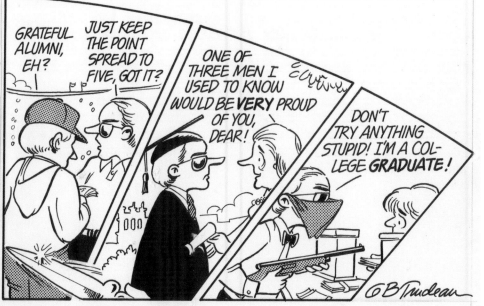

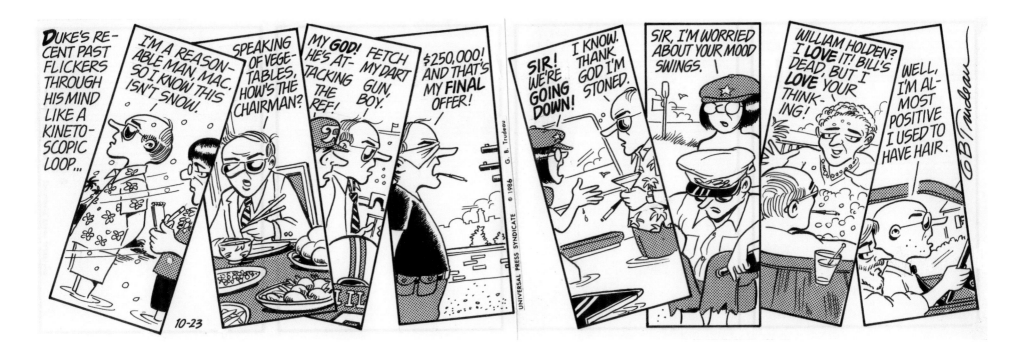

Life magazine, painting for "Doonesbury Is Back!" article, October 1984. Reviewing J.J.'s one-woman show, an art critic wrote: "While Caucus demonstrates an emerging pop sensibility, her work does seem a bit derivative."

Downtown Doonesbury, book cover painting, 1987. Peter de Sève had an artist friend help him design the background for this spoof of the avant-garde East Village art scene.

(opposite)
Death of a Party Animal, painting for cover of trade paperback book, Henry Holt and Company, 1986. Peter de Sève worked for Trudeau painting books, magazines, and posters throughout the 1980s. In de Sève's watercolor background, a Duvalier-like Haitian dictator looked malevolently down at Duke's zombified corpse.

Duke, unpublished grease pencil sketch by Trudeau.

The Other Inaugural, pencil drawing and poster (opposite),
Americans for Democratic Action, This event took place after
Reagan defeated Walter Mondale in the 1984 presidential
election. Trudeau is an admirer of the French artist
Henri de Toulouse-Lautrec.

Newsweek, pencil drawing and finished painting for cover article, "The Year of the Yuppie," December 31, 1984. *Newsweek* editor Dominique Browning explained that Trudeau was chosen to illustrate covers because "he's someone who thinks about a lot of different issues and has a funny way of making a quick point." This was the first of four *Newsweek* covers that Trudeau did.

Mother Jones, design drawings for magazine cover, May 1985. Trudeau did multiple treatments of Mike and Mark debating for an article entitled, "What's Happening to Your Politics? A Neo-Liberal and a Radical Democrat Face Off."

Adirondack Life, pencil drawing and finished cover for Special Twentieth Anniversary Issue, May–June 1989. A 22-by-35-inch poster of this illustration was sold to raise funds for the Adirondack Council's wilderness preservation efforts.

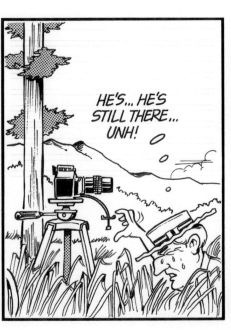
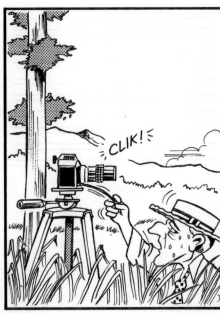
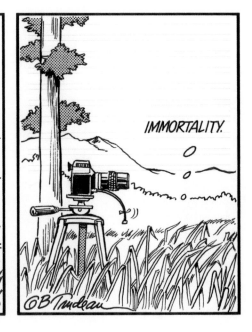

Doonesbury daily strips, November 6 and 7, 1986. Lacey Davenport's husband, Dick, an ardent bird-watcher, spotted a rare Bachman's Warbler before expiring in this moving sequence.

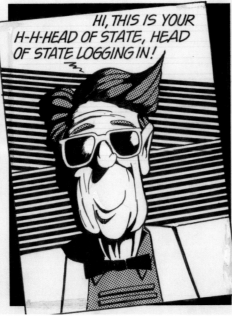
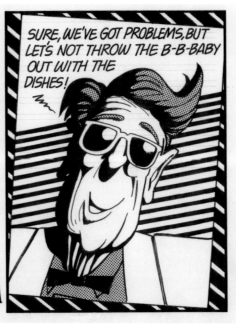
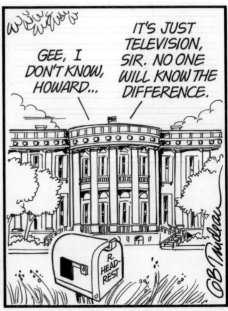

April 28, 1987. Max Headroom, the star of a British TV movie and a short-lived American television series, was the inspiration for Ron Headrest, Ronald Reagan's alter ego.

August 12, 1987. Boopsie prepared for the Harmonic Convergence which New Age philosophers predicted would occur on August 16, 1987.

October 1, 1987. Trudeau had fun spoofing the graphics of America's national newspaper, *USA Today*.

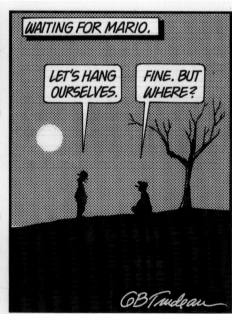

November 30, 1987. Mario Cuomo's indecisiveness about making a run for the presidency in 1988 led to this take-off on Samuel Beckett's existential play *Waiting for Godot*.

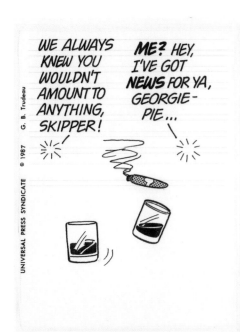
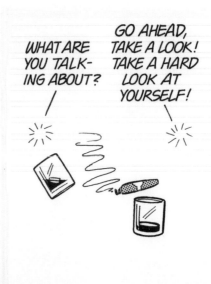
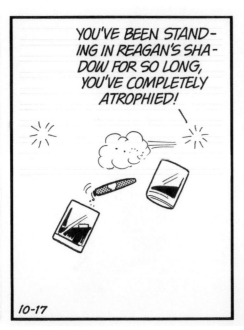

October 17, 1987. George H. W. Bush, represented by a vanishing point of light, had a man-to-man talk with his cigar-smoking, fictional twin brother, Skippy.

June 27, 1988. Bush attended a reunion of Skull and Bones, a secret society at Yale that included William F. Buckley, Jr., John Kerry, and George W. Bush among its members. Trudeau was in a rival society at Yale, Scroll and Key.

January 27, 1988. Boopsie posed for the *Sports Illustrated* swimsuit issue.

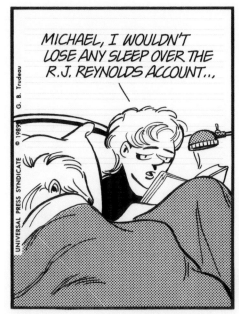

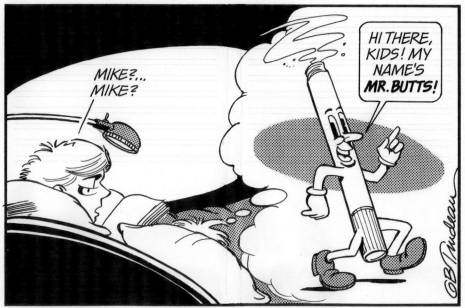

April 19, 1989. Mike dreamed up Mr. Butts while working on an advertising campaign for the R. J. Reynolds tobacco company. When he told J.J. about his vision, she said, "Mike, I think you read too many *Zap Comix* in college."

Doonesbury Sunday page, June 12, 1988. Reverend Sloan showed Zonker the devastation wrought on Walden by acid rain in a page with a powerful environmental message.

Doonesbury daily strip, May 30, 1989. Honey returned for her class reunion at Beijing University just in time for the protests in Tiananmen Square.

October 14, 1989. The Drug Enforcement Agency thought Mike's apartment was a crack den and made a televised raid while a crowd of freeloading friends were visiting.

Harry Chapin Tribute, drawing for a poster, December 7, 1987. A concert was held at Carnegie Hall to commemorate what would have been Chapin's forty-fifth birthday, had he not died in a car accident. Chapin and Trudeau were friends.

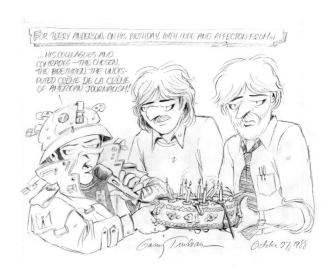

Pencil drawing for Terry Anderson's forty-first birthday, October 27, 1988. A correspondent for the Associated Press, Anderson was taken hostage in Lebanon in 1985 and held until 1991. Trudeau was asked by Anderson's family to do this drawing while he was still a captive.

Pencil drawing for Charles "Sparky" Schulz, commemorating the fortieth anniversary of his comic strip *Peanuts*, July 12, 1990.

Sally's Pizza, poster, 1988. George Corsillo created a retro look for this New Haven pizzeria that Trudeau frequented when he was a student at Yale.

Sally's Pizza, 1988. Drawing for a T-shirt.

(opposite) *Doonesbury Desk Diaries*, Henry Holt and Company. The 1988, 1989, and 1990 editions were among the first products that George Corsillo designed for Trudeau.

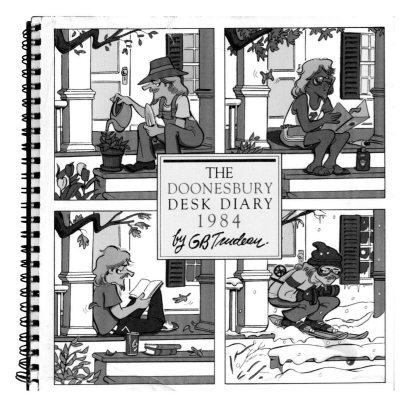

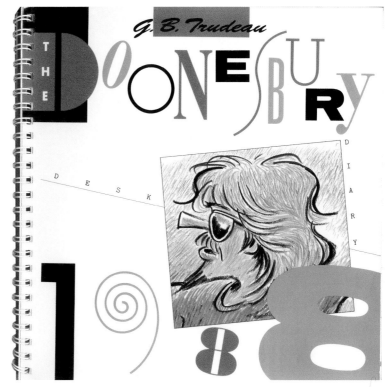

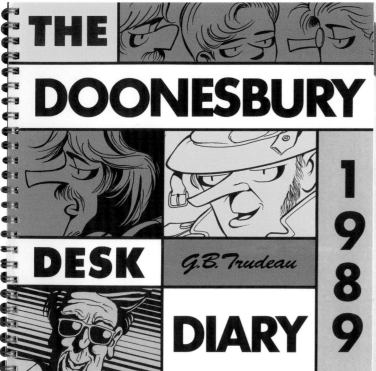

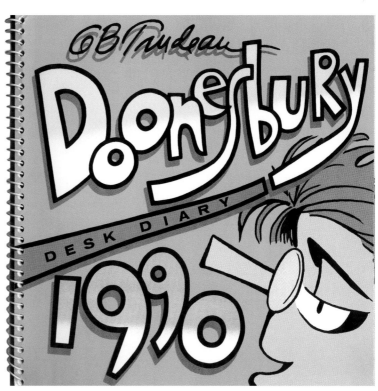

The 1990 Doonesbury Stamp Album, Penguin Books, 1990. The cover of this unique collectible was designed to look like a bound package that had been shipped by mail. Inside were 153 custom stamps printed on sixteen gummed and perforated sheets.

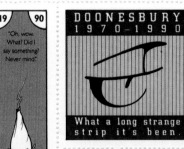

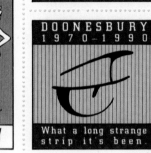

The 1990 Doonesbury Stamp Album, Penguin Books, 1990.
Zonker and Duke each got his own page of stamps.

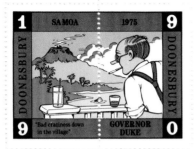

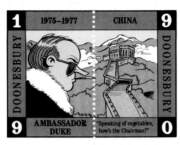

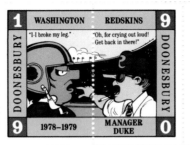

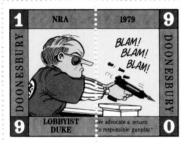

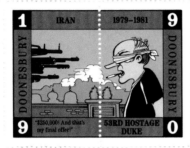

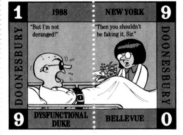

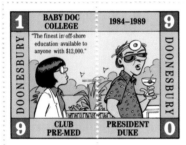

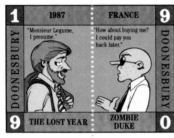

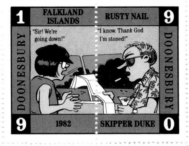

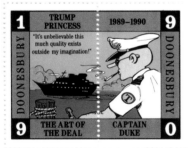

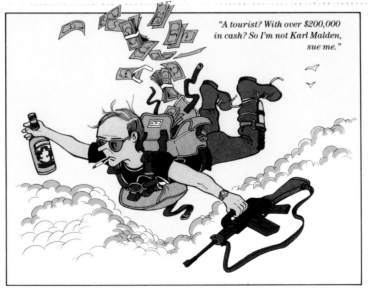

> "A tourist? With over $200,000 in cash? So I'm not Karl Malden, sue me."

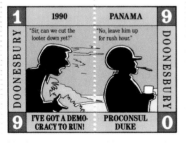

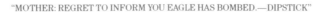

"MOTHER: REGRET TO INFORM YOU EAGLE HAS BOMBED.—DIPSTICK"

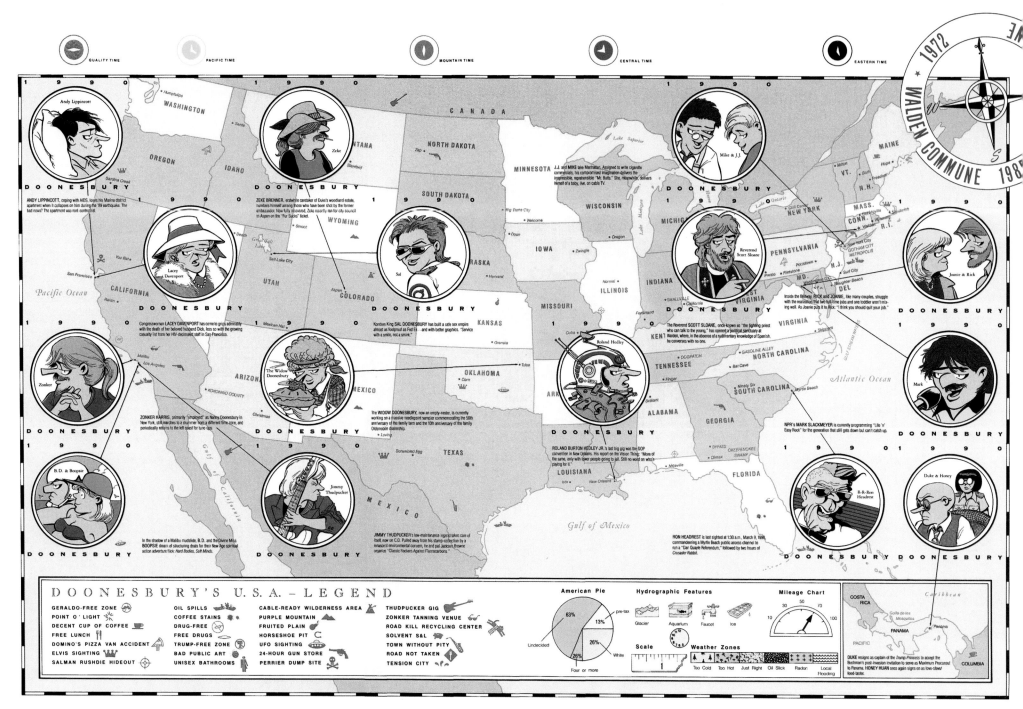

The 1990 Doonesbury Stamp Album, Penguin Books, 1990. The center spread featured a detailed map of "Doonesbury's U.S.A." and was made into a poster.

WHAT A LONG STRANGE STRIP IT'S BEEN

Garry Trudeau celebrated the twentieth anniversary of his professional cartooning career by submitting himself to an interview. The headline on the cover of the October 15, 1990, issue of *Newsweek* announced the main story: "Inside Doonesbury's Brain: Garry Trudeau Finally Talks." In the article, the reporter Jonathan Alter struggled to define what made Trudeau unique: "He is as much journalist as artist—an investigative cartoonist, Zeitgeist megaphone, flight attendant for his generation. . . . This is beginning to sound like a bad imitation of one of his baby-boomer strips."

Alter, who had visited Trudeau in his studio, described his process of drawing the strips in pencil and faxing them every Friday to inker Don Carlton: "The originals look almost identical to what Carlton redraws in ink, except for filling some black backgrounds and minor technical instructions. This is common among cartoonists."

The *Newsweek* article was followed by a piece in *Entertainment Weekly* entitled "Ghost Stories" about uncredited collaborators in the arts. "Virtually no one knows it but the hand that has been drawing *Doonesbury* for the last twenty years belongs not to the hermetic Garry Trudeau but to Kansas City based artist Don Carlton," the *EW* writers alleged. Although the magazine subsequently admitted that it had misrepresented Carlton's role, the conservative *Wall Street Journal* jumped at the opportunity to bash the liberal-leaning cartoonist.

In a short "Aside" on November 21, 1991, under the headline "Garry Vanilli," the *Journal* maintained that "Mr. Trudeau writes his own text but doesn't draw the published cartoons." It went on to accuse Trudeau of "Cartoon Synching," comparing him to the music group Milli Vanilli, which was disgraced when it was revealed that its members did not sing on their Grammy Award–winning album.

Lee Salem, the comics editor of Universal Press Syndicate, immediately demanded a retraction from the *Journal,* and when he didn't get a response,

Newsweek, October 15, 1990. Pencil drawings of Zonker and Duke were used to make life-size, color cut-out figures for the photograph on the cover.

Doonesbury daily strip, pencil drawing, January 16, 1995.
Trudeau began saving the pencil drawings for his strips in 1990.

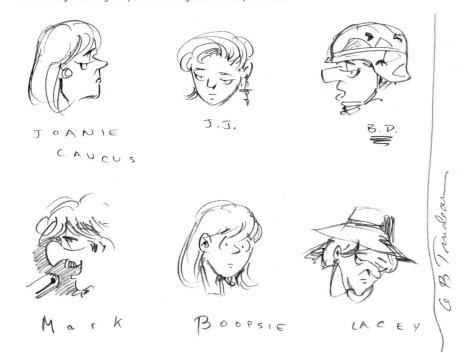

JOANIE CAUCUS

J.J.

B.D.

Mark

BOOPSIE

LACEY

The Great Doonesbury Sellout Supplement, 1992, T-shirt character sketches.

turned the matter over to the syndicate's attorneys. The *Journal* eventually printed a half-hearted apology on December 18: "If our 'Garry Vanilli' headline and reference to Cartoon Synching suggested that we consider Mr. Trudeau a complete fraud, we somewhat overstated the case. We were using what an experienced satirist might recognize as hyperbole, caricature, lampooning or burlesque."

Trudeau responded to these accusations in a letter that was printed in the *Journal* on December 27: "After years of absorbing the blame for the drawing in *Doonesbury,* it's odd to wake up one day and find myself stripped of the credit." Jonathan Alter came to the cartoonist's defense, claiming, "I had the chance to watch him sketch his strips in pencil, which he does to save time." Alter concluded, "Even the faintest suggestion that the art is not his—or that the strip should have a co-byline—is ludicrous."

At one point during this controversy, the *Journal* requested samples of Trudeau's pencil drawings to compare them to the finished strips inked by Carlton. Although this was not done before the *Journal* printed its retraction, Trudeau stated in his December 27 letter: "I would like to issue the *Journal*

an open invitation to visit and cart off as many pencil drawings—and their inked companion pieces—as you may need to satisfy future curators. The fine-art mavens may not go along with your characterization of the drawings as 'polished' (the kindest description I have ever received in print, by far), but perhaps they will concur that little has been lost or gained in the transformation of my light gray pencil lines into photo-reproducible black lines."

For years, Trudeau had disposed of these drawings, assuming they had no value. His part-time office assistant and book editor David Stanford reminisced about the weekly ritual in the studio during the 1980s: "[Trudeau] does these incredibly tight pencils and I would see them and he would finish the week or finish the ones he was doing that night, and then he'd stick them in the fax machine and send them over to Don for inking, and then he would tear up the originals." When the *Wall Street Journal* incident occurred, Trudeau had only recently stopped destroying his pencil drawings. "*Newsweek*'s Jonathan Alter dissuaded me of this practice, and I now have several hundred of them cluttering up my studio," he wrote in the December 27 letter.

Trudeau admitted that he preferred the penciled art over the finished inks. "Early drafts always have a kind of looseness—a fluidity that's hard to capture in the ink. If I could get away with submitting pencils, I'd be tempted,

The 1990 Doonesbury Stamp Album. A preliminary
sketch by Trudeau for one of the stamp designs.

Doonesbury daily strip, December 30, 1992. A self-deprecating comment on
the artistic skills of the strip's creator.

Drawing for a fan, 1990s. Trudeau has featured an annual series on Mike and Zonker reading the mail since the early 1990s.

but the tones wouldn't hold in reproduction, particularly at the reduced scale." He characterized the inking process as "an interface—dressing the drawings up to get them in the paper."

In the early 1990s Trudeau began to experiment more frequently with self-referential commentary in *Doonesbury*, having his characters speak directly to the readers, discussing the inner workings of the strip. This type of inside humor, dubbed "metacomics" by the scholar Thomas Inge, had been used previously by Al Capp in *Li'l Abner*, Ernie Bushmiller in *Nancy*, and Walt Kelly in *Pogo*. Mort Walker and Jerry Dumas did a short-lived feature in the early 1960s, *Sam's Strip*, which included walk-on appearances by famous cartoon characters and gags about the hidden secrets of life within the panel borders. During the 1980s Trudeau and other contemporary cartoonists, including Bill Griffith (*Zippy*) and Berke Breathed (*Bloom County*) revived the playful behind-the-scenes perspective.

Among the innovative series during this period was a trio of Sunday pages from 1991 in which the *Doonesbury* supporting characters staged a coup to overthrow the "big three"—Mike, Mark, and B.D. The new feature, retitled "Duke's World," failed after ratings plummeted and the conspirators were harshly punished. Duke, the ringleader of the "gang of eight," was banned from the daily strip for six weeks and from the Sunday comics until 1993. During a two-week daily strip sequence from September 1992, the feature chronicled its condemnation by the Commissioner of Comics after failing to pass a routine screening for family values. The strip returned with a replacement writer, Diego Tutweiler, but after a few days, the "old writer" was given a second chance when the characters passed a family values litmus test. In a Sunday page on August 22, 1993, Mark revealed a recently discovered "lost episode" in which Mike and Boopsie got married. It turned out to be a hoax.

Since that time, Trudeau has continued to feature two series on an annual basis—Mike and Zonker reading the mail and Mike's summer daydream. Although he acknowledges that "it's fun to mess with people's heads," he also realizes that with self-referential humor, less is more. "It's something you want to do sparingly. When you've invited readers into a fictional world and persuaded them to suspend disbelief, you need to be very careful not to break the spell too often. Otherwise they'll start to feel like suckers."

During the Nixon administration, Trudeau began to use "offstage voices" to suggest conversations that might have taken place within the walls of the White House. He clarified why this method worked better than drawing caricatured versions of real politicians: "A caricature substitutes the artist's imagination for the reader's. If you get the dialogue right, the reader will supply his own visual and the scene will seem more real, more plausible. At least that's the theory. What I can say for certainty is that if the dialogue misfires, there is nothing more sorry than four identical drawings of the White House."

Trudeau took this approach a step further in 1987 when he depicted Vice President George H. W. Bush as a vanishing point of light, suggesting his lack of accountability and moral character, and turning his "thousand points of light" campaign back on him. He continued to use this symbol throughout the Bush administration and also drew Vice President Dan Quayle as a feather in reference to his widely perceived stature as an intellectual lightweight. By the time Bill Clinton became president in 1993, readers had become proactive, sending in suggestions for symbols to use for the new chief executive. On August 14, 1994, Mike and Mark gave readers two choices—a flipping coin or a waffle—in a nationwide referendum to choose a presidential icon. The (predetermined) winner—the waffle—was announced on August 22.

Between September 5, 1990, when B.D. informed Boopsie that he had been called up by the Army Reserve, and May 6, 1991, when he returned home, Trudeau did almost 250 *Doonesbury* episodes devoted to the war in the Persian Gulf. Although he had been bitterly opposed to the war in Vietnam in the early years of the strip, he felt that he had always been supportive of the soldiers who were serving in that conflict. During B.D.'s deployment in the Gulf War, he again tried to focus on the everyday problems of enlisted men. When Trudeau applied for permission to visit Kuwait in December 1990, his request was denied. But at the recommendation of Army Chief of Staff General Gordon Sullivan, after a traveling exhibit of original *Doonesbury* strips made a tour of army bases, the Pentagon finally approved his application.

Temporarily delayed by some visa problems with the Saudi consulate, Trudeau was finally contacted by Colonel Bill Nash, a tank brigade com-

I'd Go with the Helmet, Ray, book cover, Andrews and McMeel, 1991. Almost 250 strips focused on the Gulf War, many of which were reprinted in this collection.

Friends of Museum Park refrigerator magnet, 1990.

Friends of Museum Park, pen-and-ink drawing of Zonker on a stegosaurus from the "Doonesbury Dinosaurs" series of products sold at the American Museum of Natural History, 1990.

mander stationed outside of Kuwait City, and instructed to fly to Riyadh, where he was escorted past customs by two U.S. soldiers. When Trudeau arrived at Camp Thunderrock, Nash took him on a helicopter tour, viewing oil wells burning in the desert and touching down alongside the Highway of Death.

Nash had first read *Doonesbury* in *Stars and Stripes* when he served in Vietnam and was aware that Trudeau was covering the Gulf War. "So here I was doing it again, trying to convey something I hadn't directly experienced," the cartoonist recollected. "Nash figured that if this time I got it right, maybe something useful could come from it, from telling the story of his war through the unique, incremental alternative reality of a comic strip."

Trudeau spent the nights during his visit talking with Nash's men, who took him for rides in their Blackhawks and Bradleys and let him drive an M-1A tank. "When I got back from my tour of the war zone, my wife asked me how I felt," he wrote later. "I told her I felt like Brooke Shields—and proudly unrolled the commendations I'd received. Then it suddenly dawned on me that for the first time in my life, I had attracted institutional approval, and worse, that that approval had come from my first target all those years ago—the military establishment. Frankly, I can do without that kind of cheap irony in my life."

In 1990 Trudeau became involved in a fund-raising project that was close to home. He often took his children to play in the park adjacent to the American Museum of Natural History on Central Park West in Manhattan. The neighborhood was trying to raise money to renovate Museum Park, so Trudeau, in collaboration with George Corsillo, designed a line of products featuring Zonker and the "Doonesbury Dinosaurs" to sell in the museum's gift shop. Among the items were T-shirts, a baseball hat, a silk necktie, a coffee mug, posters, note cards, buttons, and magnets. A three-dimensional display of Zonker riding on an eight-by-ten-foot stegosaurus was on view in the museum's store window during the 1990 Christmas season. The success of this effort encouraged a larger-scale charity campaign that was announced a few months later.

Beginning in the early 1970s, Trudeau and his original editor at Holt, Don Hutter, developed what they called the "*Doonesbury* voice" to use on the jacket copy for his books. They wrote it to convey what Trudeau describes as the "hip, breezy, ironic tone that we hoped the *Doonesbury* reader would

find amusing. It doesn't actually mimic any voice in the strip itself. Nor is it the same as the wise-guy voice that defines the Web site, the voice we call 'Management.'" This persona was initially developed in *The Great Doonesbury Sellout,* a charity merchandising campaign that was launched in October 1991.

The idea for that project came from a conversation with Paul Hawken, founder of the Smith and Hawken mail-order catalog of gardening supplies, who convinced Trudeau to merchandise his characters to benefit four organizations—Trees for the Future, Asia Watch, the Coalition for the Homeless, and the Center for Plant Conservation. The catalog copy, which was written by Trudeau, spoofed the conventions of mail-order marketing by refusing to take the products seriously. Among the thirty-five items offered in the catalog were a ceramic Mr. Butts ashtray that was described as a "dandy little cancer caddy." A series of four "investment-grade cloisonné pins baked with pride" were promoted as "the future superstars of the English-speaking collectors market, destined to fetch prices far in excess of what conscience permits us to charge you here." A set of phony White House press credentials were a steal at $25, and the Duke A-2 Aviator Classic bomber jacket, complete with *Doonesbury* patches, was a splurge at $395.

The Doonesbury Company, drawing for a business envelope, 1991.

Left: *The Great Doonesbury Sellout,* Mr. Butts ashtray, 1991. On the other side of this cancer caddy was the message, "Go ahead. You're immortal."

The Doonesbury Game, box cover art, 1993.

As one observer wrote, "The whole operation seems to have been dipped in an aged wooden cask of ironic yuks." In a sixteen-page supplemental catalog that was mailed out the following year, "Management" tooted its horn: "*The Great Doonesbury Sellout* did what none of the so-called experts thought we could do: we survived. We took a tiny mom-and-pop business with three employees, refinanced it, and in ten short months transformed it into a bustling profit center with five employees." Richard Shell, the president of the *Doonesbury Company*, remarked: "Everything Garry works on is infused with his insights and sense of parody, and I think our products have been well received as faithfully capturing the *Doonesbury* cachet."

Around this time, Trudeau was approached by two young designers from Seattle who had a concept for a *Doonesbury* board game. David Stanford, who contributed to the development of The Doonesbury Game, characterized it as "just a wonderfully self-contained manifestation, a new aspect of *Doonesbury*—it was about trivia, it was about the strip, it was about the characters, it had *Doonesbury* humor, *Doonesbury* art, it was just perfect." Although the game was based on the strip, it was designed to be an interactive experience among the players, who were required to share secrets about their "most disastrous date" or to "explain the various problems facing mankind" in thirty seconds. The game was over when the player with the fewest points decided it was over.

All of these projects were extensions of what Stanford calls the "*Doonesbury* Universe": "Garry as a designer has always considered the entire *Doonesbury* realm his project. As the creator he deserves to have and does have control over the imagery and all of the manifestations of the feature wherever they may be. As a corollary to that, he's always had a very clear sense of where the boundaries of that territory are and of how big that universe is."

Trudeau continued to do outside projects throughout the 1990s. *The People's Doonesbury,* which was hosted by online book retailer Amazon on May 4–18, 1998, invited contestants to provide dialogue for an ongoing interactive *Doonesbury* comic strip. In exchange for this unique promotional opportunity, Amazon made a donation to the literacy organization Reading is Fundamental. In December 1998 the first products in the Doonesbury@ Starbucks partnership were available for purchase at five hundred Starbucks

locations and online. Among the items were posters, coffee mugs, and coasters, as well as collectible figurines, neckties, and Hawaiian shirts, all custom-designed by Trudeau and George Corsillo. This campaign raised more than $1 million for literacy programs across the country.

In the mid-1970s, Trudeau started a tradition of delivering commencement addresses at the nation's colleges. "Writing a graduation speech is a way of working through what you value most at the time," he explained. "Beyond the honor of being asked and the joy of the occasion, I viewed it as a periodic opportunity to revisit and challenge my most cherished assumptions." During one of these campus visits in the 1990s, he discovered that modern college students were not reading *Doonesbury* in the newspapers, and later he acknowledged, "Although I still love the little black-and-white drawings I've spent my life producing, I'm skeptical that a generation that's grown up experiencing the world through screens will support comics as I've known them."

In 1995 the *Doonesbury* universe ventured into the digital realm with three products that were developed by Mindscape Inc.—a set of *Doonesbury* screen savers, an election simulator for the 1996 presidential campaign, and a flashback CD-ROM containing twenty-five years of *Doonesbury* strips, plus numerous bonus items. Mindscape, which later became Headland Digital Media, also designed www.doonesbury.com, one of the first comic strip sites on the Web, which launched in December 1995. Officially named The Doonesbury Electronic Town Hall, it offered many original features, including a Straw Poll, Mike's Kwik Kwiz, a Flashback archive, GBT's FAQs, where Trudeau answered selected questions, and The Sellout, where products could be purchased. Sound Bytes, a four-part chat hall which provided a forum for fans of the strip, eventually had to be shut down when some of the posters became unruly. The site moved over to Andrews McMeel Universal's digital division, uclick, in 1998 and was redesigned. There was another major overhaul in 2000, and since 2005 the site has been hosted by Slate.com.

David Stanford, who has served as the site's "duty officer" since the original launch and has provided ongoing content for features, says that since Trudeau made the move into the digital world, "the *Doonesbury* universe

Doonesbury@Starbucks, logo designed by George Corsillo, 1998.

Doonesbury@Starbucks, early idea sketch by Trudeau, 1998.

Doonesbury Screen Saver, package designed by George Corsillo for Mindscape, 1995.

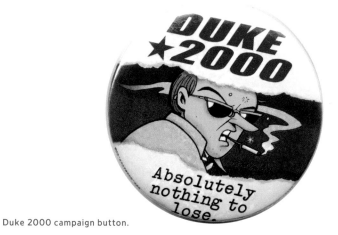

Duke 2000 campaign button.

seems to emanate from the Web site. The strip is at the center of it. It's like a power station out there in space."

The *Doonesbury* universe continued to expand with *D2K*, a project which used three-dimensional, computer-generated, motion-capture technology to document Duke's campaign in the 2000 presidential election. This technique, pioneered by the digital media company Protozoa (later dotcomix), was used to produce thirty short Duke videos, written by Trudeau, in Protozoa's San Francisco warehouse studio. The voice actor Fred Newman, a regular on *Prairie Home Companion,* donned a motion capture suit with Velcro-attached sensors. His vocal improvisations and body movements were then fed to a computer and synched with a 3-D digital character on screen. This technology enabled a computer-animated Duke to do press conferences and interviews in real time on *Larry King Live, Today,* and dozens of other TV programs. Unfortunately, the technology was ahead of the curve for the mass audience, since most home computers at that time did not have the bandwidth speed to watch the *Duke 2000* films on the D2K Web site.

It was another time-consuming but rewarding experience for Trudeau. "Part of this project is to determine whether a Web-based video strip is something worth pursuing," he told *Wired* magazine. "The jury is still out on that."

Although Trudeau continued to court controversy throughout the 1990s, many believed that the strip had lost its edge during the Clinton years. "It's not as biting now," remarked the political analyst Jeff Greenfield. "He's more hostile to the Republican Congress than he is to the vaguely liberal president." Trudeau defends his lack of fairness: "Balanced satire is a contradiction in terms. Satire has a point of view. An even-handed satirist is more correctly called a humorist. They're not the same thing. Clinton may have rained disgrace on himself, but Bush did irreparable harm to the country. Why would I treat them the same?"

On May 18, 1996, the National Cartoonists Society presented Trudeau with the Reuben Award as the outstanding cartoonist of the year at a black-tie dinner in New York. It was the sixteenth time he had been nominated for the award. Although he had realized early in his career that certain elements of cartooning's old guard would never respect his work, he did admit that it

was a sweet victory. "It was the twenty-fifth anniversary of the strip. My generation had finally arrived. All my previous nominations had been doomed by the older members. Winning brought to mind what my editor had once said about the crusty old publishers who kept kicking me out of their papers: 'Don't worry, kid. Sooner or later, these guys die.'"

In December 1999, shortly after Charles Schulz announced that he was retiring after producing *Peanuts* for forty-nine years, Trudeau spoke for the entire cartooning fraternity when he wrote an elegant tribute in the *Washington Post*: "While the public at large regards *Peanuts* as a cherished part of our shared popular culture, cartoonists also see it as an irreplaceable source of purpose and pride, our gold standard for work that is both illuminating and aesthetically sublime. We can hardly imagine its absence." Two months later, on Saturday, February 12, 2000, the legendary cartoonist passed away, hours before his final *Peanuts* Sunday page appeared in the newspapers.

It had taken Trudeau a long time to come to terms with his avocation. "I was years into it before I understood I'd found my life's work," he admitted. "After all, I was being paid to stand on a corner firing spitballs at the passing parade. I worked erratic hours, and there was no dress code. It didn't seem like an actual job."

Photograph of Trudeau by Emmanuela Gardner, for *The Portable Doonesbury*, 1990.

U.S. News and World Report, "Plugged In," pencil drawing for cover of Zonker surfing on a hard drive, December 6, 1993.

NEIL BUSH of Denver, CO, AS A SILVERADO BANK DIRECTOR, UNWITTINGLY VOTED TO APPROVE OVER **$100 MILLION** IN LOANS TO HIS BUSINESS PARTNERS, NEVER GRASPING IT WAS A *CONFLICT OF INTEREST!*

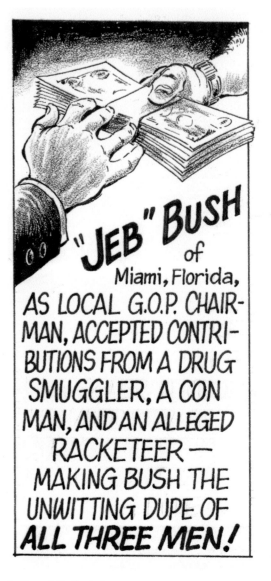

"JEB" BUSH of Miami, Florida, AS LOCAL G.O.P. CHAIRMAN, ACCEPTED CONTRIBUTIONS FROM A DRUG SMUGGLER, A CON MAN, AND AN ALLEGED RACKETEER — MAKING BUSH THE UNWITTING DUPE OF *ALL THREE MEN!*

Above: "Believe It. Not!" *New York Times*, March 27, 1992. A take-off on *Ripley's Believe It or Not!* chronicled the shady dealings of the Bush clan. This was one of a series of illustrated columns Trudeau did for the *New York Times* between 1990 and 1994.

PRESCOTT BUSH, JR., PAID OVER $250,000 FOR ARRANGING U.S. INVESTMENTS FOR WEST TSUSHO, BECAME AN UNWITTING FRONT MAN FOR *THE JAPANESE MOB!*

GEO. BUSH, JR. of Dallas, Texas, DIRECTOR OF HARKEN ENERGY, UNWITTINGLY DUMPED **$848,560** WORTH OF STOCK ONLY **ONE WEEK** BEFORE A POOR EARNINGS REPORT SENT PRICES TUMBLING!

"The Post Neo-Nixon (Annotated)," *New York Times*, May 20, 1990. Caricatures for a column about Richard Nixon's memoir, "In the Arena."

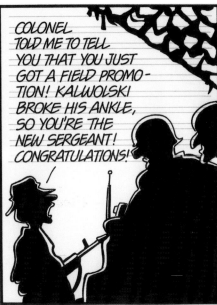

Doonesbury daily strip, January 18, 1991. B.D. served in Operation Desert Storm for eight months.

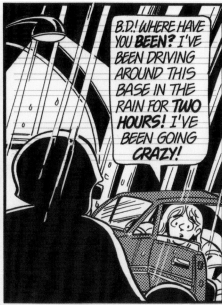
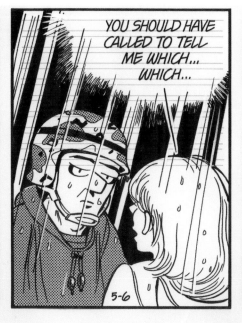

May 6, 1991. B.D. and Boopsie were reunited after his tour of duty ended.

Doonesbury Sunday page, July 14, 1991. In Kuwait City, Honey and Mr. Butts worked the bar at Duke's Club Scud, "home of the $200 hamburger."

Friends of Museum Park postcards designed by Trudeau and George Corsillo were sold in the American Museum of Natural History gift shop, 1990.

Friends of Museum Park, T-shirt and mug, 1990.
These were some of the first products other than books and calendars that Trudeau licensed.

Friends of Museum Park, pencil drawing and finished art of Zonker and a baby stegosaurus, 1990.

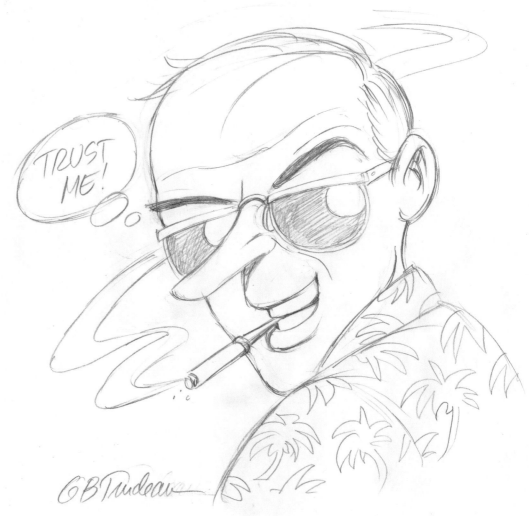

The Great Doonesbury Sellout, catalog and pencil drawing for cover, 1991. In the first catalog Management boasted: "We think we have put together a lineup of offerings that will prove irresistible to fans of the greatest comic strip in history, but we could be wrong, especially about the strip (the rights to *The Far Side* were already tied up)."

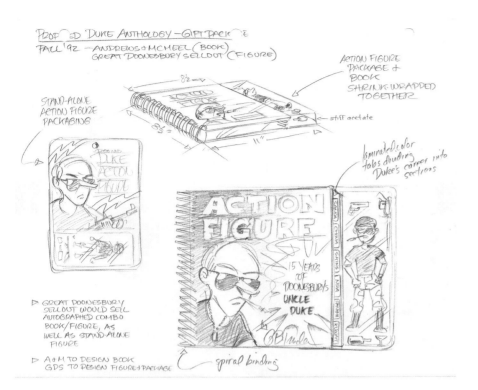

PROPOSED DUKE ANTHOLOGY — GIFT PACK?
FALL '92 — ANDREWS & MCMEEL (BOOK)
GREAT DOONESBURY SELLOUT (FIGURE)

STAND-ALONE
ACTION FIGURE
PACKAGING

ACTION FIGURE
PACKAGE &
BOOK
SHRINK-WRAPPED
TOGETHER

stiff acetate

laminated color
tabs dividing
Duke's career into
sections

▷ GREAT DOONESBURY
SELLOUT WOULD SELL
AUTOGRAPHED COMBO
BOOK/FIGURE, AS
WELL AS STAND-ALONE
FIGURE

▷ A&M TO DESIGN BOOK
GDS TO DESIGN FIGURE+PACKAGE

spiral binding

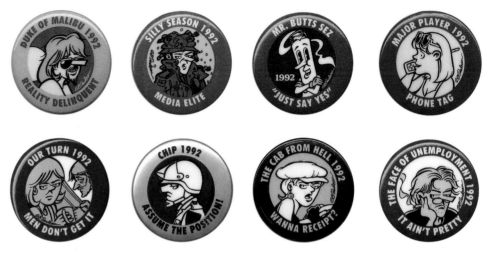

The Great Doonesbury Sellout, set of eight metal commemorative buttons, 1992.

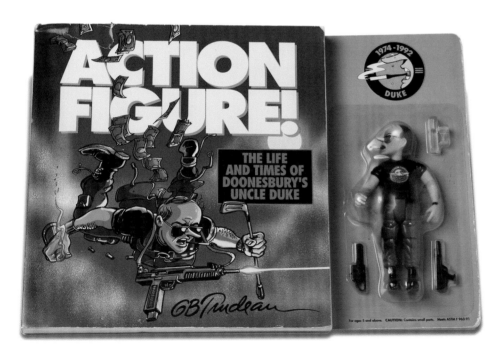

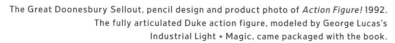

The Great Doonesbury Sellout, pencil design and product photo of *Action Figure!* 1992.
The fully articulated Duke action figure, modeled by George Lucas's
Industrial Light + Magic, came packaged with the book.

The Great Doonesbury Sellout, set of four cloisonné pins, 1991.

The Great Doonesbury Sellout, pencil drawing and product photo of "Baby Woman" T-shirt, 1991, "an exuberant pre-post-feminist message."

The Great Doonesbury Sellout, the Democracy Scarf, 1991. This high-quality silk scarf reproduced the art from the May 30, 1989, daily strip.

The Great Doonesbury Sellout, "Death before Unconsciousness" T-shirt, 1991. The catalog copy advised: "A slogan to live by. We're not sure what it means, but we're guessing it's true. If you're into fistfights, then this tee's probably for you."

The Great Doonesbury Sellout, pencil drawings for "Men of Doonesbury" and "Women of Doonesbury" T-shirts, 1992.
Above, left to right: Zonker, B.D., Mark, Duke, and Mike; below: Boopsie, Honey, Joanie, J.J., and Lacey.

THE
DOONESBURY
GAME

WALDEN COMMUNE
5 POINTS FOR PASSING BY
10 POINTS FOR LANDING HERE

START HERE

Public Opinion

D

Soundbites

Brainstorm

ALICE'S AND ELMONT'S SHELTER
LOSE IT ALL, BEG FOR MORE.

Flashback

ROLL AGAIN

Brainstorm

Flashback

Soundbites

MR. BUTTS' LAND OF IMMORTALITY
PAY 10 POINTS OR ROLL 7, 11 OR DOUBLES

D

Public Opinion

Flashback

ROLL AGAIN

BOOPSIE'S CHANNEL CHANGE
THE BIG SWITCH

Soundbites

Brainstorm

POP! POP!

The Doonesbury Game, designed by Trudeau and George Corsillo for Mikrofun, Inc., 1993.
"The entertainment equivalent of three full sets of tennis."

Mr. Butts Goes to Washington, model sheet for a thirty-second animated public service advertisement produced by J. J. Sedelmair Productions, 1995. "The Mr. Butts character is a takeoff of an old-fashioned cartoon character, using all the classic devices–the little wedge cut out of the eye and so forth," explained Sedelmair, who collaborated with Trudeau on the TV spot.

Great American Smokeout poster, November 19, 1992. Mr. Butts took on the "nicotine Nazis" in a mock debate to promote the American Cancer Society's annual event.

Mr. Butts No Smoking sign, designed by Trudeau for the city of Santa Monica, 2005. These three-foot-long signs were wrapped around garbage cans.

The Great Doonesbury Sellout, Mr. Butts T-shirt, 1991. On the back of this shirt were words to die for: "Go ahead, kids. You're immortal!"

Great American Smokeout sticker, November 19, 1992.

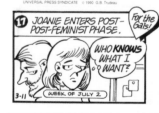
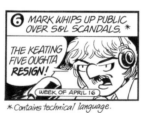
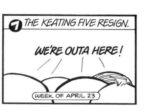

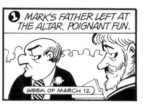
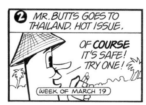
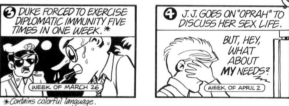
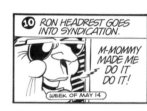
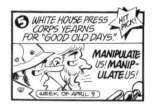
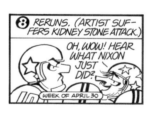
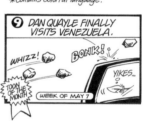
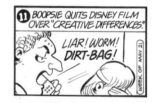
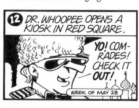
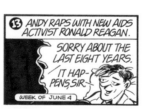
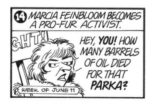
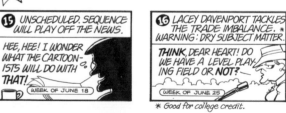

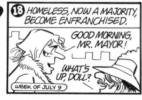
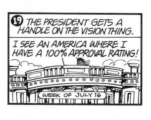
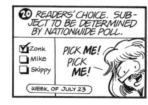

Doonesbury Sunday page, March 11, 1990. The concept of "A Doonesbury Planner," which previewed upcoming highlights, was reprised on June 17, 2007.

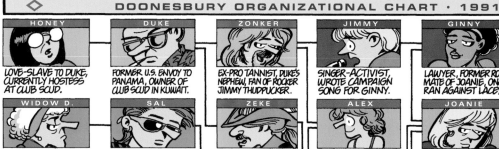

August 11, 1991. "The Doonesbury Organizational Chart," which helped readers sort out the complicated web of relationships among members of the cast, was updated on May 26, 1996.

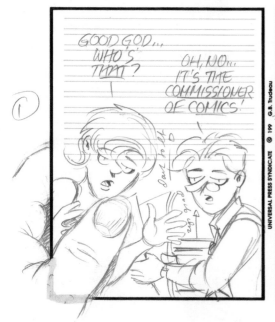
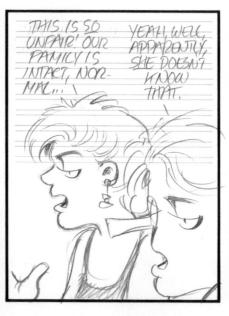
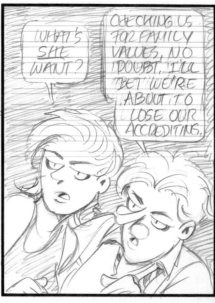
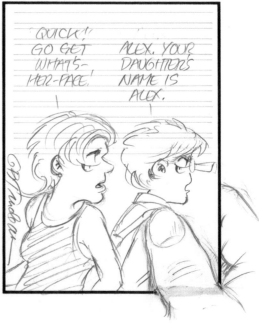

Doonesbury daily strips, pencil drawing and finished version, September 14, 1992. These two examples, representing different stages of the production process, demonstrate how closely Trudeau's linework was inked by Don Carlton.

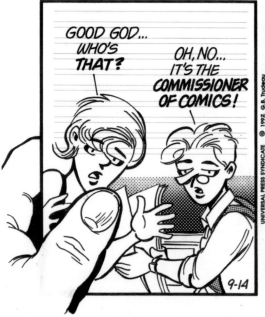

Doonesbury

BY ~~GARRY TRUDEAU~~

September 16, 1992. The Commissioner of Comics shut down the strip because the characters failed to pass a family values test.

Doonesbury

BY DIEGO TUTWEILLER

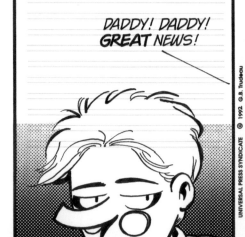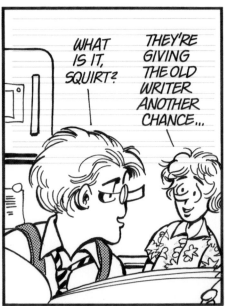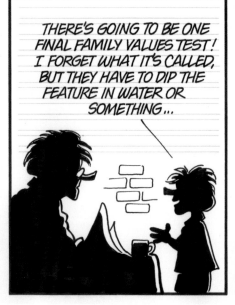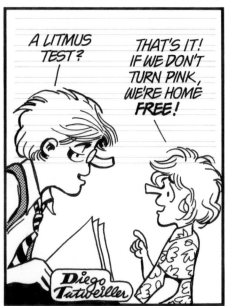

September 19, 1992. The replacement artist "Diego Tutweiller," who drew Mike's nose out-of-joint, was eventually let go when the "old writer" was given a second chance.

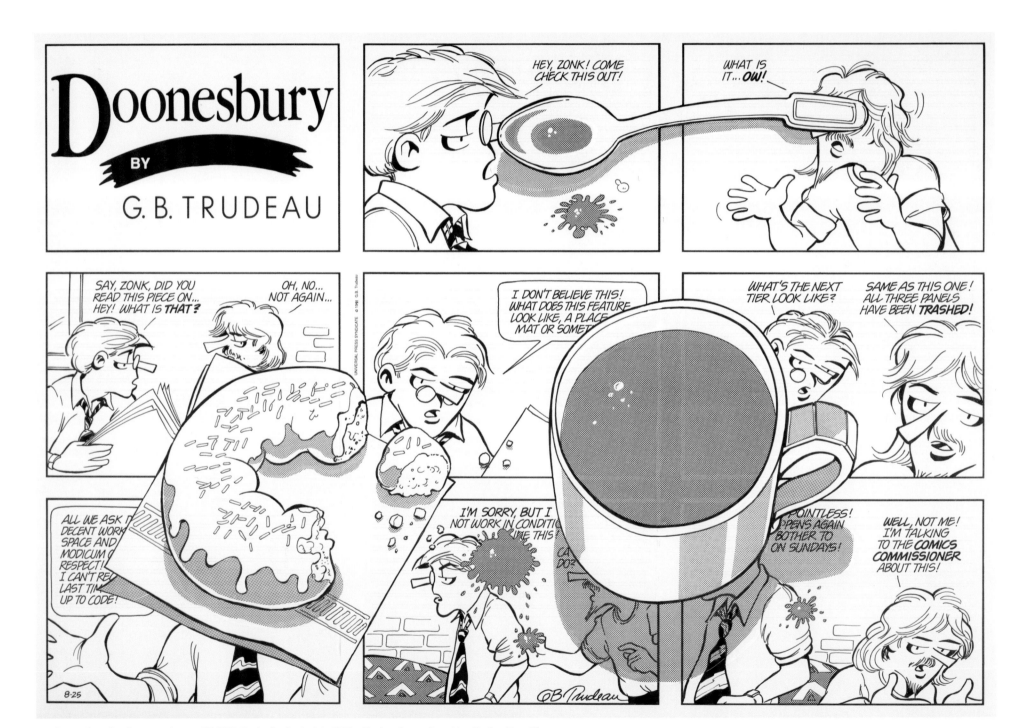

Doonesbury Sunday page, August 25, 1991. Beginning in the late 1980s, Trudeau began "breaking the fourth wall" more frequently by having his characters speak directly to the readers.

Doonesbury daily strip, pencil drawing, December 28, 1992. The year-end mail-bag sequence became an annual event.

January 12, 1994. Mike and Zonker explained to readers how the production of the strip had been outsourced.

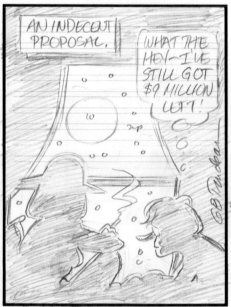

Pencil drawing and finished version, July 14, 1993. Another recurring series was Mike's summer fantasy.

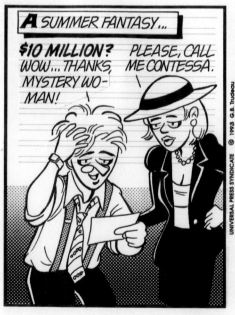

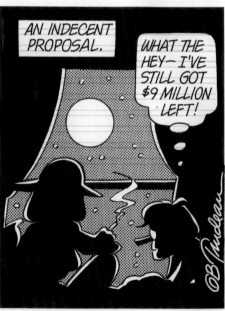

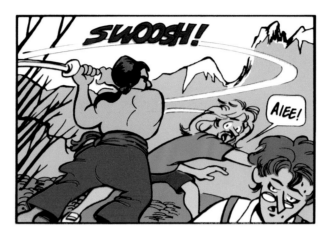

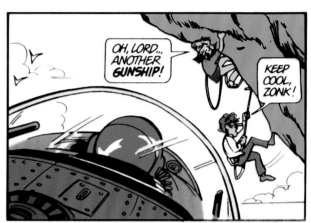

Doonesbury Sunday page, July 25, 1993. An action-adventure summer blockbuster.

May 23, 1993. Mike offered alternate versions of the strip for different age groups.

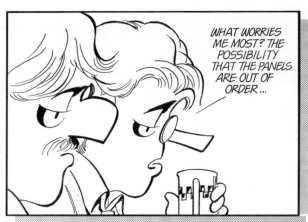

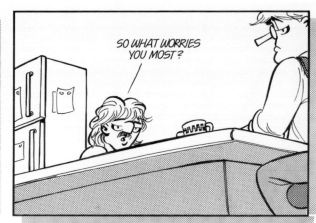

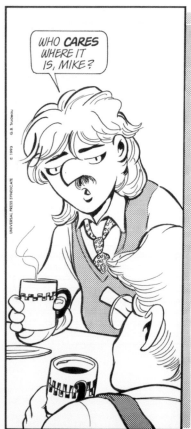

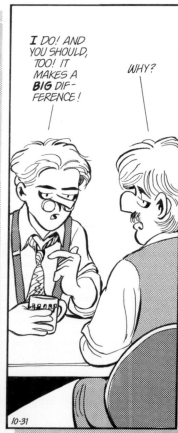

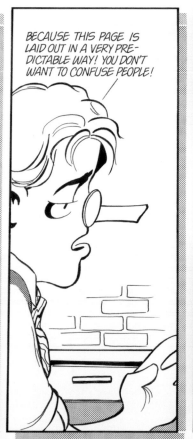

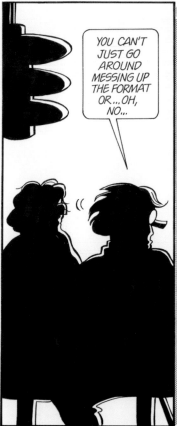

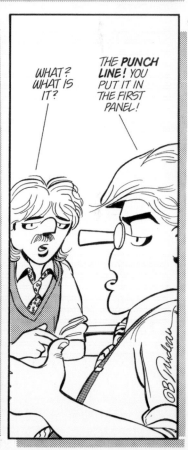

October 31, 1993. Messing with the panel layout.

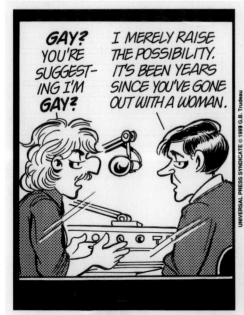

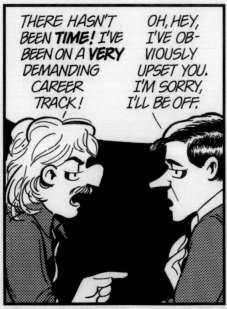

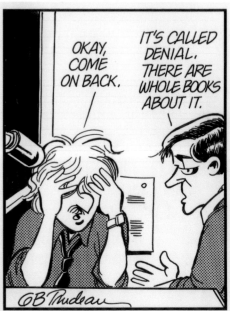

Doonesbury daily strip, September 2, 1993. Mark was questioned about his sexual orientation while on the air.

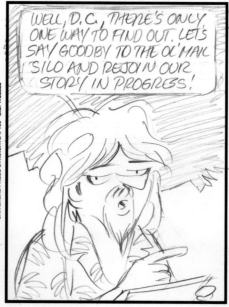

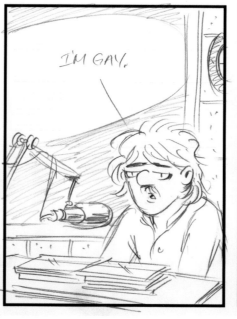

Pencil drawing, January 18, 1994. Four months later, Mark made a startling revelation.

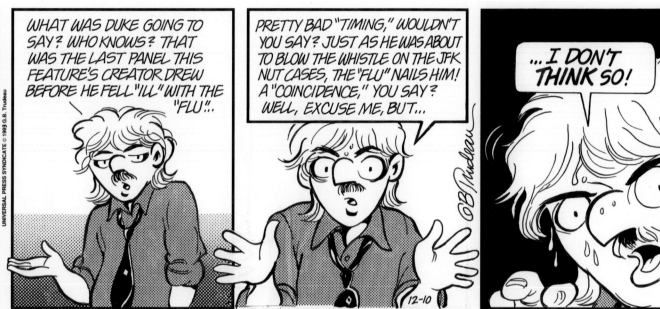

December 10, 1993. Was there a conspiracy to silence the author of the strip?

Pencil drawing, December 11, 1993. Two views of the JFK assassination.

Doonesbury Sunday page, August 14, 1994. Mike and Mark asked readers to help select an icon for President Bill Clinton.

Doonesbury daily strip, pencil drawing, August 22, 1994. The people's choice for Clinton's icon was a waffle.

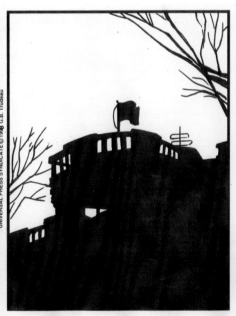
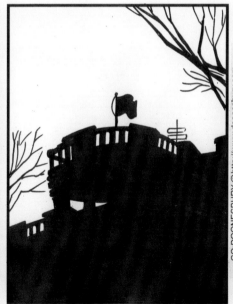
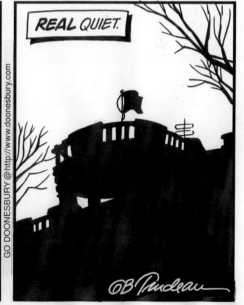

February 2, 1998. Trudeau portrayed the mood in the White House after the Monica Lewinsky scandal broke.

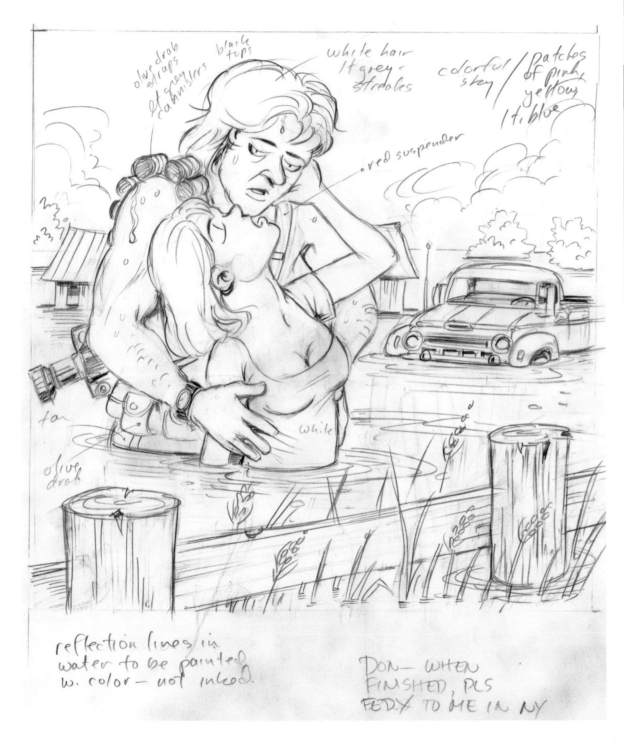

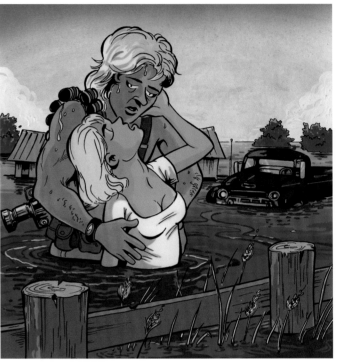

Washed Out Bridges and Other Disasters, pencil drawing and painting for book cover, Andrews and McMeel, 1994. A spoof of the wildly popular novel *Bridges of Madison County* by Robert James Waller.

What Is It, Tink, Is Pan in Trouble? painting for book cover, Andrews and McMeel, 1992. Zonker suffered from Peter Pan syndrome.

Doonesbury Nation, painting for book cover, Andrews and McMeel, 1995. Zonker went to Woodstock in an alternate alternative lifetime.

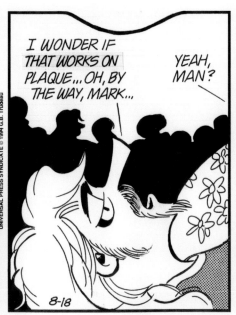

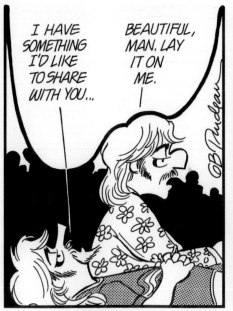

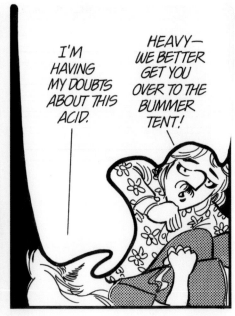

Doonesbury daily strip, August 18, 1994. While he was at Woodstock, Zonker took some bad acid.

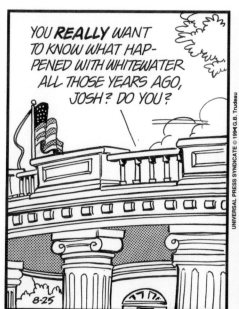

August 25, 1994. Zonker's acid flashback interrupted Clinton's Whitewater revelation.

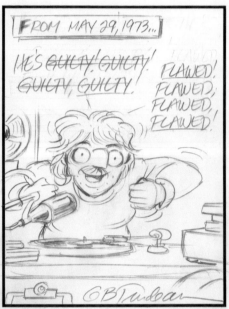

Pencil drawing, May 9, 1994. Revisionist history of the Nixon years.

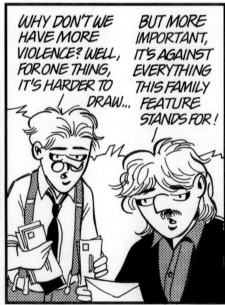
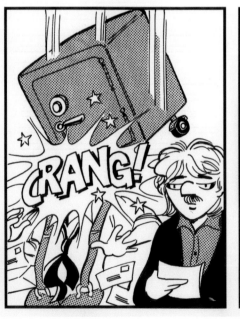
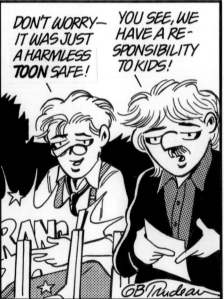

January 7, 1995. A little cartoon violence never hurt.

Doonesbury Sunday page, November 20, 1994. A screen saver is needed.

Newsweek, pencil drawing and painting for cover article, "The Overclass," July 31, 1995.
This was perceived as the next stage beyond yuppie for Baby Boomers.

Doonesbury Flashbacks: 25 Years of Serious Fun, CD-ROM package design
by George Corsillo for Mindscape, 1995.

The Doonesbury Election Game: Campaign '96, package design
by George Corsillo for Mindscape, 1995.

Doonesbury Town Hall, drawings for Web site, ca. 2000. The first *Doonesbury* Web site was designed by Mindscape and launched in December 1995. It was overhauled when the site moved to Andrews McMeel's digital division, uclick, in 1998. Numerous modifications, redesigns, and upgrades have been made since, always with Trudeau's detailed design involvement. The Walden Commune house, shown in seasonal variations, welcomed Web surfers to the home page.

ZONKER / FRISBEE ANIMATION
MODEL SHEET # 1

ZONK ENTERS FRAME IN PROCESS OF LAUNCH

ZONKER / FRISBEE ANIMATION
MODEL SHEET # 2

EYE CLOSED AT MOMENT OF CONTACT

interior circles rotating to create spinning illusion

FULLY EXTENDED AT MOMENT OF CATCH

ARMS IN CANINE POSITION

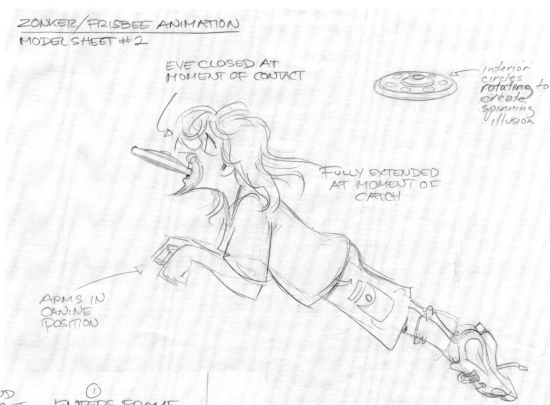

② "FWAP" SOUND AS HE NAILS IT.

① ENTERS FRAME AT MOMENT OF TAKEOFF

③ EXTENDS HANDS TO BREAK FALL, TUCKS HEAD AND SOMERSAULTS OUT OF FRAME

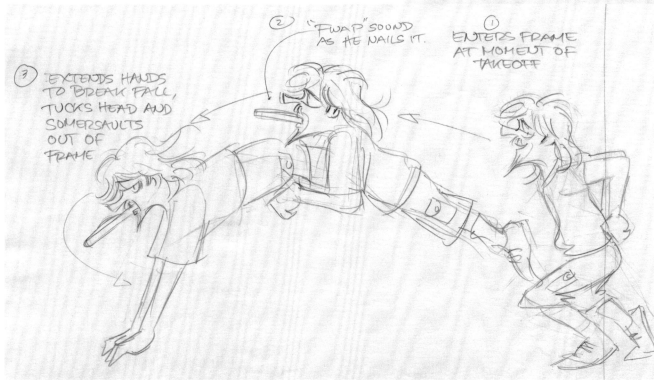

Doonesbury Town Hall, pencil animation drawings for Web site, ca. 2000. Zonker set the summer theme by catching a Frisbee in a short Flash animation sequence.

DAILY DOSE

THE CAST

DOONESBURY @ 30

MULTIMEDIA

CONTROVERSIAL STRIPS

TIMELINE

YALE STRIPS

STRAW POLL

E-GREETINGS

CASTMASTER

ASK DUKE

Doonesbury Town Hall, pencil drawings for Web site, ca. 2000. Trudeau drew twenty-two icons that provided links to different areas on the site.

SOLITAIRE

JIGSAW PUZZLES

DAILY BRIEFING

GET INVOLVED

ABOUT DTH

CONTACT DTH

BOOKS

POSTERS

FREE STUFF

SUITABLES

REVISED ROLAND

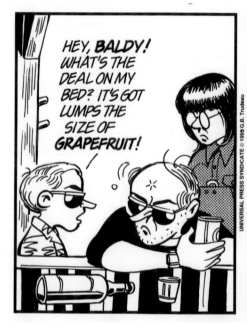

Doonesbury daily strip, April 12, 1995. Duke met his illegitimate son Earl for the first time when he was running a cost-efficient orphanage with Honey.

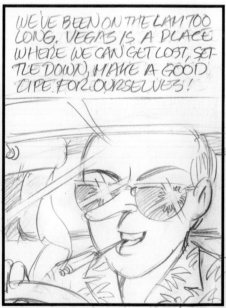

Pencil drawing, December 4, 1995. Duke and Earl bonded during a trip to Las Vegas.

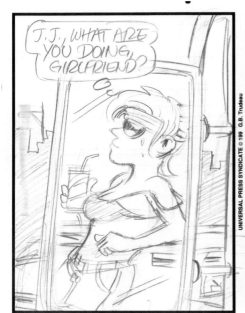
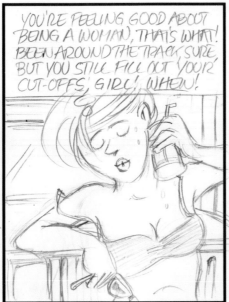
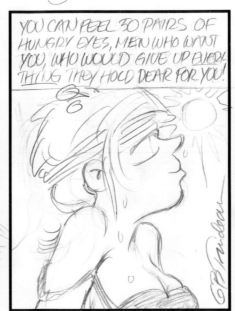
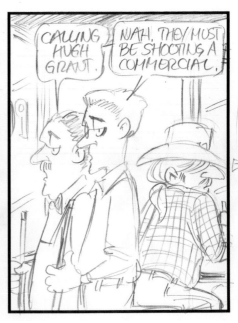

Pencil drawing, July 12, 1995. J.J. rediscovered her hot side after she ran off with Zeke Brenner.

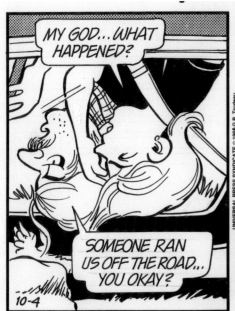
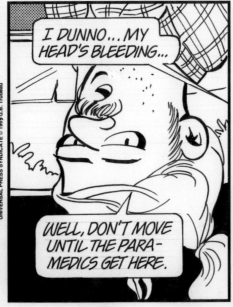
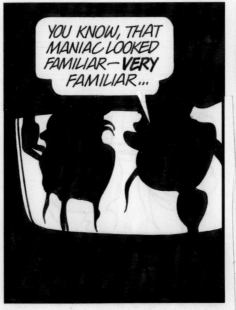
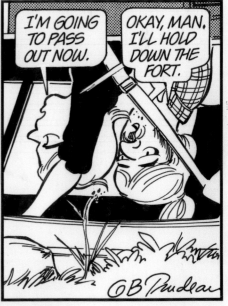

October 4, 1995. Things turned topsy-turvy when Zeke and J.J.'s pickup truck
was run off the road by Duke and Earl.

February 8, 1996. Mike met computer whiz Kim Rosenthal while working in marketing at
Bernie's Byte Shack, a Seattle software firm.

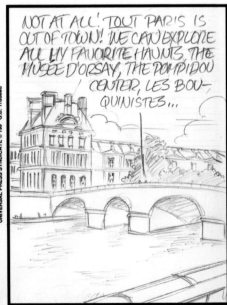

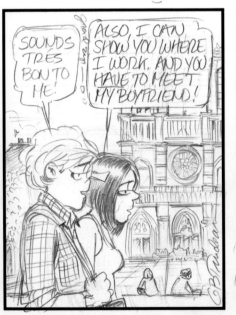

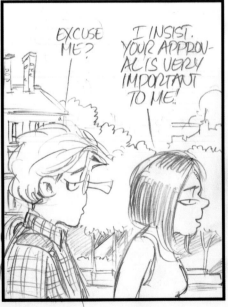

Pencil drawing, August 7, 1996. After Kim was hired by another company and
moved to Paris, Mike made a surprise visit.

Doonesbury Sunday page, October 6, 1996. Kim returned to Seattle.

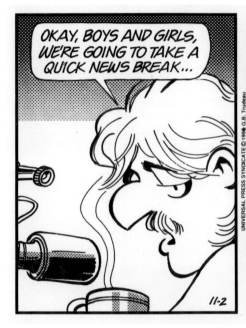
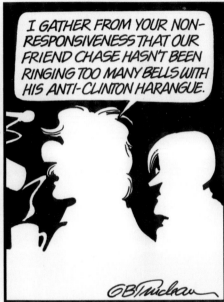
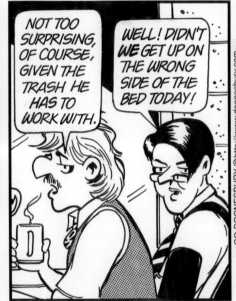
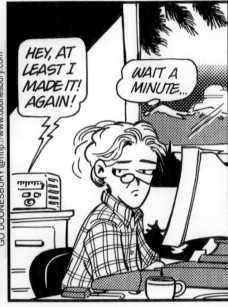

Doonesbury daily strip, November 2, 1996. Mike suspected that Chase might be more than just a guest on Mark's radio show.

Pencil drawing, July 7, 1996. B.D. visited his old friend Phred in Vietnam. This story was done after Trudeau made a trip to Southeast Asia in 1996 while doing research on a screenplay he was writing, based on the book *The Tunnels of Cu Chi*.

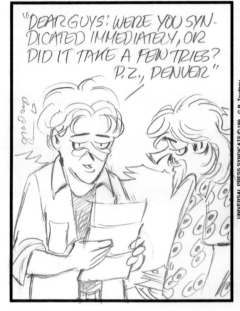
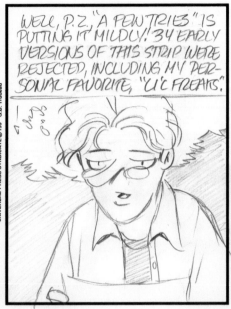

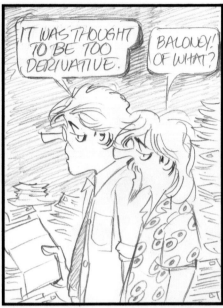

January 9, 1997. Aspiring cartoonists have been known to send "copy-cat strips" to the syndicates.

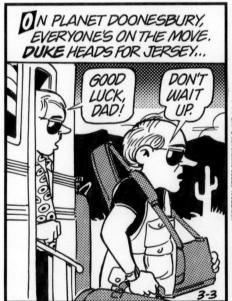
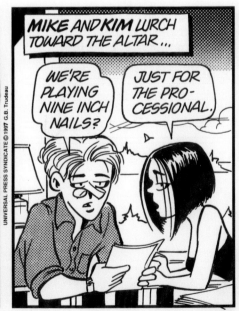
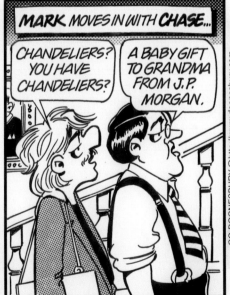
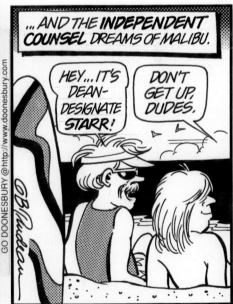

March 3, 1997. An update on the inhabitants of "Planet Doonesbury."

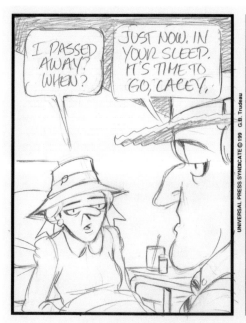
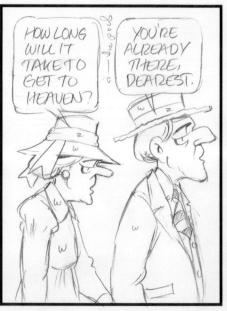
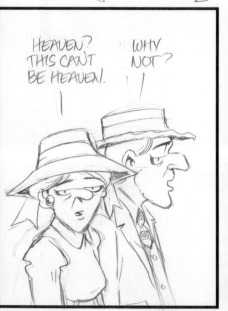
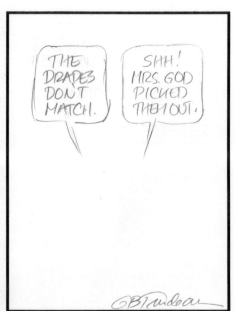

Pencil drawing and finished strip, August 15, 1998. Lacey fades away with the help of gradated screens.

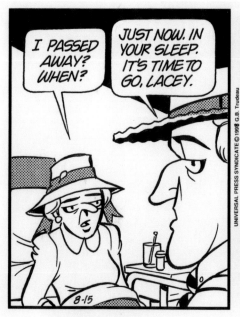
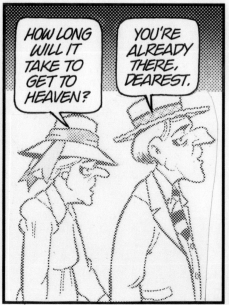
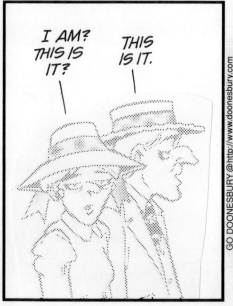
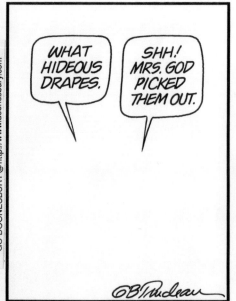

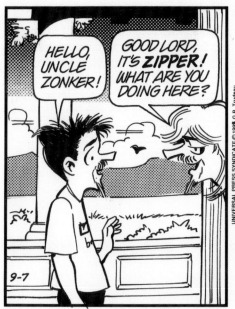

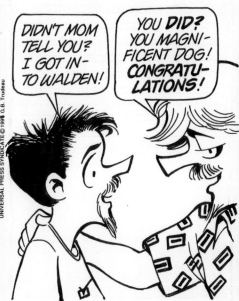

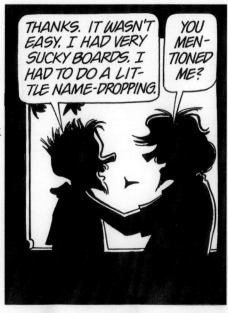

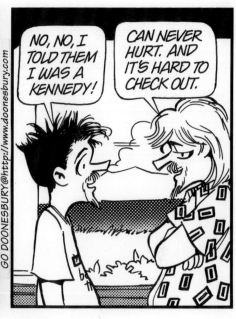

September 7, 1998. Zipper followed in the footsteps of his Uncle Zonker.

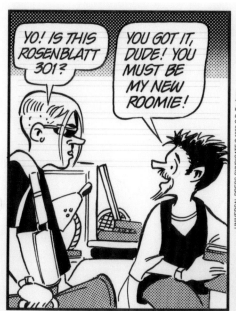

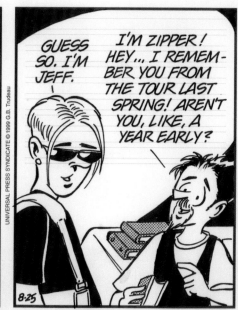

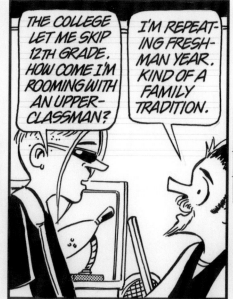

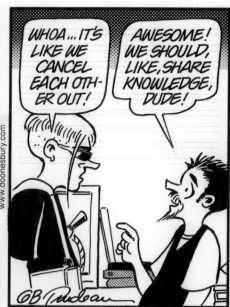

August 25, 1999. Zipper met his new college roommate, Jeff, the son of Joanie and Rick.

Collaborator:
George Corsillo

George Corsillo has worked with Garry Trudeau for almost twenty-five years, and says of the collaboration, "He's the best art director I've ever had." The two speak the same language, which is not always true with Corsillo's corporate clients. "It's like we can use our own shorthand," says Corsillo. "He'll start to say something and I'll think, 'Yes, that's exactly what I was thinking.'" Together they have designed *Doonesbury* posters, stamps, apparel, books, figurines, lampshades, trading cards, buttons, pins, mugs, coasters, mailing labels, and Web sites.

Corsillo was born in Hartford, Connecticut, on February 23, 1950. He attended mostly Catholic schools and majored in graphic design and film at Pratt Institute from 1968 to 1972. Between 1974 and 1977 he worked as an assistant to the designer Paul Bacon, whose credits include book jackets for *Catcher in the Rye, Ragtime*, and *Jaws*. In 1977 Corsillo and his wife, Susan McCaslin, a fine artist he met at Pratt, moved to Los Angeles, where he started working for Gribbit! Design studio. He was soon specializing in album art and did covers for Bob Dylan, Jefferson Starship, the Village People, and the movie soundtrack album of *Grease*.

In 1980, after the birth of the first of their three children, Corsillo and McCaslin moved back east to Connecticut. At first, Corsillo managed an office in New York City for Gribbit! but eventually opened a studio with design partner Patti Manzone. He focused on doing book jackets for most of the major publishing houses and continued to create album covers as well.

Among his many high-profile projects were the jackets for Bret Easton Ellis's *Less Than Zero* and Larry McMurtry's *Lonesome Dove*.

In the mid-1980s, Robert Reed at Henry Holt and Company hired Corsillo to design a cover for a *Doonesbury* book collection. Soon after, Trudeau called and asked Corsillo whether he would be interested in working on a *Doonesbury Desk Diary* that Holt was publishing. "The rest is history," chuckles Corsillo. After that, "anytime Garry wanted graphic design, he would come to me." The first time he visited the *Doonesbury* studio, Trudeau showed him a closet filled with old rubber stamps, coupons, mailing labels, magazines, and print ephemera, and Corsillo knew he had found a kindred spirit.

In 1988 Trudeau asked Corsillo to design a poster for Sally's Pizza, a New Haven establishment that Trudeau frequented during his Yale years. "I did this sketch of Zonker throwing a pizza," Corsillo remembered. "It came back to me from Garry and this little spark of an idea had been elaborated into an incredible drawing." The retro-style poster established a look that they would adapt to many future projects.

During the 1980s Corsillo continued to work for other clients and developed long-term art direction relationships with John Cougar Mellencamp and Luther Vandross. He received a best LP jacket Grammy nomination in 1984 for the Yoko Ono tribute album *Every Man Has a Woman* and also designed the logo and poster for the 1985 Grammy Awards.

In the late 1980s Corsillo was in Los Angeles doing an album cover for Vandross when one of his friends showed him some business cards and custom-made stamps that had been printed by letterpress. According to Corsillo, "When I came back from L.A. and showed these to Garry, I said, 'Wouldn't it be great if we did *Doonesbury* postage stamps?' To my surprise Garry said, 'Let's go,' and we ended up doing *The 1990 Doonesbury Stamp Album*."

Published by Viking Penguin, the *Stamp Album* was a labor of love for both Corsillo and Trudeau, who collaborated on the project for more than a year. It featured elegantly designed faux postage stamps and labels, as well as a double-page center spread map of "Doonesbury's U.S.A." It was one of

the last design jobs Corsillo did as a paste-up mechanical. "Things were cut out by hand and glued or waxed to a board. It would be so much easier to do now with Photoshop or Illustrator," notes Corsillo. At one point Trudeau jokingly asked, "What are you making, like fifty cents an hour?" They both agreed that the finished product was worth the elaborate effort they had put into it.

The next project gave them the opportunity to design T-shirts, hats, neckties, mugs, and buttons, as well as printed items, for the Museum of Natural History. These were sold in the museum's gift shop to raise money for the renovation of Museum Park. Trudeau did drawings of Zonker playing with a variety of realistically rendered dinosaurs, which were reproduced on note cards, shirts, and shopping bags. Corsillo worked with a fashion consultant to select a color palette for the clothing items, one that anticipated the upcoming seasonal trends. These were the first commercially available *Doonesbury* products, other than books and calendars, that Trudeau had licensed.

Corsillo designed most of the wearables—T-shirts, patches, and buttons—for *The Great Doonesbury Sellout*, which followed in 1991. During the mid-1990s, he also worked on The Doonesbury Game and the packaging for three CD-ROMs produced by Mindscape. Although initially not adept with technology, Corsillo purchased his first Macintosh computer in 1991 and assisted with the design and color choices for the *Doonesbury* Web site.

In the late-1990s, a friend of Trudeau's encouraged him to seek new opportunities to license his characters for charitable causes. It was eventually decided that Starbucks would be a good fit for this purpose because the company was one of the major donors to CARE. Corsillo and Trudeau worked up a presentation with designs for T-shirts, mugs, and other items, and Starbucks enthusiastically agreed to produce a line of *Doonesbury* products that would be sold in a select group of their outlets. This program lasted for two years and raised more than $1 million to promote literacy.

"That project allowed us to do a lot of unusual, creative, interesting things," Corsillo remembered. Cindy Clarke from Starbucks was instrumental in finding ways to manufacture the products that Corsillo and Trudeau would design, making sure that they weren't produced in sweat shops that violated child labor laws—a major concern for Trudeau. Six distinctive posters established the motif for corresponding lines of mugs, tumblers, and coasters. "Java Pipeline" depicted Zonker with a surfboard in an Easter Island setting and introduced the slogan "Catch the Foam." "Le Tour de Java" was inspired by Toulouse-Lautrec and featured Mike and Kim in front of the Eiffel Tower sipping coffee at Café Buzz. "Sands of Java" showed Duke on a camel "Hauling Beans from the Edge of Madness," with Moroccan minarets in the background. "Monte Grande" starred B.D. and Boopsie skiing in the Alps. A "Jazz Festival" poster had Duke tickling the ivories and Zonker blowing sax. "Duke for Prez 2000" was printed on a simulated bag of peanuts.

One of the items in the "National Parks"–themed line was a "*Doonesbury* Wilderness Wristwatch" that unfortunately never made it past the prototype stage. Reyn Spooner manufactured an authentic, custom-designed Hawaiian shirt with Zonker and Duke incorporated into the pattern. Other products included three collectible figurines, two sets of playing cards, and a one hundred percent woven silk crepe de chine necktie. Corsillo said, "It was great to work with a company that had such amazing resources."

The Starbucks campaign gave Corsillo an opportunity to experiment with new techniques, like posterizing photographs on the computer, which led directly to the next area of collaboration. In 2001 Trudeau proposed that he take over the coloring on the *Doonesbury* Sunday pages. At first he was hesitant, since this required an ongoing weekly commitment, but eventually he agreed to accept the challenge. One of the first pages he colored was a moving scene of Ground Zero, with tangled girders and acrid smoke in the background. Since that time he has featured many visual innovations in the *Doonesbury* Sunday pages, including limited complementary color schemes, gradated shading, custom-designed clothing patterns, and changing logo art. Trudeau encouraged Corsillo to innovate so that he would be stimulated by a task that could otherwise become tedious. "If you look at those pages that George does," Trudeau explained, "there is always a guiding color idea on every Sunday—it's not a paint by numbers. I can't wait to open them up when he sends them to me."

Corsillo continues to collaborate with Trudeau on book and magazine

covers, posters, and other special assignments. "Whenever I send him a design for approval," Corsillo claims, "he'll call me back and say, 'Let's change this' or 'Let's change that.' As a designer you usually don't want to change anything because you think that your idea is great, and you dig your heels in. But whenever Garry does it, it comes from such an intelligent place that it always makes it better. Always. It's fascinating to me how it works, and I think it's because we fundamentally think alike as designers."

In 2002 Corsillo and McCaslin started their own design company, Design Monsters, and their brochure declares, "We try to outrageously exceed our client's expectations." They also try to find clients who allow them to have fun, a philosophy which is the secret to the success of Corsillo and Trudeau's collaboration. "I'm still a kid coloring in my coloring book," says Corsillo, and Trudeau describes the weekly Sunday pages that Corsillo sends him as "presents." Corsillo sees it as a mutually beneficial relationship. "If I can keep sending him presents and he lets me keep playing in the *Doonesbury* playground, I can't imagine anything better than that."

Doonesbury mailing label, one of George Corsillo's favorite designs, 2004.

G. B. Trudeau business card, designed by George Corsillo, 2000s.

Color swatches. In 2001, when Corsillo took over the coloring of the *Doonesbury* Sunday pages, he made a chart to remind himself to use "dirty" colors.

Doonesbury@Starbucks, Java Pipeline poster, 1998–2000.
David Stanford came up with the phrase "Surf ergo sum"
for this line of products.

Doonesbury@Starbucks, Monte Grande poster, 1998–2000.
The series was styled after vintage European travel posters.

Doonesbury@Starbucks, Sands of Java poster, 1998–2000.
Photographs were "posterized" to add a real-world dimension.

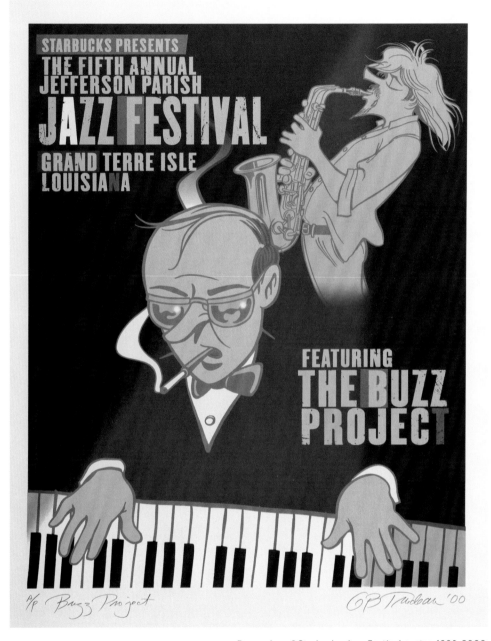

Doonesbury@Starbucks, Le Tour de Java poster, 1998–2000.
Don Carlton used an unusually heavy line to simulate the style of Toulouse-Lautrec.

Doonesbury@Starbucks, Jazz Festival poster, 1998–2000.
A New Orleans vibe set the tone.

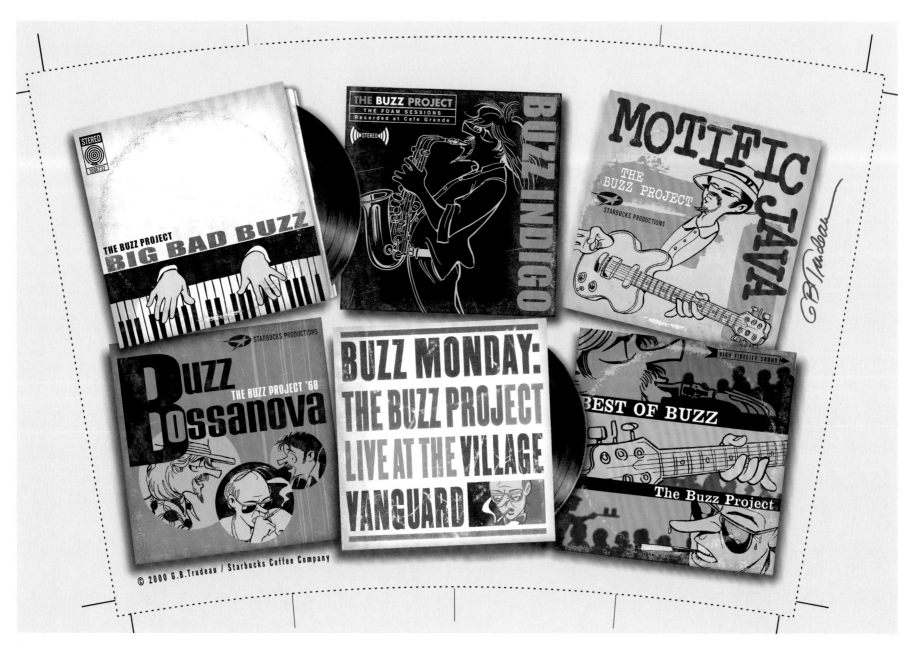

Doonesbury@Starbucks, Jazz Festival tumbler, 1998–2000.
Graphics inspired by classic jazz albums. Copy by David Stanford.

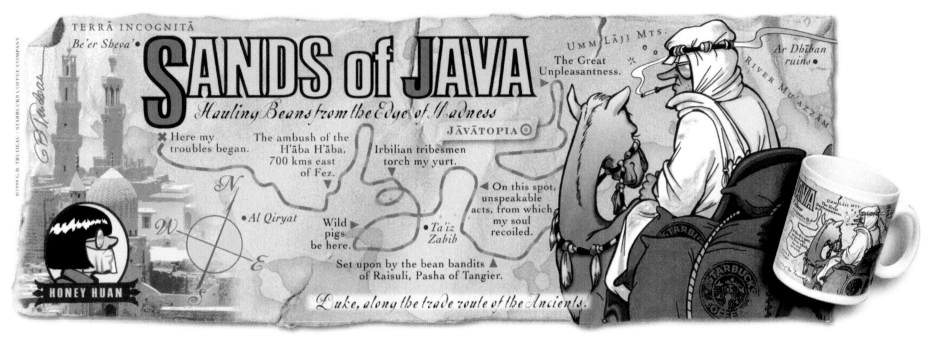

Doonesbury@Starbucks, Sands of Java mug, 1998–2000.
Wraparound images were created for the coffee mugs.

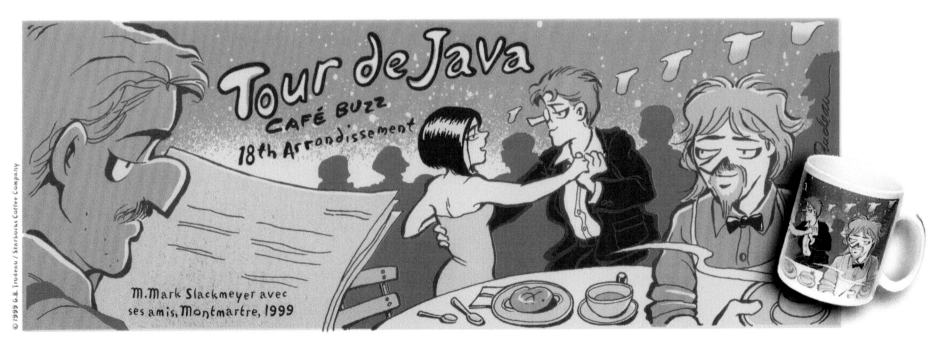

Doonesbury@Starbucks, Tour de Java mug, 1998–2000.

Doonesbury@Starbucks, Aero Espresso figurine, 1998–2000.

Doonesbury@Starbucks, Java Pipeline figurine, 1998–2000.

Doonesbury@Starbucks,
Duke's Hi-Test Java figurine, 1998–2000.

Doonesbury@Starbucks, Silk "postcard" necktie.

Doonesbury@Starbucks, Doonesbury Wilderness Survival Wristwatch, 1998–2000.
Fossil was going to manufacture this watch, but it never made it past the prototype stage.

Custom Reyn Spooner label.

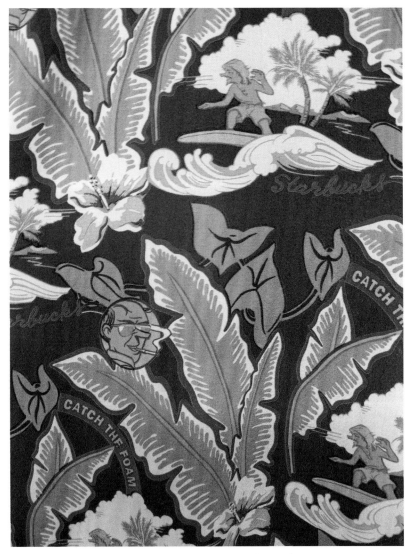

Faux vintage Hawaiian pattern designed by Trudeau and George Corsillo.

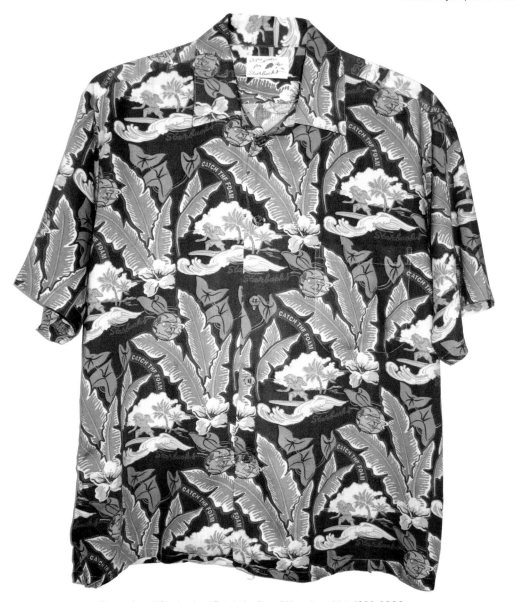

Doonesbury@Starbucks, "Catch the Foam" Hawaiian shirt, 1998–2000.
Reyn Spooner made classic shirts with a custom-designed pattern.

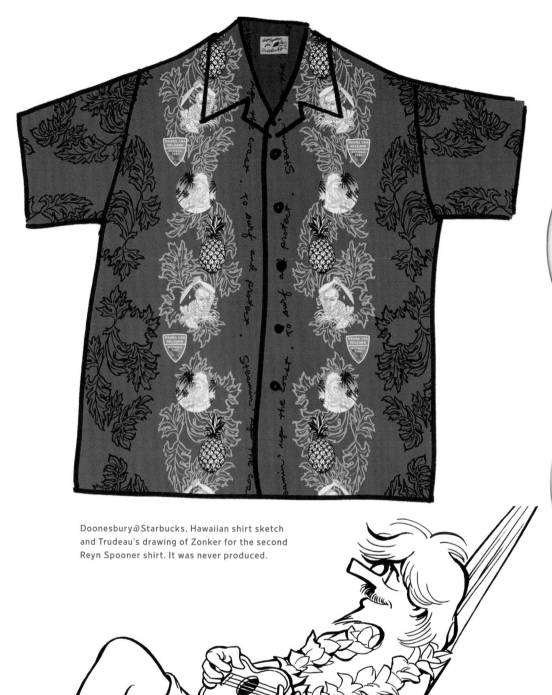

Doonesbury@Starbucks, Hawaiian shirt sketch and Trudeau's drawing of Zonker for the second Reyn Spooner shirt. It was never produced.

Doonesbury@Starbucks, Ceramic coasters, 1998–2000. Susan McCaslin did woodcuts from Trudeau's drawings.

Doonesbury lamps with coordinated shades were custom-made for the members of Team Doonesbury, 2000. The lamp bases were made by San Francisco lampmaker Jim Misner.

The *See America* shade with retro inspired travel decals.

The *Casino* shade incorporates the Starbucks playing cards and Duke's *House of Cards* matchbook.

The Zonker *Reality Intern* shade recycles several previously used phrases and images.

Doonesbury@Starbucks, poker-size playing cards, 1998–2000.

Doonesbury@Starbucks, Duke for Prez playing cards, 1998–2000.

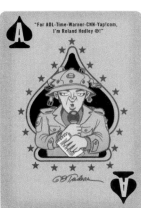

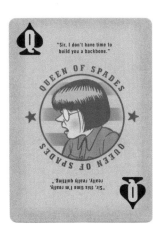

Doonesbury mailing labels designed by George Corsillo, 1992–2002. Trudeau moved out of this studio in 2009.

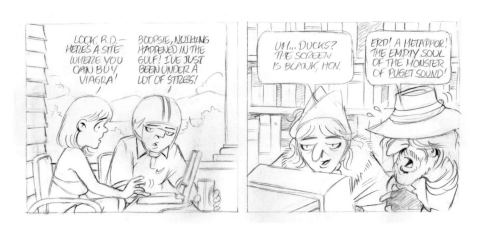

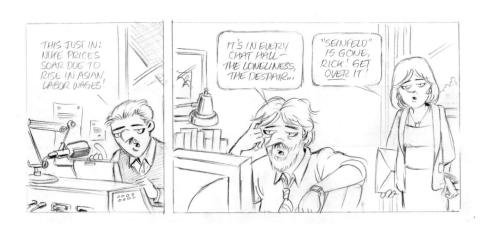

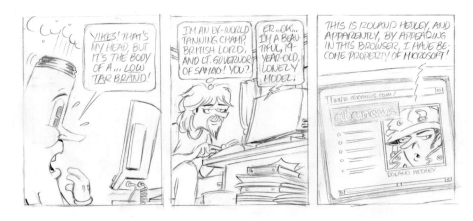

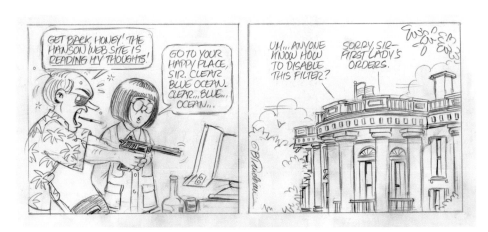

The People's Doonesbury, pencil drawings for an interactive, six-part, online comic strip hosted by Amazon.com, 1998. Contestants sent in dialogue for each installment.

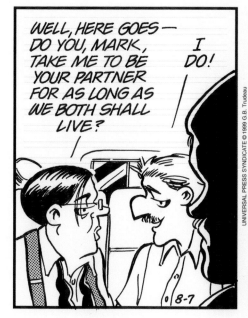
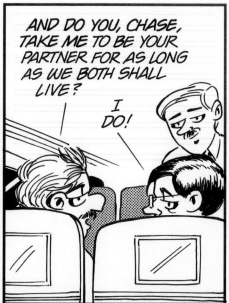
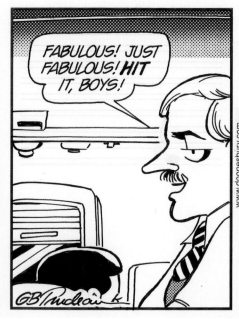
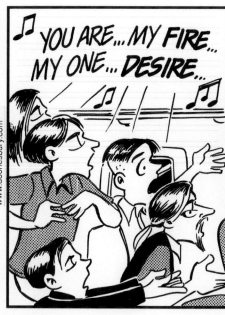

Doonesbury daily strip, August 7, 1999. Mark and Chase are serenaded by the Hanoi Gay Men's Glee Club after they exchanged wedding vows on a grounded airplane in Pago Pago.

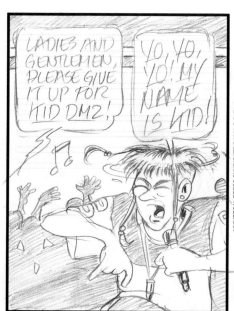
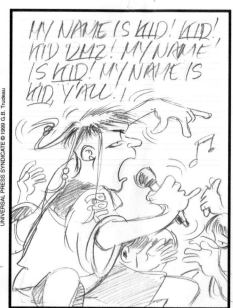
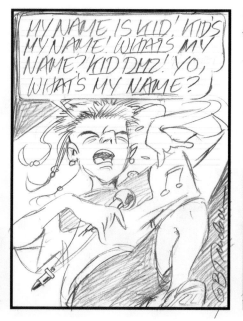
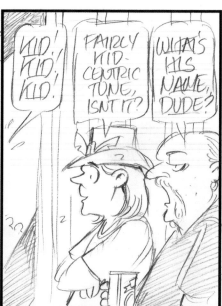

October 5, 1999. Jimmy Thudpucker produced a live NetAid concert from Saigon starring Kid DMZ, Frag Gurlz, and the Tet Boys.

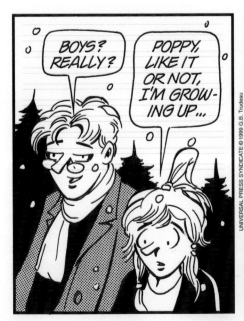

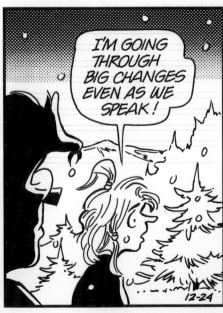

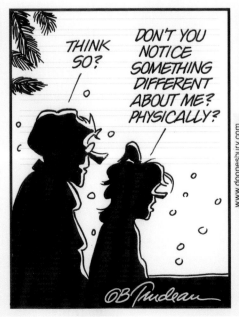

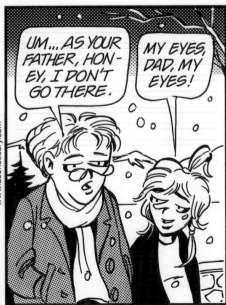

December 24, 1999. Mike's daughter Alex became a mature member
of the cast when Trudeau changed the way he drew her eyes.

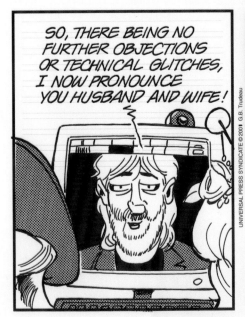

March 28, 2001. J.J. and Zeke's marriage was a pay-per-view Webcast to all of their
friends and family.

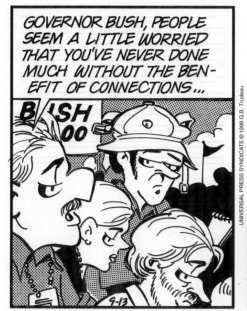

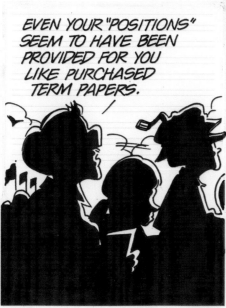

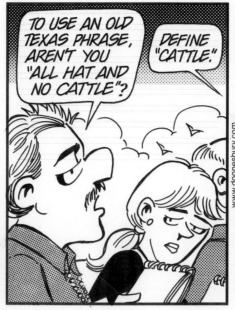

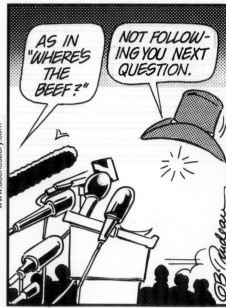

September 13, 1999. George W. Bush was represented by a point of light beneath an empty cowboy hat during the 2000 presidential election campaign.

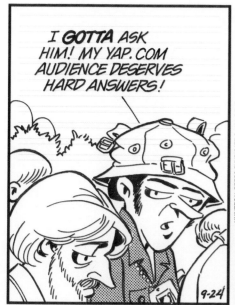

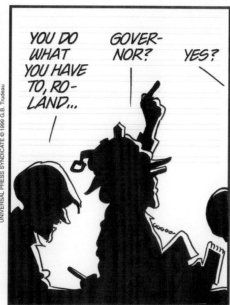

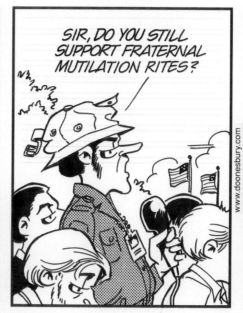

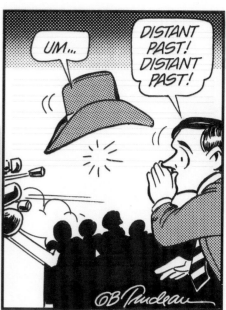

September 24, 1999. Roland Hedley brought up the old fraternity hazing incident during a Bush press conference.

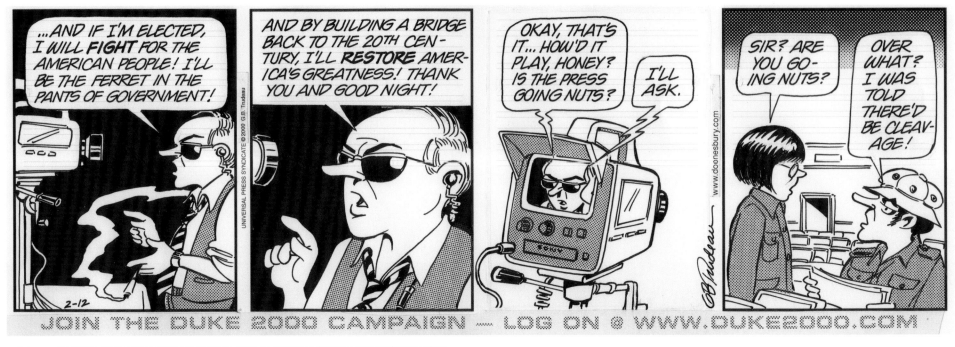

February 12, 2000. Duke nailed down his platform when he announced he was running for president.

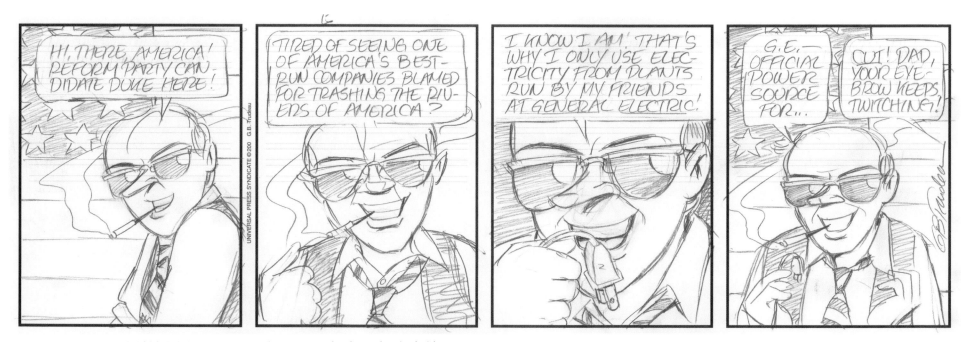

Pencil drawing, March 23, 2000. Duke's appearances in the strip were closely synchronized with the D2K computer-animated character's performances.

Newsweek, pencil concept drawings for cover article on "The New Middle Age," April 3, 2000.

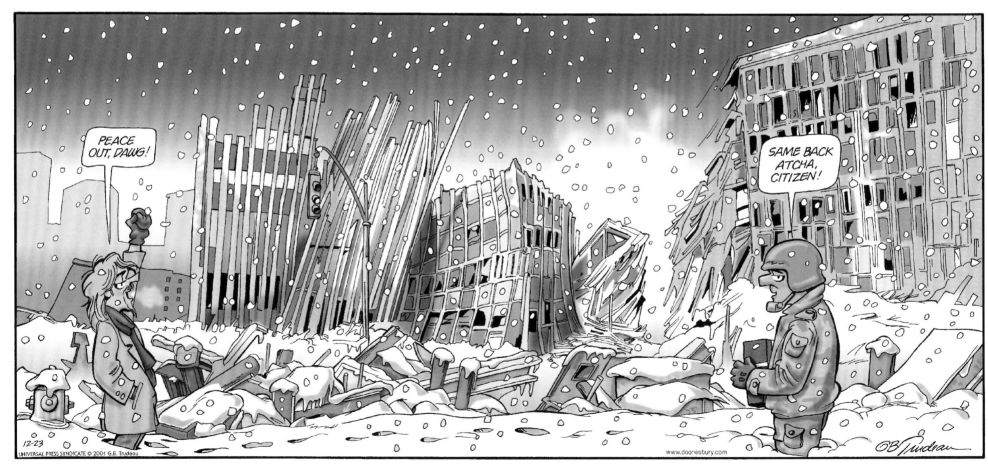

Doonesbury Sunday page, December 23, 2001. A moving scene of Ground Zero, the site of the 9/11 terrorist attack. This was one of the first pages that George Corsillo colored.

STILL A WORK IN PROGRESS

The major events of the early twenty-first century—the disputed presidential election of 2000, the terrorist attack of 9/11, the war in Iraq—presented Garry Trudeau with new creative challenges. He responded by raising the level of writing and character development in his strip. Unfortunately, the newspaper business was also changing. "Trudeau's greatest work is coming at a time when *Doonesbury* is fading a bit from the national consciousness," noted Gene Weingarten in the first major profile of the cartoonist since the start of his career. "He's still in six hundred newspapers, but that number has been higher; there simply aren't as many newspapers as there once were, and their readership is dwindling."

The George W. Bush administration provided Trudeau with ample ammunition for a rejuvenated satirical assault. "Cartoonists already look back on the Bush years as something of a golden age, every bit the equal of Watergate. The president was a satirist's dream. The cocky persona, the mangled syntax, the prideful ignorance—there was a lot to work with. Too much, actually; I almost stopped writing about other subjects. It was clear early on Bush was taking us over a cliff, and I said so. There was no pleasure in being proven right. It was, in my view, the most harmful presidency in our history."

Early in the 2000 presidential campaign, Trudeau caricatured Bush as a point of light beneath an empty cowboy hat, riffing on the old Texas put-down that the candidate was "all hat and no cattle." When the Supreme Court decided the election in Bush's favor, he changed the point of light to an asterisk, representing the "footnote to history" that will always be attached to the circumstances of Bush's victory. After America invaded Iraq on March 20, 2003, the cowboy hat was replaced by a Roman Legionnaire's helmet, which became increasingly battered as the war dragged on. In 2004 Trudeau offered a $10,000 reward to any reader who could provide definitive proof that Dubya had actually shown up for National Guard service during the Vietnam War, a challenge that has not been met to this day. The money

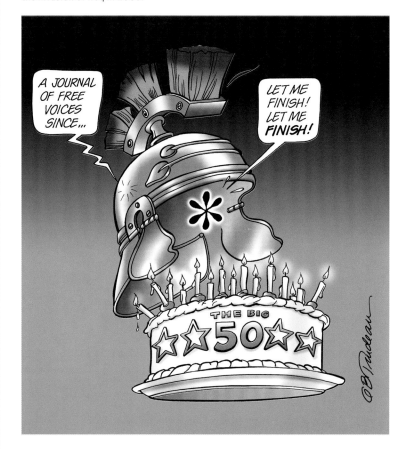

The *Texas Observer* cover art, December 3, 2004. Trudeau depicted George W. Bush as an asterisk beneath a Roman legionnaire's helmet after the invasion of Iraq in 2003.

Rolling Stone, "Doonesbury at War" cover story. August 5, 2004. In the introduction to his interview, Eric Bates described Trudeau: "Despite the flecks of gray in his hair, at fifty-six he has the easygoing, curious manner of a grad student still fascinated by the world around him."

was donated to charity. Trudeau revisited the old DKE fraternity hazing incident in a 2005 Sunday page that questioned Bush's policy on torture and in numerous strips chronicled the president's frequent malapropisms, word-for-word.

Some observers questioned the motivation for this intense focus on Bush and his many blunders. Kerry Soper, author of *Doonesbury and the Aesthetics of Satire,* speculated that Trudeau's public disapproval of the entire Bush clan might run deeper. "Perhaps because of having shared similar privileges and schooling experiences (all of the men attended Yale), Trudeau seemed to be more personally invested in these critiques," theorized Soper. "Indeed, it seemed at times as if he had a driving need to shame and discredit this family—as if he were trying to take down what he perceived as his conservative alter-egos."

Whatever his motives, Trudeau never argued that satire was fair. "There is no denying that satire is an ungentlemanly art," he once said in a speech. "It has none of the normal rules of engagement. Satire picks a one-sided fight, and the more its intended target reacts, the more its practitioner gains the advantage. And as if that weren't enough, this savage, unregulated sport is protected by the U.S. Constitution." In 1988 Bush Sr. fell into Trudeau's trap by lashing back at the cartoonist with the now-famous rant, "He speaks for a bunch of Brie-tasting, Chardonnay-sipping elitists." George Jr. did not make the same mistake; he never publicly commented on any of the *Doonesbury* episodes in which he was mentioned.

B.D. was called on to serve his country again during the war in Iraq, and when he left for active duty on February 10, 2003, he told Boopsie, "See you in five to seven years." Fourteen months later, the most harrowing episode in the long history of the feature began. On Monday, April 19, 2004, B.D.'s army buddy, Ray Hightower, called for a medic. The next day, Ray urgently told B.D., who had yet to be revealed, "You're not dying here, man! Not today!" In the following episode, B.D. was shown without his helmet for the first time ever, lying on a stretcher, with the lower half of his leg missing. Waking up in triage on Friday and discovering the extent of his injury, he yelled out, "Son of a bitch!" So began the eight-month tale of B.D.'s rescue, evacuation, recuperation, and eventual return to his family.

It wasn't until two years later, while in therapy for post-traumatic stress disorder, that B.D. put together the pieces of what had happened that day near Fallujah. When his armored vehicle was attacked by insurgents, the gunner opened fire. In a desperate attempt to escape and save his men, B.D. ordered his driver to take off through a crowded marketplace while the guns were still blazing. B.D. had been tormented by this gruesome episode ever since and blamed himself for the innocent civilians who had presumably been killed. By coming to terms with his repressed emotions, B.D. was finally on the road to recovery.

Trudeau had originally planned to have B.D. killed in this sequence, but his death would have been the end of the story. Having one of the major characters wounded seemed to create more possibilities, but he wasn't sure what would happen next. A few days after B.D. lost his leg, Trudeau received a call from the Department of Defense offering to help him with his research. "Before they had a clue where I was going with it," he recounted, "caregivers and patients all along the chain of medical treatment—from Landsthul to Walter Reed to the outpatient facilities Mologne and Fisher House to the Vet Centers—all generously met with me and walked me through the radically changed personal and social environment that amputees and post-traumatic stress disorder patients must negotiate."

This plotline presented another challenge—to tell the gripping story of B.D.'s recovery but also include some plausible elements of humor. "Not only did I still have the cartoonist's obligation to keep the strip entertaining," Trudeau allowed, "I also had to get the details right on an extremely sensitive subject. The last thing I wanted to do was contribute to the pain of the very people whose experiences I was trying to describe."

Although the conservative commentator Bill O'Reilly criticized Trudeau for "using someone's personal tragedy to advance a political agenda," most readers and critics agreed that he successfully mixed realism and humor in the story. When B.D. first talked to Boopsie on the phone from the hospital he tried to be upbeat about the loss of his leg: "Well, the good news is I'm finally down to my ideal weight." When B.D.'s daughter Sam gave a school report about how her father was wounded by a rocket-propelled grenade explosion, she downloaded a photo of an atomic bomb blast to use as a

The Long Road Home: One Step at a Time, book collection of strips spanning eight months of B.D.'s injury and recovery, Andrews McMeel, 2005.

The War Within, 2006, and *Signature Wound*, 2010, rounded out the trilogy of books that started with *The Long Road Home*.

visual aid. In the introduction to *The Long Road Home*, a book collection of B.D. strips that raised funds for Fisher House—the "home away from home" for families of wounded warriors—Senator John McCain commented: "Biting but never cynical, and often wickedly funny, these comic strips will make you laugh, reflect and—in the end—understand."

Trudeau was nominated for another Pulitzer Prize in 2004, but the award went to the political cartoonist Matt Davies. David Astor, who wrote in *Editor and Publisher* that "the *Doonesbury* creator did some of his best work this year," called for a comment. Trudeau conceded that all the bad news of the year was "good for business. For a satirist, it's always easier to get purchase in a time of conflict."

Around the time that B.D. was wounded, Universal Press Syndicate informed Trudeau of a new policy. He could no longer wait until the end of the day on Friday to deliver his strips. Since the late 1970s, Trudeau had followed a relatively consistent schedule. On Monday and Tuesday he would "front load," devouring newspapers, magazines, books, and cable news in the hope that some idea would "bubble up." Fortunately, it always did.

Mike Seeley, who started working as Trudeau's office manager in 1990, observed this process many times: "He works from a series of artist notebooks where he doodles, sketches, and writes out dialogue. They are pretty cool to look through. They hold a scrambled history of his thoughts for the strip as he goes week by week through them. While Fridays are particularly busy, I know he is thinking about content and story lines all during the week."

On Wednesday, Trudeau would finish his Sunday page, which had a longer lead time of five or six weeks and therefore had to be less topical than the daily strips. Thursdays and Fridays were for writing and drawing the six dailies. "I got that down to such a precise routine that I could have told you at any given minute on a Thursday afternoon or Friday where I needed to be," he explained. He rarely wrote the strips in order. "Out of necessity, I would take any acceptable idea that came to me—no matter where it was in the sequence—and reverse engineer the story to accommodate it. It's never been a linear process." By Friday afternoon he would be absorbed in a frenzy of writing, drawing, erasing, redrawing, and faxing fragments of strips so that

Don Carlton could get the final product to the syndicate by 5 P.M. The advantage to this schedule was that Trudeau had his weekends free to spend with his family.

The syndicate decided that they could no longer afford the overtime on Friday for their employees to process the strips and send them to the subscribing newspapers. Carlton had to deliver the finished dailies earlier in the day. "It completely disrupted a routine that had been in place for twenty-five years," Trudeau claimed. "I couldn't make the adjustment. The window would close before I'd finished, and Don would have to bring them in on Monday." Before long Trudeau had pushed the deadline to as late as Wednesday, five days before the first strip of the sequence was scheduled to appear in newspapers. No other syndicated cartoonist works on that tight a deadline.

Trudeau found this new schedule had a significant benefit: "The wounded warrior material created a new set of demands. There wasn't as much room for error, and it required a more nuanced, naturalistic approach. I needed to be able to sit with the writing, carefully shape it, not just fire it out the door. Flattening my schedule, eliminating the intense spikes of activity on Fridays, opened up the space for a more thoughtful process." He was now spending less time front-loading, because research tools like Google had streamlined the process, and more time writing. "The newer strips have more internal humor and character interaction," he says. "It's more challenging now, particularly with the new schedule, but the payoff is a richer experience for the reader."

Trudeau did his first sit-down television interview in thirty-one years when he taped two segments for Ted Koppel's *Up Close* that aired on December 3 and 4, 2002. The format appealed to him because "the conversations had this intimate, languid coffeehouse feel to them, and I became a huge fan. By the time they called to invite me on the show, I'd already decided that if I was ever to do a TV interview again, talking to Ted Koppel would be as good as it got." On the show, he shared a low-key, self-effacing assessment of his work with Koppel: "Mostly what I do is tell stories. It's only because I seem to have made my name on the political stuff that people associate me with rapid-response cartooning. Most of the time it's not. I'm writing about things that if not timeless, are certainly not time sensitive."

Sketchbook page, 2007. Trudeau's design drawing for the layout of his new home studio.

Two panels from a *Doonesbury* Sunday page, January 7, 2007, published three months after the launch of The Sandbox at doonesbury.com.

Two years later, on October 1, 2004, he did a similar face-to-face talk on Charlie Rose's PBS program.

On October 8, 2006, The Sandbox, a military blog for soldiers stationed in Iraq and Afghanistan, opened on the *Doonesbury* Web site. Service members were invited to send in comments, anecdotes, and observations from the front and were encouraged to focus on both the ordinary and extraordinary details of everyday life. "Duty officer" David Stanford, who screened and edited the flow of postings as they arrived, was overwhelmed by the response. In the introduction to the first book collection of dispatches, published in 2007, he wrote: "We were stunned by the volume of high-quality writing that came in—epic, detailed accounts of complex and grueling missions; thoughtful meditations, moving epiphanies; historical perspectives; and humorous vignettes. Many of our posters were clearly not only service members who were writing, but writers who were serving." Trudeau described The Sandbox as the Iraq War's first literary journal.

In the *Doonesbury* comic strip on March 2, 2009, the TV newscaster Roland Hedley, using the social networking service Twitter, sent a message to his followers: "About to scratch myself, stand by." At the same time, in the digital world, Roland was sending real tweets to more than 2,900 Twitter followers. Trudeau, who was the author of these microblog posts, recognized that some geeks made productive use of the technology but that "there are also vast numbers of users, including journalists, who are so smitten with the idea of a personal broadcasting system that the absence of meaningful content to broadcast doesn't seem to concern them." Although he admitted that he had fun tweeting, and a book collection of Roland's tweets was published in the fall of 2009, it became such a time drain that its future is in doubt.

Trudeau still hadn't come up with a presidential icon for Barack Obama in May 2009 when he did a series of White House exteriors with off-stage voices. In one strip Obama's aide repeated what a "comic rep" had walked them through the previous day: "They provide the art, you provide the words. Four panels and out—easy as pie." In the next panel Obama asked the aide, "Other presidents did this?" The aide responded, "From Nixon to Bush." In the last panel a worried Obama replied, "What if I'm not funny?" The aide reassured him, "They handle all that. Just be yourself."

As Trudeau approached the four-decade milestone of his comic strip career, members of the media weighed in on the long-term significance of his work. "*Doonesbury* has been America's Comic Strip of Record," proclaimed Scott Stossel in the *Baltimore Sun.* "A hundred years from now, readers could get a pretty good sense—a better sense, I'd wager, than from many contemporary history books—of the last three decades of American history by reading the Trudeau oeuvre."

From the world of academia, Kerry Soper, director of American Studies at Brigham Young University, wrote in 2008 that Trudeau is "arguably the premier American political and social satirist of the last forty years." Soper made perhaps the ultimate assessment of the cartoonist's contribution: "While many satirists seem to grow increasingly more misanthropic with age, Trudeau seems to have gone in the other direction—developing a stern but Horatian worldview that can condemn social evils and political stupidity without resorting to simplistic scapegoating, condescending caricature, or flippant mockery. Most comic strip artists lapse into stale complacency after they gain tenure on the comics page; Trudeau has remained alert and engaged, determined to keep his work relevant and resonant."

There were critics who claimed that *Doonesbury* had lost its relevance. Jesse Walker, in an article entitled "Doonesburied" that appeared in the July 2002 issue of *Reason* magazine, argued: "Trudeau's career arc mirrors the evolution of baby-boomer liberalism, from the anti-authoritarian skepticism of the 1970s to the smug paternalism of the Clinton years. In 1972 the strip was engaged with the world; in 2002 it is engaged with itself."

Trudeau admitted to Charlie Rose in 2004, "I can't believe they're letting me do this thirty-four years later. It's a tremendous privilege." He now finds himself among an elite group of veteran professionals in the comic strip business. In the early years of his career, college-aged cartoonists would occasionally ask for his advice, but Trudeau rarely hears from aspiring artists anymore. "I wish there were more artists to mentor," he sighed, "but all the really talented people I've encountered in recent years want to go into graphic novels or animation. Nobody sees comic strips as a viable profession anymore."

Although Trudeau has no plans to retire, he is concerned about the fate of the print media. "I don't think newspapers are going to be around in paper

My Shorts R Bunching. Thoughts? The Tweets of Roland Hedley, book collection of strips featuring "frontline micro-blogging from the self-anointed dean of Washington journotwits." Andrews McMeel, 2009.

Tee Time in Berzerkistan pencil sketch for book cover, 2009. A pariah state that borders Iran, Berserkistan is run by President-for-life Trff Bmzklfrpz.

Trudeau on a working vacation, 2009.

form much longer," he predicted in a recent interview. He speculated that a digital device, like a Kindle reader, combined with an economic model that required consumers to pay for content, in the same way that they purchase music for their iPods or applications for their iPhones, might save newspapers. "Our art form is inextricably dependent on newspapers; without them we're dead," he lamented. "Unless media outlets like the *New York Times* and the *Washington Post* band together and start charging on the cable model, I don't see a future for us."

Doonesbury will not be continued by another artist after Trudeau is no longer producing the strip. Similar to other personality-driven features that revolutionized comics in the 1970s, *Doonesbury* is closely associated with its creator. A "classic" approach, reprinting old strips in the same way that *Peanuts* is currently being syndicated, also would not make sense with *Doonesbury.* Episodes that were timely when they first appeared would seem dated if they were reprinted years later. Fortunately, Trudeau owns the copyright to the feature, so he is able to determine the future of his creation.

After forty years, Trudeau's sense of moral indignation still fuels his creativity, but it has been tempered by experience. "Satire works by inference. What you condemn should reveal what you value, what you stand for. That's why I don't like categoric, 360-degree attacks. Scorched-earth artists leave no room for hope."

"I'm the opposite of a cynic," Trudeau says with a smile. "I have a childlike faith in our better angels, and that sense of optimism informs the strip in every way. I really do believe we can get it right."

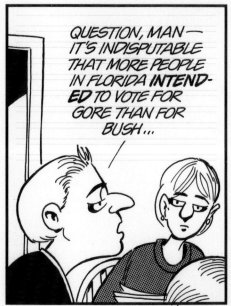
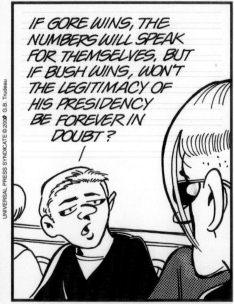
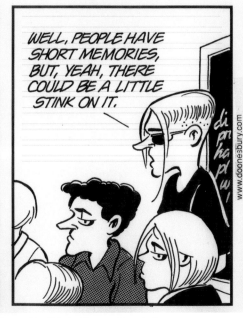
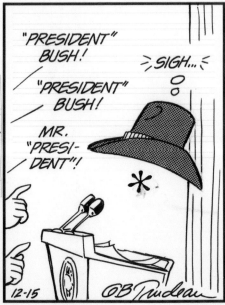

Doonesbury daily strip, December 15, 2000. The debate over the disputed Florida vote recount in the 2000 presidential election continued after Gore finally conceded to Bush on December 12, 2000. Trudeau replaced the point of light under Bush's cowboy hat with an asterisk.

December 21, 2001. Zonker brought a marijuana-laced fruitcake to B.D., who was working as a volunteer at Ground Zero.

June 8, 2002. During the Bush administration, Trudeau began rendering the South Facade of the White House in more dramatic perspectives. In this strip, President Bush was having a conversation with his press secretary, Ari Fleischer.

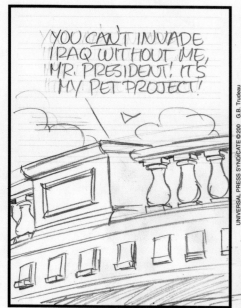
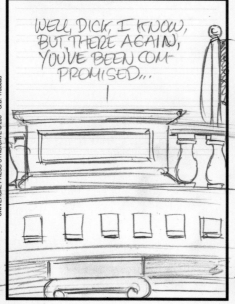
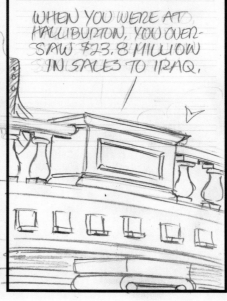
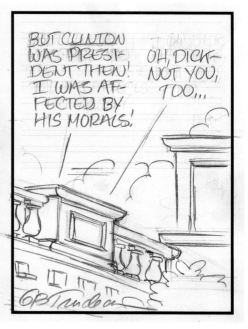

Pencil drawing, July 24, 2002. Bush and Vice President Dick Cheney discussed the invasion of Iraq, which began eight months later, on March 20, 2003.

October 29, 2002. Mark looked into the future of the conflict in the Middle East.

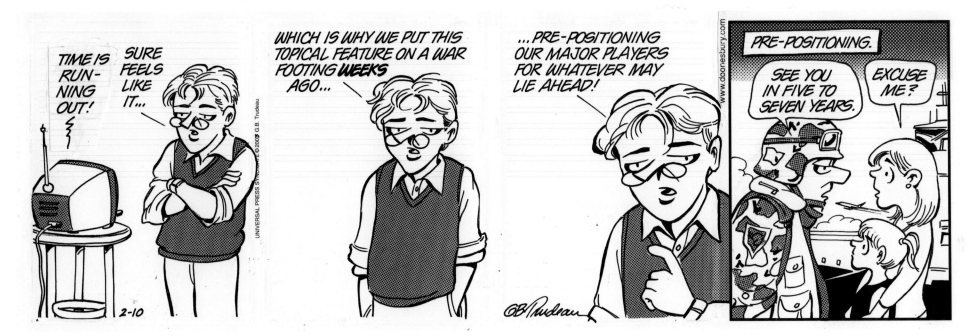

February 10, 2003. B.D. told Boopsie and Sam that his tour of duty in Iraq might last a long time.

Doonesbury Sunday page, February 17, 2002. Jeff Redfern discusses his C.I.A. training with Zipper. George Corsillo experimented with a limited color palette in the backgrounds.

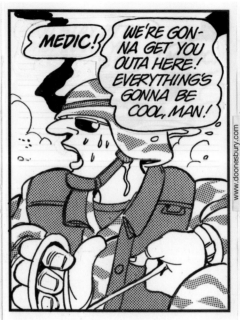

Doonesbury daily strip, April 19, 2004. B.D.'s buddy Ray Hightower came to his rescue.

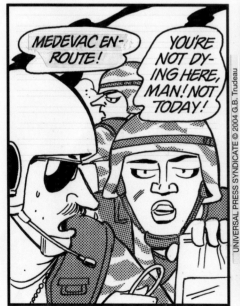
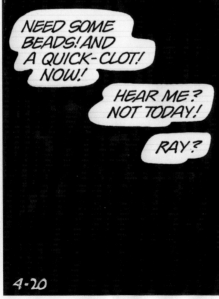
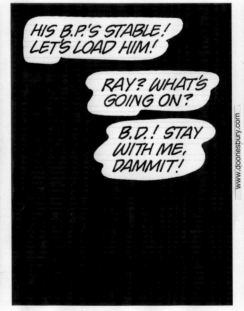
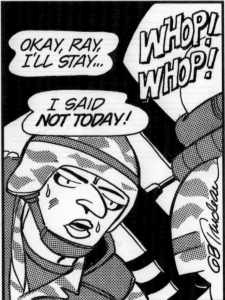

April 20, 2004. They waited until the Medevac arrived.

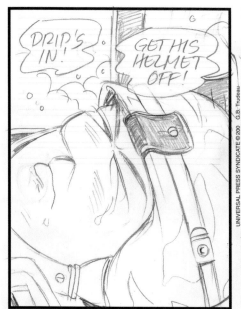

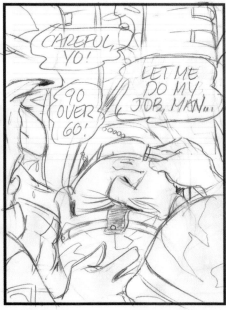

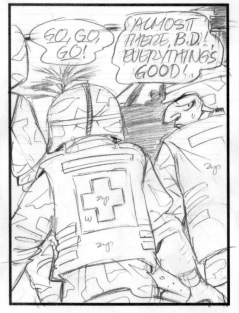

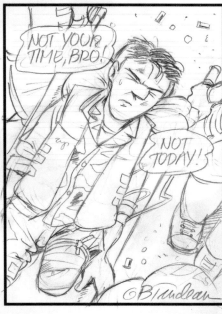

Pencil drawing, April 21, 2004. The first time B.D. ever appeared without his helmet.

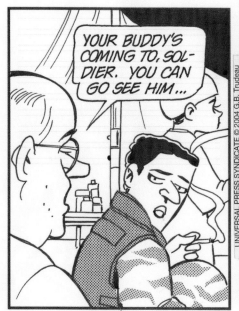

April 23, 2004. B.D. woke up in triage. This was strong language for the comics pages.

(left)
Rolling Stone, pencil drawing for cover,
August 5, 2004.
(opposite)
Rolling Stone, finished color artwork for cover,
Trudeau had to try several color combinations
before deciding how B.D.'s hair would look.
George Corsillo did the color in stages to see
how gory Trudeau wanted the scene to be.

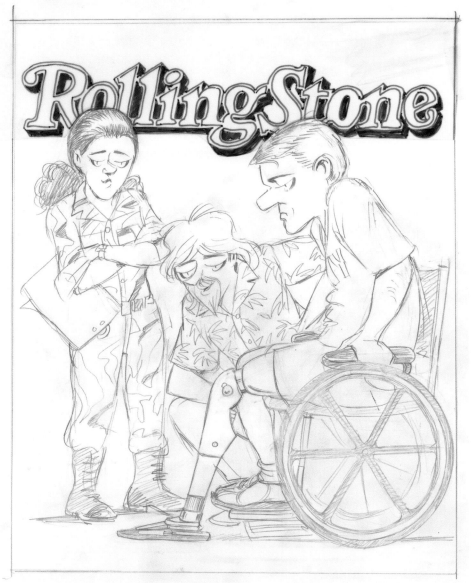

Rolling Stone, pencil concept drawing
for cover, unpublished.

Rolling Stone, pen-and-ink illustration for interior page
of article, August 5, 2004. This image was also used on
the cover of *The Long Road Home: One Step at a Time*, 2005.

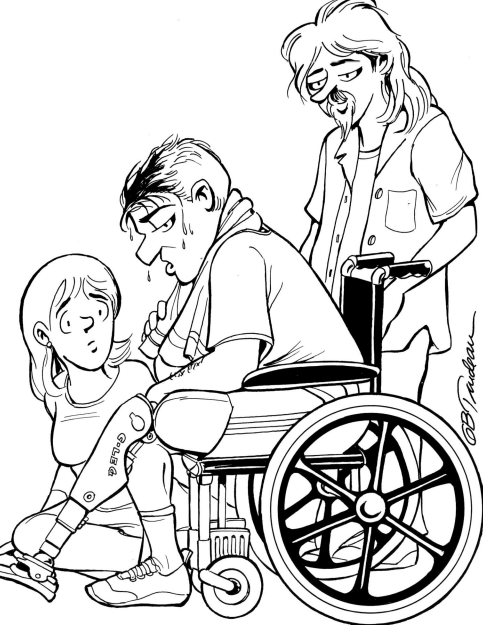

Doonesbury daily strip, pencil drawing, December 20, 2004. Zonker built a wheelchair ramp in preparation for B.D.'s return home.

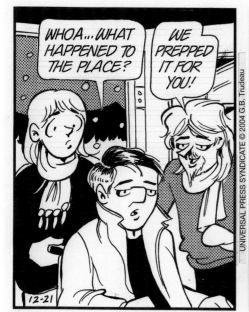
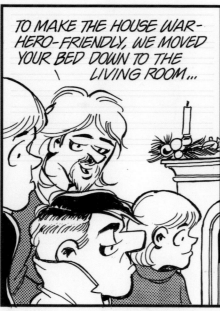
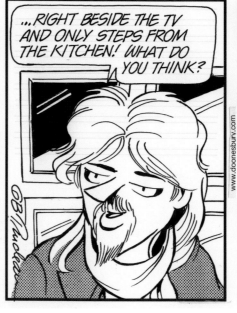
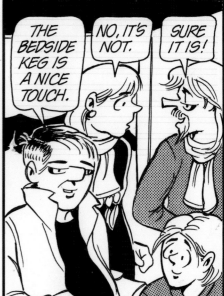

December 21, 2004. The wounded warrior discovered that other changes had also been made to his house.

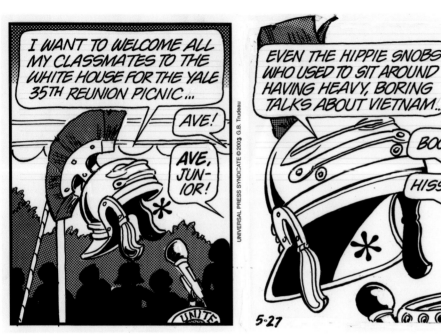

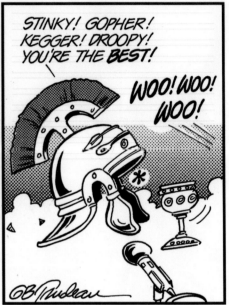

May 27, 2003. When the United States invaded Iraq, Trudeau swapped Bush's cowboy hat for a Roman legionnaire's helmet. Bush wore the new headgear to his Yale thirty-fifth reunion.

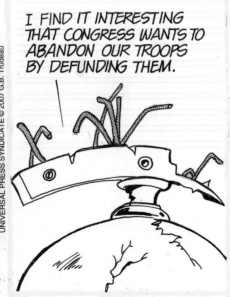
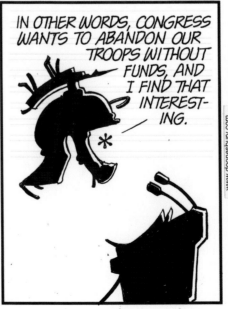
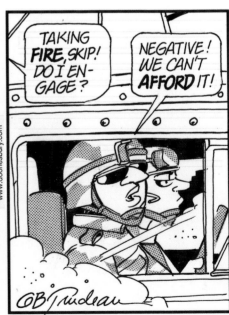

May 11, 2007. As the war dragged on, Bush's helmet became more beaten and battered.

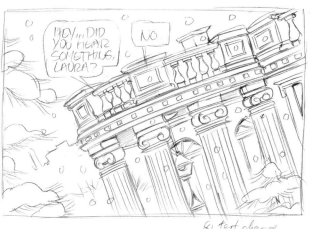
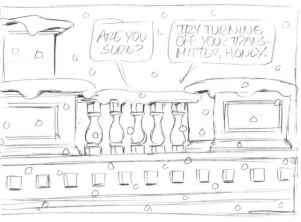
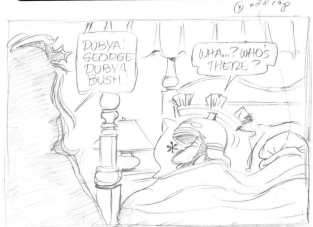
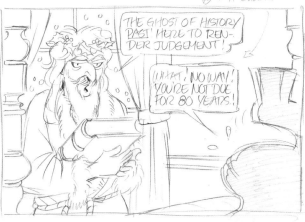
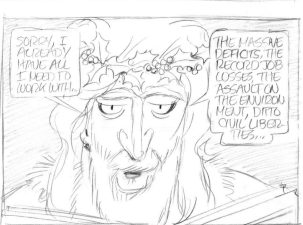
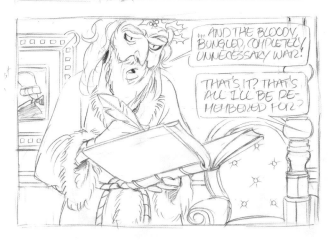
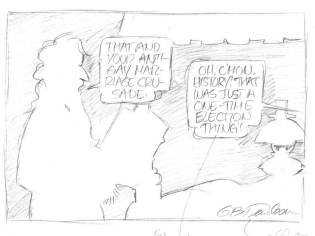
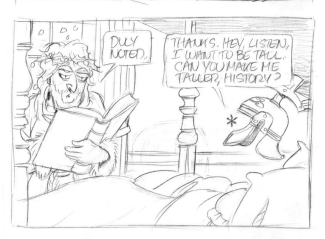

Doonesbury Sunday page, pencil drawing, December 19, 2004. The ghost of history visited Dubya shortly after his election to a second term.

Trinity Tonight: An Evening of Cabaret, pencil drawing and poster (opposite)
for a fund-raising event at the high school that all three of Trudeau's children attended, March 10, 2003.

Free for All: A Call for Free Speech, poster for benefit sponsored by People for the American Way, December 9, 2002. For this poster, designed by George Corsillo, Trudeau did the drawing, from which Susan McCaslin made a woodcut.

U.S. COMEDY
ARTS FESTIVAL
ASPEN, COLORADO
FEBRUARY 9 - 13, 2005

U.S. Comedy Arts Festival, poster designed
by George Corsillo, February 2005.
Trudeau opted to use Corsillo's loose ink
sketch of Zonker to add to the playful
tone of the poster.

Doonesbury daily strip, pencil drawing, July 4, 2005. Duke was proconsul of Al Amok during the Iraqi insurgency.

Pencil drawing, March 30, 2009. With a new administration in the White House, the focus shifted back to the remote mountains of Afghanistan.

Pencil drawings, March 7 and 9, 2005. Duke sensed a disturbance in the force after Hunter S. Thompson committed suicide on February 20, 2005. Panel 3 above is Trudeau's nod to the style of Thompson's friend and longtime illustrator Ralph Steadman.

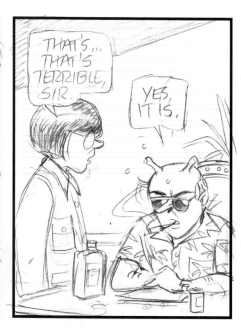
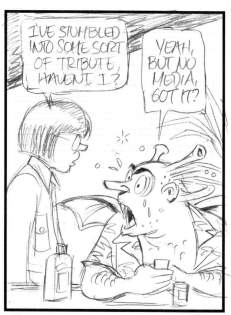

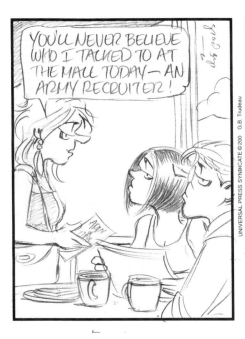

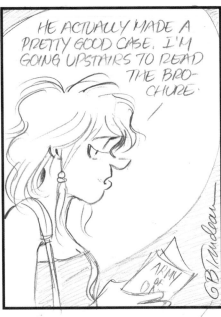

Pencil drawings, April 8 and 9, 2005. Mike and Kim remained frozen for five panels, over the course of two days, when Mike's daughter Alex informed them she was talking to an army recruiter.

November 30, 2005. Much to Mike and Kim's relief, Alex decided to go to college and visited Zipper and Jeff at Walden. The younger generation of *Doonesbury* characters was beginning to take center stage in the strip.

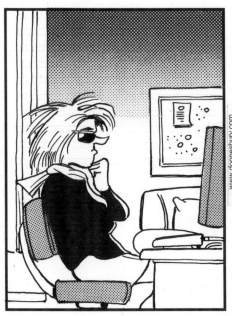
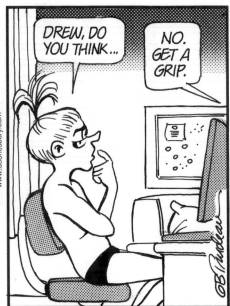

September 5, 2007. Alex experimented with a new image for her Facebook profile.

Dude: The Big Book of Zonker, preliminary design and finished cover, 2005.
Trudeau and Corsillo were inspired by the Dorling Kindersley (DK) line of books
when they came up with the cover design for this anthology.

Washington Post Magazine, pencil sketch and cover for article, "Getting to Know Garry Trudeau. Finally," by Gene Weingarten, October 22, 2006. Jonathan Alter, who wrote the *Newsweek* cover story on *Doonesbury* in 1990, disputes the claim that this was the first in-depth profile of Trudeau since his early career.

Doonesbury Sunday page, pencil drawing, August 20, 2006. Trudeau provided a tour of Middle East hot spots with the aid of his pencil.

August 20, 2006. George Corsillo colored Mike's summer daydream.

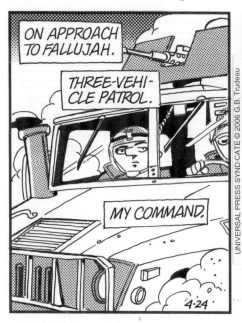

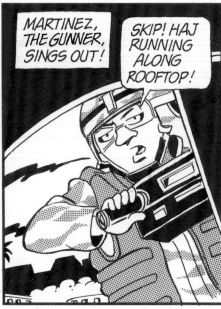

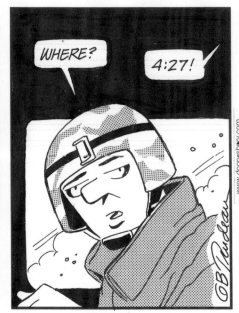

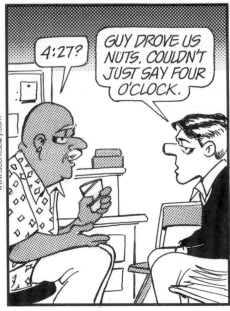

Doonesbury daily strips, April 24 and 25, 2006.
While in therapy for post-traumatic stress disorder, B.D. relived the day he was wounded near Fallujah.

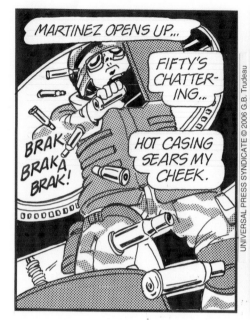

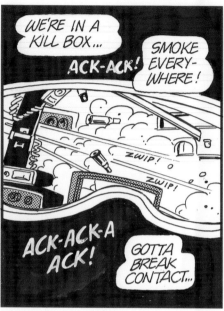

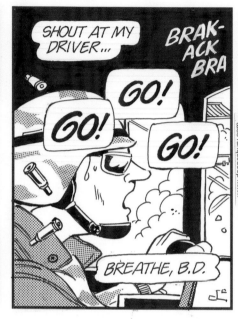

April 26 and 27, 2006. Trudeau achieved a new level of artistic expression with powerful scenes like these.

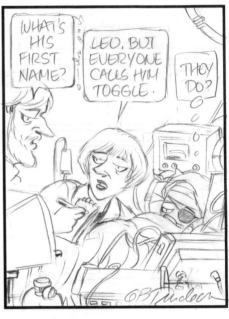

Pencil drawing and finished strip, January 27 and 28, 2008. Another war casualty, Toggle (a.k.a. Leo), arrived at Andrews Air Force Base. A brain injury left him with aphasia, an impairment of his ability to speak.

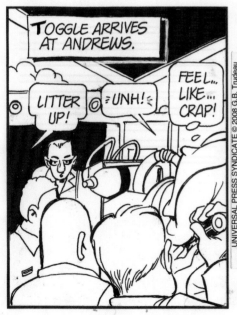
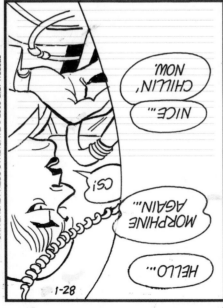
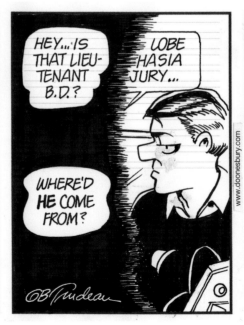

Pencil drawing and inked version without dialogue, December 24, 2008. Toggle attended a Christmas party of Iraq war veterans. Trudeau hired a typographer to develop a *Doonesbury* computer font. The lettering was added after the inked strip was scanned. From this point forward, all of the original artwork looked like this.

The Sandbox, pencil design sketch by Trudeau and finished cover by George Corsillo, 2007. A book collection of posts from the *Doonesbury* military blog was edited by David Stanford.

The Sandbox, patch and challenge coin (front and back), 2007. The service patch is sent to every contributor to *The Sandbox*. Trudeau gave the coins to soldiers he met when he visited Iraq in October 2009.

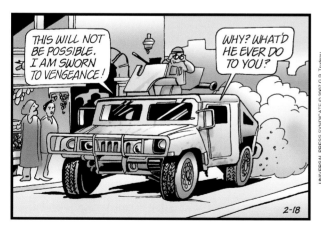

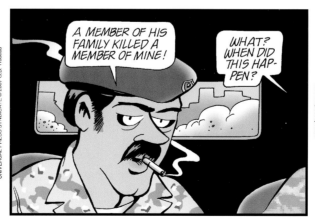

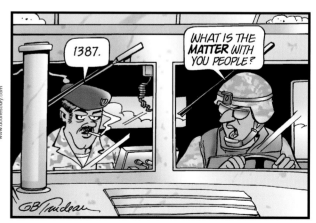

Doonesbury, Sunday page, February 18, 2007.
Corsillo designed camouflage patterns that he added digitally to the soldiers' uniforms.

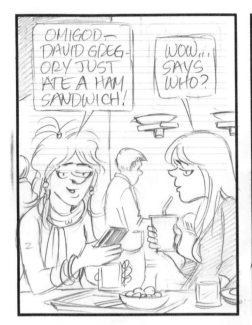

Doonesbury daily strips, pencil drawing and inked version, March 2, 2009.
Alex followed the tweets of her favorite celebrities while Roland Hedley twittered away.

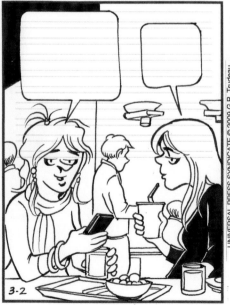

Pencil drawing, March 21, 2009. When Toggle showed B.D. the girl he met online, B.D. recognized her as Mike's daughter.

Pencil drawing, May 15, 2009. Alex and Toggle spent a romantic night under the stars talking about their dreams.

Doonesbury Sunday page, September 27, 2009. When conservatives made comparisons between the Obama administration and the Nazis, Trudeau, a history buff, finally had an opportunity to do some World War II scenes.

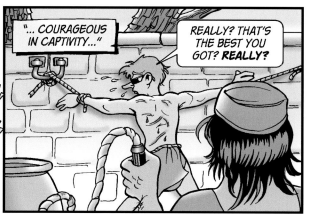

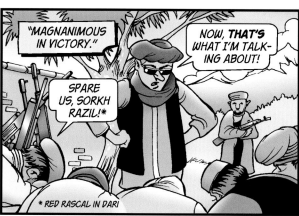

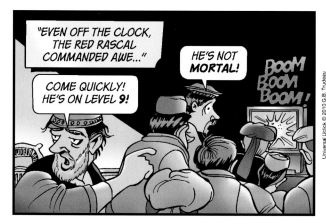

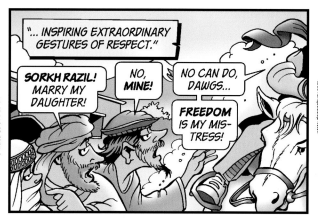

May 16, 2010. The legend of the "Red Rascal" is told in this action-packed episode, inspired by the classic adventure-hero genre.

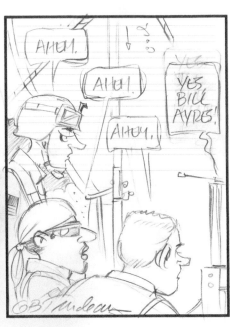

Doonesbury daily strip, pencil sketch and inked version, November 3, 2008. This episode appeared the day before the historic 2008
presidential election.

Pencil drawings, May 25 and 27, 2009. President Obama learned how the White House dialogue worked.

Doonesbury.com individual elements (above) and home page (right).
The completely redesigned Web site is scheduled to launch in fall 2010.

Doonesbury Sunday page "header" panels, 2006–2009. Each week, Trudeau designs a shorthand illustration for the title panel that reflects the theme of the strip.

BIBLIOGRAPHY

Adler, Dick. "Trudeau Captions a Decade." Review of *The Doonesbury Chronicles*. *Los Angeles Times*, December 14, 1975.

Alter, Jonathan. "Comics in Yuppiedom." *Newsweek*, October 1, 1984.

——. "Real Life with Garry Trudeau." *Newsweek*, October 15, 1990.

Alter, Jonathan, and Frank Bruni. "Doonesbury Contra Sinatra." *Newsweek*, June 24, 1985.

Amdur, Neil. "Dowling Makes It in Comic Strip." *New York Times*, November 20, 1968.

Andersen, Kurt. "Doonesbury at War." *New York Times*, June 19, 2005.

"The Art of Telling War Stories." *Vanguard* (U.S. Department of Veterans Affairs), November–December 2006.

"Asides: Garry Vanilli." *Wall Street Journal*, November 21, 1991.

Astor, David. "About 25 Clients Pull Doonesbury Strips." *Editor and Publisher*, November 16, 1991.

——. "Cartoonists Will Do Comics on Hunger." *Editor and Publisher*, September 28, 1985.

——. "Controversy over Sexism Flares in the Cartoon World." *Editor and Publisher*, June 16, 1984.

——. "Doonesbury Content and Width Still Making Waves." *Editor and Publisher*, October 27, 1984.

——. "Doonesbury Gets Controversial Almost Immediately." *Editor and Publisher*, October 13, 1984.

——. "Doonesbury Man Discusses His Strip." *Editor and Publisher*, September 30, 1995.

——. "Doonesbury on the Tube." *Editor and Publisher*, December 9, 2002.

——. "Doonesbury Strip Showing Bush Defending Frat Torture at Yale Is 'Fact-Based,' Says Garry Trudeau." *Editor and Publisher*, November 29, 2005.

——. "Doonesbury Will Hit Its 20th Anniversary This Week." *Editor and Publisher*, October 20, 1990.

——. "Few Irked by Doonesbury Masturbation Strip." *Editor and Publisher*, September 18, 2003.

——. "Giving Cartoonists a Break." *Editor and Publisher*, July 17, 2003.

——. "Good Work in Bad Times." *Editor and Publisher*, 2004.

——. "Newspapers May Go to Court over Doonesbury Size." *Editor and Publisher*, November 3, 1984.

——. "Newspapers Rush to Buy Doonesbury." *Editor and Publisher*, July 28, 1984.

——. "A Number of Newspapers Pull or Edit Doonesbury." *Editor and Publisher*, April 26, 1986.

——. "Over 175 Cartoonists Comment on Hunger Problem." *Editor and Publisher*, December 7, 1985.

——. "Over 20 Papers Drop Trudeau Comics about Sinatra." *Editor and Publisher*, June 22, 1985.

——. "Perennial Nominee Is Finally a Winner." *Editor and Publisher*, May 25, 1996.

——. "Trudeau Defends 44-Pica Size for Doonesbury Strip." *Editor and Publisher*, August 18, 1984.

——. "Trudeau Is 'Amazed' His Comic Endures." *Editor and Publisher*, October 23, 2000.

——. "Trudeau to Start Three-Month Sabbatical in June." *Editor and Publisher*, May 2, 1992.

——. "Tumultuous Time for Doonesbury." *Editor and Publisher*, June 2004.

——. "Two Major Dailies Change Doonesbury Wording." *Editor and Publisher*, August 9, 1986.

——. "Universal Birthday Celebrated in K.C." *Editor and Publisher*, February 18, 1995.

——. "The Wall Street Journal vs. Doonesbury." *Editor and Publisher*, December 28, 1991.

Barclay, Dolores. "Can Frogs and Chimps Take on Doonesbury?" *Sunday Post*, January 2, 1983.

——. "On His Sabbatical, They'll Get the Rest." *New York Daily News*, September 12, 1982.

Barron, James. "A Cartoonist Feasts on a President. So?" *New York Times*, August 31, 1994.

Bates, Eric. "Doonesbury Goes to War." *Rolling Stone*, August 5, 2004.

Berger, Joseph. "Doonesbury Leaves Salad Day Behind for Grown-Up World." *New York Times*, 1984.

Berlin, Eric. "The Doonesbury Game." *Game Magazine*, August–September 1994.

Berman, Dan. "Doonesbury: From Outsider to Icon." *Advocate and Greenwich Time*, December 24, 1995.

Bianculli, David. "Tales of Trudeau." *New York Post*, June 17, 1988.

Blumenthal, Karen. "Can No. 2 Papers Hold Onto Doonesbury?" *Wall Street Journal*, October 17, 1989.

Buhler, Nelson. Correspondence with Garry Trudeau. August 24, October 30, 1970.

——. Correspondence with Milton Kaplan/King Features Syndicate. August 31, September 4, 1970.

Bunch, William. "He Leaves 'Em Puzzled." *Newsday*, January 18, 1987.

Campbell, Don. "Sex and the Sports Mags." *Ottawa Citizen*, February 5, 1989.

Carlson, Raymond. "For Trudeau, Road to Comic Fame Began on York Street." *Yale Daily News*, April 11, 2008.

Carlton, Don. Letter to Bill Janocha. June 28, 1993.

Cawthorne, Zelda. "The World According to Garry Trudeau . . ." *South China Morning Post*, October 10, 1987.

Chaplin, A. M. "Watch Out, World: The Convergence Is Near." *Baltimore Sun*, August 13, 1987.

Chase, Cliff. "Newsweek Story Inspires Doonesbury Strip." *N/w* (*Newsweek*'s in-house newsletter), January 8, 1988.

Chow, Kimberly, and Jack Mirkinson. "Cartoon on Bush Recalls Yale Frat Hazing." *Yale Daily News*, December 1, 2005.

Clay, Carolyn. "Of Human Bondage: Thoreau-ly Modern Doonesbury." *Boston Phoenix*, October 25, 1983.

Clow, Gerry. "Yalie Clicks with Doonesbury." *Boston Globe*, August 22, 1971.

Coburn, Randy Sue. "Trudeau, Doonesbury Creator, Tries to Preserve Privacy." *Washington Star*, June 18, 1979.

Cochran, J. R. "Repression for the Hell of It: The Doonesbury Scandal!" *Inside Comics*, 1973.

Cohen, Noam. "The Parody Tweets That Went on Too Long." *New York Times*, April 20, 2009.

Cone, Edward. "The Revolution Will Be Satirized!" *Wired*, August 2000.

Conklin, Richard. "Doonesbury's 'Deals' McMeel." *South Bend Tribune*, March 9, 1980.

Corry, John. "'Tanner '88': A Satire on Presidential Campaigns." *New York Times*, February 15, 1988.

Coto, Juan Carlos. "GI's Comic Strip Satirizes Gulf Crisis." *Miami Herald*, January 27, 1991.

Covert, Colin. "Well, I Guess It's Time I Took a Rest." *Detroit Free Press*, January 2, 1983.

Cruse, Howard. "Andy, We Hardly Knew You." *Outlook*, Winter 1991.

Davis, Yusuf. "Doonesbury Debuts on Screen Saver." *Atlanta Journal-Constitution*, September 17, 1995.

Deford, Frank. "B.D." *Sports Illustrated*, September 5, 1988.

"Doonesbury: Drawing and Quartering for Fun and Profit." *Time*, February 9, 1976.

"Doonesbury a Record of Pain, Pleasure, Lunacy." *Adirondack Enterprise*, 1971.

"Doonesbury Comes Home to Andrews and McMeel." *Publishers' Weekly*, January 13, 1989.

"Doonesburying Reagan." *Newsweek*, November 10, 1980.

"Doonesbury on Leave." *Newsweek*, September 20, 1982.

"Doonesbury Size Flap in Massachusetts." *Comics Journal*, March 1985.

"Doonesbury Strip in Comic Flop." United Press International, November 14, 1976.

Dunham, Elisabeth. "Doonesbury Debuts 'Politically Correct' Line of Merchandise." *Fresno Bee*, October 20, 1991.

Evanier, Mark. "Point of View." *Comic Buyers Guide*, September 13, 1996.

"Garry Trudeau and Amazon.com Launch 'The Peoples Doonesbury Amazon.com.'" PRNewswire, May 4, 1998.

"Garry Trudeau Creates Button for S. L. Carnival." *Lake Placid News*, December 17, 1981.

Gettelman, Elizabeth. "War on the Funny Pages." *Mother Jones*, January–February 2007.

Goodgame, Dan. "Two Faces of George Bush." *Time*, July 2, 1990.

Goodman, Ellen. "The Midlife Baby Blues." *Boston Globe*, January 6, 1983.

Grant, Linda. "Welcome Back B.D." *Guardian*, September 19, 2005.

Greeman, Catherine. "Mindscape Inks Trudeau: CD-ROM Funny Man." *HFN–Retailing Home Furnishings*, April 17, 1995.

Grenier, Melinda Patterson. "Trudeau Sketches Out Future of Comics in Cyberspace." Wall Street Journal.com, October 26, 2000.

Grove, Lloyd. "Trudeau Speaks." *Washington Post*, November 12, 1986.

Hackett, Larry. "Trudeau's Got a Stake in the Crass." *New York Daily News*, October 20, 1991.

Hart, Bob. "Kansas Artist Completes Doonesbury Comic Strip." *Northwestern Kansas Register*, April 19, 1991.

Healey, Barth. "Stamps: Gummed Labels in the Doonesbury Album Can Be Used to Brighten Envelopes for Personal Letters." *New York Times*, July 8, 1990.

"Helping Hands: Cartoon Characters Unite for a Worthy Cause." *Life*, June 1986.

Henry, William A., III. "Attacking a 'National Amnesia.'" *Time*, December 8, 1986.

Hinckley, David. "A Decade of Doonesbury." *New York Daily News*, 1980.

———. "Doonesbury: A Strip Down Memory Lane." *New York Daily News*, October 24, 1995.

———. "Doonesday! Trudeau's Troupers Trooping In." *New York Daily News*, September 23, 1984.

———. "Doonesbury's Blog of War." *New York Daily News*, October 11, 2006.

———. "Doonesbury's Dying Art." *New York Daily News*, August 16, 1998.

———. "Doonesbury Still a Top Draw at 30." *New York Daily News*, October 26, 2000.

———. "For Comic Artists, Love Is a Many-Paneled Thing." *New York Daily News*, November 19, 1996.

———. "Happy 20th, Doonesbuddy!" *New York Daily News*, October 21, 1990.

———. "Politics: A Real Comical Matter." *New York Daily News*, November 19, 1988.

———. "Trudeau's Selling of the Precedent." *New York Daily News*, October 29, 1991.

Holden, Stephen. "Doonesbury Spawns a Partisan Revue." *New York Times*, September 30, 1984.

Holland, Robert. "The Bull behind Bull Tales." *New Haven Register*, March 1, 1970.

Hubley, John, Faith Hubley, and Garry Trudeau. "The Doonesbury Special." Pacific Arts Video, 1977.

Ignatius, David. "The Bygone Day When Doonesbury Was Funny." *Minneapolis Star and Tribune*, August 31, 1986.

Jacobs, Frank. " . . . When Those 'Old Line' Comic Strips Follow the New Wave, Cerebral 'Doonesbury' Trend." *MAD*, July 1978.

Jaffee, Larry. "Second Doonesbury Sellout Catalog Bound into Copies of Spy Magazine." *Los Angeles Daily News*, December 14, 1992.

Johnson, Wayne. "Trudeau Confessions." *Seattle Times*, April 2, 1987.

Jones, Alex S. "Sinatra Seeks List of Papers Printing Doonesbury Comic." *New York Times*, June 21, 1985.

Joseph, Regina. "Study in Pen and Ink: Garry Snipe Is Tripe." *Media Week*, November 11, 1991.

Kahn, Joseph P. "Garry Trudeau Continues to Draw Controversy." *Boston Globe*, May 29, 2004.

Kelly, Kevin. "The Trudeau Touch." *Boston Globe*, December 22, 1985.

Kierstead, Robert. "The Ombudsman: Doonesbury and the Pica War." *Boston Globe*, September 2, 1984.

Kogan, Rick. "Rap Master Garry Trudeau." *Chicago Tribune*, November 24, 1985.

Koppel, Ted. Interview with Garry Trudeau. *Up Close*, aired on December 3, 4, 2002.

Krinsky, Alissa. "Smitten with the Idea of a Personal Broadcasting System." *Journos*, April 21, 2009.

Lambert, Bruce. "Millicent Fenwick, 82, Dies; Gave Character to Congress." *New York Times*, September 17, 1992.

Lawson, Carol. "Coming Next Fall, a Song-and-Dance Mike Doonesbury." *New York Times*, June 24, 1983.

Leonard, John. "Books of the Times: A Tad Overweight, but Violet Eyes to Die For." *New York Times*, February 28, 1980.

Lewis, Anthony. "The Giftie Gie Us." *New York Times*, January 3, 1983.

Maeder, Jay. "Jay Maeder and Garry Trudeau on Problems Cartoonists Face." *Cartoonist PROfiles*, June 1980.

Malloch, Archibald. "James De Berty Trudeau: Artist, Soldier, Physician." Read before the Charaka Club, February 18, 1931. Reprinted from the Proceedings of the Charaka Club, 1935, vol. 8, Columbia University Press.

Marcus, Ruth. "Doonesbury and Gang Charm in Premier of Trudeau Film." *Yale Daily News*, October 20, 1977.

McCain, Nina. "'Survival Tactics' Honestly Portrayed." *Boston Globe*, April 3, 1989.

McKeever, James. "Twenty Years of Adirondack Life." *Post Standard*, May 16, 1989.

Minzesheimer, Bob. "Trudeau Tries Web Funnies Business." *USA Today*, May 4, 1998.

Mitchell, Karen. "Be Like Duke." *Sunday Camera*, December 6, 1992.

Mitgang, Herbert. "Aging Agitator." *New York Times*, July 12, 1981.

Moody, Emily. "Trudeau's 15th: Doonesbury Pins Fit Tradition of Winter Carnival to a 'T.'" *Press Republican*, February 12, 1995.

Muniz, C. L. Smith. "B.D.'s Not a Comic." *New York Daily News*, September 5, 1986.

Myers, Linnet. "Laughing at Death." *Chicago Tribune*, April 9, 1989.

Nash, Alanna, and Harriet Barovick. "Ghost Stories." *Entertainment Weekly*, November 8, 1991.

"New Look on the Funny Pages." *Newsweek*, March 5, 1973.

Nightingale, Benedict. "As Theater, Doonesbury Lacks True Satirical Bite." *New York Times*, November 27, 1983.

O'Briant, Don. "Trudeau Aims to Help Stamp Out Illiteracy with Doonesbury Book." *Atlanta Constitution*, June 22, 1990.

O'Connor, Christine. "Doonesbury Grows Richer with Age." *Sunday Oakland Press*, January 11, 2004.

O'Neil, Dennis. "Profile: Garry Trudeau." *Comics Journal*, December 1980.

O'Rourke, P. J. Interview with Hunter S. Thompson. *Rolling Stone*, November 5, 1987.

Parachini, Allan. "Social Protest Hits the Comic Pages." *Columbia Journalism Review*, November–December 1974.

Radolf, Andrew. "Don't Shrink the Comics." *Editor and Publisher*, April 30, 1988.

——. "Doonesbury Creator Addresses Associated Press Managing Editors Conference." *Editor and Publisher*, December 1, 1984.

Rich, Frank. "Stage: Partisan Revue, Rap Master Ronnie." *New York Times*, October 4, 1984.

Rizzo, Frank. "Trudeau Gives 'Interview.'" (New Haven) *Journal-Courier*, November 4, 1980.

Robinson, John. "Bush, Kerry and Skull-duggery." *Boston Globe*, May 27, 1988.

Roel, Ronald. "Garry Trudeau." *New Journal*, May 18, 1973.

Rose, Charlie. Interview with Garry Trudeau. *Charlie Rose*, aired on October 1, 2004.

Rosenstiel, Thomas B. "Doonesbury Strips on Quayle Provoke Uproar." *Los Angeles Times*, November 6, 1991.

Rothschild, Richard. "Goodbye, Doonesbury; We'll See You Again in '84." *Connecticut Newspapers*, September 19, 1982.

Rowen, John. "Saranac Lake Sanatorium Makes Inspiring Story." (Schenectady, N.Y.) *Sunday Gazette*, August 11, 2002.

Rubien, David. "Brilliant Careers: Garry Trudeau." *Salon*, November 2, 1999.

Rulison, Larry. "Dr. Francis B. Trudeau Jr. Honored in Ceremony Sunday." *Adirondack Daily Enterprise*, August 6, 1996.

"The Satirist and the Inker." *Wall Street Journal* (Europe), December 24, 1991.

Schapiro, Judy. "The Four-Panel Smile." *Yale Alumni Magazine*, June 1969.

Schneier, Frank. "Major Papers Refuse to Print 'Explicit' Trudeau Cartoon." *Yale Daily News*, November 16, 1976.

Sharbutt, Jay. "Rap Master Garry: 365 Days a Year." *Los Angeles Times*, August 8, 1985.

Shenk, Joshua Wolf. "Drawing on Idealism." *Washington Monthly*, July–August 1996.

Shepard, Scott. "'Wimp' Cartoons Made Bush Angry." *Atlanta Constitution*, October 15, 1987.

Shih, Michelle. "Games People Are Playing: A Gift, Perhaps?" *New York Times*, December 11, 1994.

Siegel, David. *Secrets of Successful Web Sites*. Carmel, Ind.: Hayden, 1997.

Simon, John. "Farcial Worlds." *New York*, December 5, 1983.

Singer, Mark. "Boola-Boola: Bush vs. Trudeau, Chapter 1." *New Yorker*, January 8, 2001.

Singleton, Don. "Doonesbury Irks Gays." *New York Daily News*, April 5, 1989.

Snider, Mike. "Doonesbury on CD-ROM." *USA Today*, May, 1995.

Snow, Nick. "Artist Trudeau Is a Lot Like His Comics." *Salt Lake City Deseret News*, June 7, 1977.

Solomon, Charles. "Life with Doonesbury Group." *Los Angeles Times*, April 27, 1986.

Soper, Kerry D. *Doonesbury and the Aesthetics of Satire*. Jackson: University Press of Mississippi, 2008.

Stanley, Alessandra. "Trudeau Chat Offers Koppel and His Style a Showcase." *New York Times*, December 2, 2002.

"Starbucks and Garry Trudeau Blend Coffee and Commentary to Promote Literacy; New Line of Beloved Doonesbury Characters Grace Limited Edition Products." *Business Wire*, August 5, 1999.

Stein, Ruthe. "A Chat with the Man behind Doonesbury: Garry Trudeau." *San Francisco Chronicle*, September 26, 1986.

Steward, Hartley. "The New Comic-Strip King Is only 25." *Toronto Star*, May 13, 1974.

Story, Richard David. "From Walden Puddle to . . ." *USA Today*, November 15, 1983.

Stossel, Scott. "Doonesbury as History: Thirtysomething Years Writ Large." *Baltimore Sun*, March 9, 2004.

Trudeau, Garry. "Believe It. Not!" *New York Times*, March 27, 1992.

——. Correspondence with John B. Kennedy/James F. Andrews. November 24, 1968–July 16, 1970.

——. "The Doonesbury Gang Comes Alive." *TV Guide*, November 26, 1977.

——. "Doonesbury Is Back! *Life*, October 1984.

——. "Duke 2000: Whatever It Takes." Animation Entertainment, 2000.

——. "I Hate Charlie Brown: An Appreciation." *Washington Post*, December 16, 1999.

——. "Investigative Cartooning." *Washington Post*, December 15, 1991.

——. "On Being Dubbed by Dubya." *Time*, February 12, 2001.

——. "On Magnifying Grains of Truth." *Chicago Tribune*, December 8, 1971.

——. "The Post Neo-Nixon Annotated." *New York Times*, May 20, 1990.

——. Remarks to American Association of Sunday and Feature Editors, September 30, 2005, Denver.

——. "The Rolling Stone Interview: Jimmy Thudpucker." *Rolling Stone*, February 9, 1978.

——. Speech at Ohio State University Festival of Cartoon Art, 1995.

——. Speech before Associated Press Managing Editors Conference, November 27, 1984.

——. Speech to the American Newspaper Publishers Association, April 25, 1984.

——. "The Tweets of Roland Hedley." *New Yorker*, April 20, 2009.

Trudeau, Garry, and Jonathan Alter. "Drawing on Its Wit, WSJ Got Inky Fingers." *Wall Street Journal*, December 27, 1991.

"Trudeau, Garry." *Current Biography*, August 1975.

"Trudeau's 'Doonesbury Dinosaurs' Stalk Museum Park." *Graphic Design U.S.A.*, December 1990.

Twiddy, David. "Doonesbury Still Feisty after 35 Years." Associated Press, 1995.

Vaden, Ted. "The Great Comics Controversy: Mallard and Doonesbury." *News and Observer*, January 27, 2008.

Walker, Brian. *The Comics: Since 1945*. New York: Abrams, 2002.

——."The Great Doonesbury Sellout: An Interview with Richard Shell." *Collectors' Showcase*, May–June 1997.

——. Interviews with Garry Trudeau, September 3 and 10, 2009.

——. Interview with Don Carlton, October 2, 2009.

——. Interview with George Corsillo, October 6, 2009.

——. Interview with Peter de Sève, November 2, 2009.

——. Interview with Mike Seeley, November 28, 2009.

——. Interview with David Stanford, August 19, 2009.

——. "The New Comix." *Silver Lining*, May 8, 1974.

Walker, Jesse. "Doonesburied: The Decline of Garry Trudeau—and of Baby Boom Liberalism." *Reason*, July 2002.

Warner, Margaret. "Doonesbury Cartoonist Painted Two Murals at N.H. Hospital." *Concord Monitor*, February 28, 1976.

"Watch Out, Here Comes Garry." *Glamour*, September 1971.

Waters, Harry F. "A Presidential Pretender." *Newsweek*, February 15, 1988.

Weingarten, Gene. "Doonesbury's War." *Washington Post Magazine*, October 22, 2006.

Whitmire, Richard. "Will Trudeau Gang Ever Grow Up?" *USA Today*, December 28, 1982.

Whitmire, Tim. "Doonesbury Cartoonist Discusses His 'Ungentlemanly Art.'" *Greenwich Time*, June 29, 1997.

Williams, Christian. "Garry Trudeau Takes Time Off to Bring Walden Puddle into the '80s." *Washington Post*, January 1, 1983.

Williamson, Lenora. "Fresh Air from the Campus in Trudeau's Doonesbury." *Editor and Publisher*, January 16, 1971.

———. "Surprising Syndicate Open to Fresh Ideas." *Editor and Publisher*, May 30, 1970.

"Will the Real Uncle Duke Please Stand Up?" *New Yorker*, May 15, 2000.

Wines, Michael. "Allegations of Drug Use by Quayle Were Judged Groundless in 80's." *New York Times*, November 7, 1991.

Woodson, Michelle. "Enter Mike Doonesbury." *Entertainment Weekly*, October 28, 1994.

"Zonkering Out! Doonesbury Creator Taking Leave." *New York Daily News*, September 9, 1982.

Ben & Jerry's Doonesberry Sorbet container, 1996. The Doonesbury Web site explained how this flavor was selected: It was an arduous process, involving hard work, luck, and two trips to Burlington, Vermont, one of which was devoted to tasting ice cream. Originally, a rich concoction of pretzels, chocolate, peanut butter, and vanilla ice cream was to be called "Zonker's Own." At the last minute, however, B&J founder Ben Cohen decided to go with that flavor's original name, "Chubby Hubby," and the Doonesbury project was postponed until the introduction of the sorbet line. From the original six flavors, the all-berry recipe emerged as the best candidate from a simple naming standpoint. It has since become B&J's most popular sorbet flavor. Permission of Ben & Jerry's.

Illustration Credits

Books by G. B. Trudeau

COLLECTIONS

Still a Few Bugs in the System, Holt, Rinehart and Winston, 1972.

The President Is a Lot Smarter Than You Think, Holt, Rinehart and Winston, 1973.

But This War Had Such Promise, Holt, Rinehart and Winston, 1973.

Call Me When You Find America, Holt, Rinehart and Winston, 1973.

Guilty, Guilty, Guilty! Holt, Rinehart and Winston, 1974.

"What Do We Have for the Witnesses, Johnnie?" Holt, Rinehart and Winston, 1975.

Dare To Be Great, Ms. Caucus, Holt, Rinehart and Winston, 1975.

Wouldn't a Gremlin Have Been More Sensible? Holt, Rinehart and Winston, 1975.

"Speaking of Inalienable Rights, Amy, . . ." Holt, Rinehart and Winston, 1976.

You're Never Too Old for Nuts and Berries, Holt, Rinehart and Winston, 1976.

An Especially Tricky People, Holt, Rinehart and Winston, 1977.

As the Kid Goes for Broke, Holt, Rinehart and Winston, 1977.

"Any Grooming Hints for Your Fans, Rollie?" Holt, Rinehart and Winston, 1978.

Stalking the Perfect Tan, Holt, Rinehart and Winston, 1978.

But the Pension Fund Was Just Sitting There, Holt, Rinehart and Winston, 1979.

We're Not Out of the Woods Yet, Holt, Rinehart and Winston,1979.

A Tad Overweight, But Violet Eyes to Die For, Holt, Rinehart and Winston, 1980.

And That's My Final Offer! Holt, Rinehart and Winston, 1980.

He's Never Heard of You, Either, Holt, Rinehart and Winston, 1981.

In Search of Reagan's Brain, Holt, Rinehart and Winston, 1981.

Ask for May, Settle for June, Holt, Rinehart and Winston, 1982.

Unfortunately, She Was Also Wired for Sound, Holt, Rinehart and Winston, 1982.

The Wreck of the "Rusty Nail," Holt, Rinehart and Winston, 1983.

You Give Great Meeting, Sid, Holt, Rinehart and Winston, 1983.

Check Your Egos at the Door, Holt, Rinehart and Winston, 1985.

That's *Doctor* Sinatra, You Little Bimbo! Henry Holt, 1986.

Death of a Party Animal, Henry Holt, 1986.

Downtown Doonesbury, Henry Holt, 1987.

Calling Dr. Whoopee, Henry Holt, 1987.

Talkin' about My G-G-Generation, Henry Holt, 1988.

We're Eating More Beets! Henry Holt, 1988.

Read My Lips, Make My Day, Eat Quiche and Die!, Andrews and McMeel, 1989.

Give Those Nymphs Some Hooters! Andrews and McMeel, 1989.

You're Smokin' Now, Mr. Butts! Andrews McMeel, 1990.

I'd Go With the Helmet, Ray, Andrews McMeel, 1991.

Welcome to Club Scud!, Andrews McMeel, 1991.

What Is It Tink, Is Pan in Trouble? Andrews McMeel, 1992.

Quality Time on Highway 1, Andrews McMeel, 1993.

Washed Out Bridges and Other Disasters, Andrews McMeel, 1994.

In Search of Cigarette Holder Man, Andrews McMeel, 1994.

Doonesbury Nation, Andrews McMeel, 1995.

Virtual Doonesbury, Andrews McMeel, 1996.

Planet Doonesbury, Andrews McMeel, 1997.

Buck Wild Doonesbury, Andrews McMeel, 1999.

Duke 2000: Whatever It Takes, Andrews McMeel, 2000.

The Revolt of the English Majors, Andrews McMeel, 2001.

Peace Out, Dawg! Andrews, McMeel, 2002.

Got War? Andrews McMeel, 2003.

Talk to the Hand, Andrews McMeel, 2004.

Heckuva Job, Bushie!, Andrews McMeel, 2006.

Welcome to the Nerd Farm, Andrews McMeel, 2007.

Tee Time in Berzerkistan, Andrews McMeel, 2009.

ANTHOLOGIES

The Doonesbury Chronicles, introduction by Garry Wills; Holt, Rinehart and Winston, 1975.

Doonesbury's Greatest Hits, introduction by William F. Buckley, Jr.; Holt, Rinehart and Winston, 1978.

The People's Doonesbury: Notes from Underfoot, Holt, Rinehart and Winston, 1981.

Doonesbury Dossier: The Reagan Years, introduction by Gloria Steinem; Holt, Rinehart and Winston, 1984.

Doonesbury Deluxe: Selected Glances Askance, introduction by Studs Terkel; Henry Holt and Company, 1987.

Recycled Doonesbury: Second Thoughts on a Gilded Age, Andrews McMeel, 1990.

Action Figure! The Life and Times of Doonesbury's Uncle Duke, Andrews McMeel, 1992.

The Portable Doonesbury, Andrews McMeel, 1993.

Flashbacks: Twenty-Five Years of Doonesbury, Andrews McMeel, 1995.

The Bundled Doonesbury: A Pre-Millennial Anthology, Andrews McMeel, 1998.

Dude: The Big Book of Zonker. Andrews McMeel, 2005.

OTHER BOOKS

Doonesbury: The Original Yale Cartoons, Sheed and Ward, 1971.

Joanie, afterword by Nora Ephron, Cartoons for New Children series; Sheed and Ward, 1974.

We'll Take It From Here, Sarge, afterword by Chuck Stone, Cartoons for New Children series, Sheed and Ward, 1975.

The Fireside Watergate (with Nicholas von Hoffman), Sheed and Ward, 1973.

Tales from the Margaret Mead Taproom (with Nicholas von Hoffman), Sheed and Ward, 1976.

John and Faith Hubley's "A Doonesbury Special": A Director's Notebook, Sheed Andrews and McMeel, 1977.

Doonesbury: A Musical Comedy, Holt, Rinehart and Winston, 1984.

The Long Road Home: One Step at a Time, foreword by Senator John McCain; Andrews McMeel, 2005.

The War Within: One More Step at a Time, foreword by General Richard B. Myers; Andrews McMeel, 2006.

Signature Wound: Rocking TBI, foreword by General Peter Pace; Andrews McMeel, 2010.

Doonesbury.com's The Sandbox: Dispatches from Troops in Iraq and Afghanistan, Andrews McMeel, 2007.

Introduction to Doonesbury.com's The War in Quotes, Andrews McMeel, 2008.

My Shorts R Bunching. Thoughts? The Tweets of Roland Hedley. Andrews McMeel, 2009.

MUSIC

Greatest Hits: Doonesbury's Jimmy Thudpucker and the Walden West Rhythm Section, Windsong Records, 1977.

Doonesbury: A New Musical (book and lyrics), music by Elizabeth Swados, MCA Records, 1983.

Rapmaster Ronnie (with Elizabeth Swados), performed by Reathel Bean and the Doonesbury Break Crew, Silver Screen Records, 1984.

Too Poor, Jimmy Ray Thudpucker's NetAid Theme, Dienbienphonix Lab, 1999.

VHS, GAMES, CD-ROMs, DVDs, and WEB SITE

A Doonesbury Special (with John Hubley and Faith Hubley), VHS, Pacific Arts Video, 1977.

The Doonesbury Game: Something to Do, board game, Mikrofun, 1993.

Doonesbury Flashbacks: 25 Years of Serious Fun, CD-ROM, Mindscape, 1995.

Doonesbury Screen Saver, Mindscape, 1995.

The Doonesbury Election Game: Campaign '96, CD-ROM, Mindscape, 1996.

Duke 2000: Whatever It Takes, DVD, Animation Entertainment, 2005.

Doonesbury.com, Universal Uclick/Slate, 1995–present.